Talking with the Clay

For the Pueblo People
and their grace in
sustaining identity
nourishing creativity
enduring through the centuries

Talking with the Clay

The Art of Pueblo Pottery in the 21st Century

20TH ANNIVERSARY REVISED EDITION

Words and Photographs by Stephen Trimble

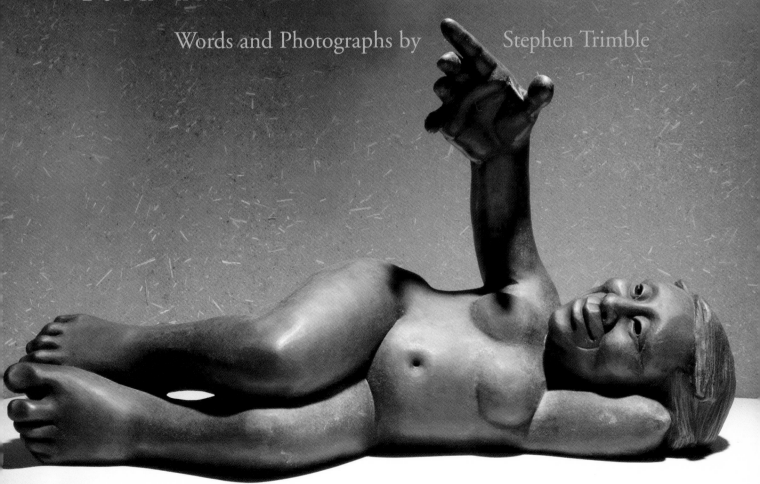

SCHOOL FOR ADVANCED RESEARCH SANTA FE, NEW MEXICO

School for Advanced Research Press

PO Box 2188 Santa Fe, New Mexico 87504-2188

www.sarpress.sarweb.org

Co-Director and Executive Editor: Catherine Cocks

Copy Editor: Kate Whelan

Designer and Production Manager: Cynthia Dyer

Proofreader: Margaret J. Goldstein

Indexer: Stephen Trimble

Printer: C&C Offset Printing Co., Ltd.

Library of Congress Cataloging in Publication data:

Trimble, Stephen, 1950–

 Talking with the clay : the art of Pueblo pottery in the 21st century / words and photographs

by Stephen Trimble.—20th anniversary rev. ed.

 p. cm.

 Includes bibliographical references and index.

 ISBN 1-930618-77-8 (cl : alk. paper)—ISBN 1-930618-78-6 (pa : alk. paper)

 1. Pueblo pottery. I. Title.

E99.P9T75 2007

738.3089'974—dc22

2006033124

International Standard Book Number 978-1-930618-77-0 (cloth); 978-1-930618-78-7 (paper)

First edition 2007.

Printed and bound in China

Photo credits: Cover, detail, Taos micaceous pot by Glenn Gomez, Taos/Pojoaque, 2006. Cover inset: Sikyatki-inspired jar by Jacob Koopee, Hopi-Tewa, 2006. Dedication page: Hopi tile by Lorna Lomakema, made in 1981–82; title page: *Hold My Hand* (artist proof from clay original) by Roxanne Swentzell, Santa Clara, 2006; page vi: detail, fine-line Acoma plate by Rebecca Lucario, 2006; page 136: detail, pot by Les Namingha, Hopi-Tewa, 2006; page 138: Santa Clara tile by Jody Naranjo, 2006; page 144: Cora Durand firing her micaceous pottery at Picuris, 1985; page 146: detail, Acoma seed jar by Dorothy Torivio, 1985; page 148: collection of ribbons awarded to Nancy Youngblood's Santa Clara pottery, 2006; page 149: beadseller's stand near Cameron, Arizona, 2006.

Contents

The Art of Pueblo Pottery in the Twenty-First Century

IT'S 2007 and time to update *Talking with the Clay.* In the twenty years since this book first reached print, new potters have become prominent and older potters have passed away or ceased working. Innovation has diversified tradition; the marketplace has evolved. This new edition introduces a younger generation of potters and two decades of change, bringing the book into the twenty-first century.

When I interviewed Daisy Hooee at Zuni in 1985, she told me stories from seventy years earlier—cherished memories of watching and learning from her grandmother, the legendary Hopi potter Nampeyo. That same year, I photographed Lucy Lewis at her home in Acoma; she was born in 1899. When I returned to Acoma in 2006 to interview potters in their thirties and forties, Delores Aragon proudly spoke of her seven-year-old daughter Grace's first efforts at making clay pendants. Carolyn Concho's grandkids had broken two of her Acoma pots well along in the journey toward firing, but she still believed that the toddlers should play by the kitchen table as she works, that it's important for them to hold the delicate pottery in their small hands.

The stories in *Talking with the Clay* now span seven generations and more than a century.

In the past twenty years, much has changed. Confident young Pueblo potters bring sophisticated university training to their art, along with skills of the digital age. They push the physical limits of clay and the academic definitions of Indian art. More and more, the Pueblo potter stands alone as an individual rather than as, first and foremost, a community member. Each Pueblo artist must forge a personalized definition of identity and culture. Nothing is a given in a world where "Pueblo people have embraced self-determination in their personal life," in potter William Pacheco's words.

In the grandmothers' generation, a Pueblo woman incorporated potterymaking as part of her cultural identity. On First Mesa at Hopi or at the pueblos of Santa Clara and San Ildefonso, nearly every woman learned to make pottery. In the final quarter of the twentieth century, as the "dominant culture" created a market for Indian art, dealers and collectors favored the families with familiar names—descendants of the better-known matriarchs. For young members of these families, there were expectations to be met.

Today potterymaking is a choice, no longer a cultural fundamental. Only those Pueblo people who consciously make art from clay, whose primary joy comes from creating, become potters now. They may be men or women, from a heavily marketed family or not, young or old, reservation-based or city-based, dedicated to their grandmother's techniques or open to kilns and all the tools available today. These are the new Pueblo potters: "transmitters," as Santa Clara sculptor Roxanne Swentzell

puts it, individuals, artists—grumpy about the narrow categories used by judges at markets and Indian fairs and eager to defy these constraints, yet proud of their heritage. Caroline Carpio gleefully entered her first bronze casting of one of her Isleta pots at the Heard Museum Indian Fair: "Does pottery always have to be clay? I wanted to test the meaning."

A few become celebrity potters. They create intricate websites and sell their pots for tens of thousands of dollars. The communal society of the Pueblos is shifting, allowing artists more comfort in that spotlight prized by the dominant culture, escalating competition in the cooperative Pueblo world. Each artist must come to terms with the dilemma articulated by Caroline Carpio: "I like being different, but I don't like standing out in a crowd."

Suburban Indians still return to their pueblos to dance in plazas on feast days, to listen to elders, to stay in touch with ever-extending families. They nourish their connection to traditional culture—at the risk of becoming, as one potter fears, "commuters playing Indian on the weekend." For those who live in the pueblos, creativity depends on distancing themselves from the looping electronic arpeggios and tinkle of slot machines pouring from the nearby tribal casino.

Potters look for ways to tell these stories—more complicated stories than the previous generations sought to tell. Figurative potters sculpt twenty-first-century stories in clay. The designs they draw and carve on their bowls embrace irony and politics, tragedy and whimsy. The line of stories and teachings handed down through

Isleta jar with corn appliqué by Caroline Carpio, 2006.

the generations by the grandmothers and aunties still exists. But it follows a more wandering path, and potters worry that their children may not learn the full power of that ancestral lineage.

For "tradition" to be anything other than stagnant, it must embrace change. In truth, the time to set aside the concept may have come, for it seems to confuse as much as it communicates. Virgil Ortiz bridles at the notion that tradition means doing only what your grandmother did: "What about your grandmother's grandmother?" Diego Romero says, "The matriarchs of traditional pottery were very contemporary for their time."

Tammy Garcia, another of today's innovative potters, "still loves the word." To her, tradition "holds a lot of information. In the broader sense, it means change, adaptability. It also means the continuing ability to do something better than before." Max Early at Laguna says that tradition "illuminates through the potter's soul." Art historian Ralph T. Coe comes close to expressing the power of tradition when he describes it as "something Indians step into in order to be themselves."

This past generation has also transformed the marketplace. As potters create finer and finer pieces, prices rise. Contemporary Pueblo pottery turns up in Sotheby's auctions, and the bidding is lively. As the value of pottery increases—and as collectors insist more on "perfection"—more and more potters use electric kilns to reduce the risk of loss in firing. With greater control, more pots survive. With greater production, collectors can be far more selective.

Collectors have a choice of buying pieces made by "the copiers, the refiners, or the innovators," as Santa Fe gallery owner Robert Nichols puts it. The copiers make pots exactly as their families have made them for decades, and these lovely, recognizable pieces remain most affordable. The refiners take technique to the limit, creating extraordinary "high-craft" pieces still in keeping with familiar styles of their pueblos. The innovators create individualistic and unpredictable art. Their explorations lead to dead ends, to interesting phases they pass through and then abandon, and, finally, to successful experiments—and the future of Pueblo pottery.

Tammy Garcia—who knows that she is one of the potters whose work "pushes the market"—saw a crossover point: "Twenty years ago, the wholesalers picked the safe pieces, and only a few picked the unusual pieces. A transition began in 1986, when the unusual pieces began to take over. It took five years." Those high-end pieces have tugged prices upward for the bread-and-butter pottery—but fewer reputable galleries stock a wide range of pieces. The newcomer has to search harder for nicely made, affordable pots and dependable information.

The World Wide Web makes educating yourself easier. Search for websites rich with information, and avoid those that feature only a few misidentified pots with half-truthful captions. (A list of useful links appears at the end of this book.) Coordinate your trip to the Southwest with a major Indian art show, fair, or feast day. When you visit Pueblo country, ask questions in museum shops. When you find knowledgeable dealers and museum docents, keep them talking for as long as you can.

The joy of talking with the potters themselves has not diminished. Look for "Potteries for Sale" signs in the windows at First Mesa, Taos, Acoma. Ask around for the homes of potters whose work you love. Knock on doors. Find excuses to begin conversations. Delight in directions like "Turn where the store that burned down used to be." Potters still prefer to sell directly to you, and not just because they make a higher percentage that way. They would rather tell their stories and build relationships than simply pocket the money paid by a wholesaler. Listen as Marvin and Frances Martinez hold forth from their perch "on the other side of the cloth," surrounded by their San Ildefonso pottery under the portal at Santa Fe's Palace of the Governors. Frances says, "You get people who don't know the faintest idea about pottery. They leave being educated. Even if they don't buy a pot, they walk away with a gift in their heart. It's a lot of history. It's a lot of art."

The word *tradition* and its physical expression in pottery capture the Pueblo people's fierce sense of community and each potter's new ability to face outward and stride unaccompanied into the twenty-first century. The two forces grind together like continental plates, with all the attendant tremors, subductions, and accretions. With poise, Pueblo potters negotiate a graceful balancing act along the zone of contact, guided by Tammy Garcia's "adaptability"—living with serenity among the shower of sparks generated by the tensions between old and new.

I extend my thanks to the potters who once again have spoken with me of their dreams and struggles. Their generosity, artistry, eloquence, and courage have made this book possible and continue to make my life infinitely richer. Reimagining *Talking with the Clay* for them was an honor—one that I look forward to repeating in another twenty years, when I loop back through Pueblo country doing fieldwork for a fortieth anniversary edition!

Stephen Trimble, Salt Lake City, July 2006

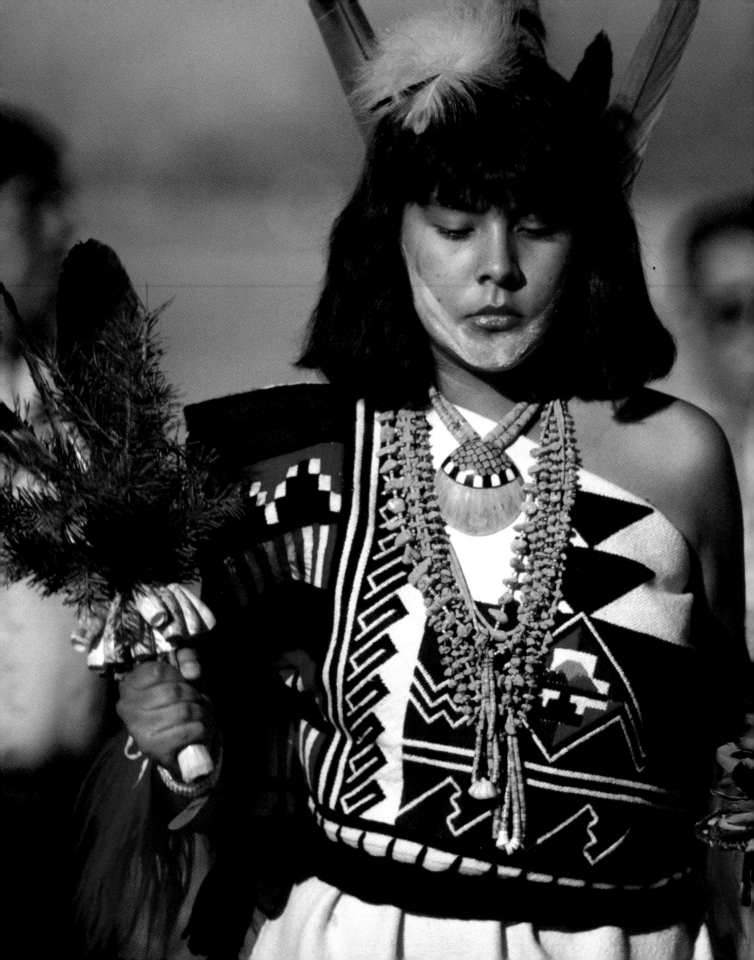

The People

*A*T PICURIS PUEBLO, cradled in the green forest of New Mexico's Sangre de Cristo Mountains, when workers prepare to restore the old adobe mission, they pile plastering dirt next to the cracked foundation. In this soil glint the sharp edges and faded designs of broken pottery—potsherds from generations past about to be mixed into mud plaster for a twenty-first-century church.

At Taos, the elders ask a young potter to make a bowl for ceremonial use in the kiva. They reject her first effort; it looks too new. They want one blackened with smoke, so she refires her bowl, smudging it black. The elders are satisfied.

Isleta Pueblo, south along the Rio Grande, celebrates its feast day every year on the fourth of September. After mass, the Isleta people carry a carved image of Saint Augustine in procession around the plaza. Near a shrine where the saint will be honored, a Pueblo woman offers food to the carved *santo*. Under the approving eyes of the village priest, she walks to the head of the procession with a pottery bowl full of steaming chile stew, wafting the steam toward the saint's chiseled face.

Facing page: Potter Candace Tse-Pe Martinez dancing in the San Ildefonso Buffalo Dance, 1985. Right: Ladder to the sky, Picuris Pueblo Church, 1985.

"We come into this world with pottery, and we are going to leave the earth with pottery," says Acoma Pueblo potter Dolores Garcia. Acomas are bathed in a pottery bowl at birth and buried with pottery when they die. A pot is shattered over the surface of each grave. At Laguna, these pots are clouds, and when these break, the people say, "Let it rain."

Pottery is a tradition, but it is also a part of contemporary life. It is art—vital, everyday art, and fine art as well—a creation and a symbol of the Pueblo people. The Pueblos are one people and many people. They share a way of life, a worldview, and a landscape. They

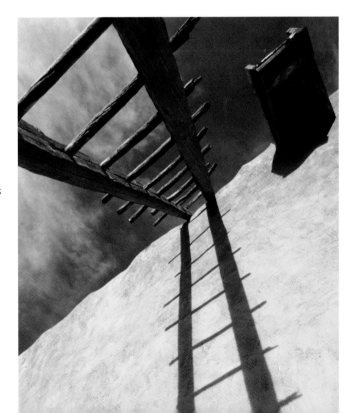

speak half a dozen languages and live in more than thirty villages scattered in a 350-mile arc that reaches from Taos, New Mexico, to the Hopi mesas in northern Arizona. Their immediate ancestors lived in an even vaster area, from central Utah to deep in northern Mexico and from Nevada to Texas.

Pottery comes from the earth. By transforming pieces of this earth—painted with minerals and plants, shaped with stones and gourds—Pueblo artists create a bond between landscape and people, between home and spirit. Hopi-Tewa potter Dextra Quotskuyva speaks of trying to incorporate the whole universe—the earth and the sky and human lives—into her designs. A Taos man says, "The story of my people and the story of this place are one single story. No man can think of us without thinking of this place. We are always joined together."

The land is where we begin.

The Pueblo Landscape

Two great rivers drain the Southwest: the Colorado and the Rio Grande. On its way from the Rockies to the Gulf of California, the Colorado River cuts through its namesake plateau in deep canyons, climaxing at the Grand Canyon, the westernmost boundary of the Pueblo world. The Rio Grande flows from the San Juan Mountains of Colorado through New Mexico in a north-south line with only a few gentle curves. Between Taos and Santa Fe, the Rio Grande passes between the two southernmost ranges of the Rocky Mountains: the volcanic circle of the Jemez Mountains on the west and the high spine of the Sangre de Cristo Mountains on the east.

The Pueblo people have woven themselves into this geography. Beginning at the north, away from the Rio Grande, the two northernmost pueblos sit in spectacular settings: Taos, right up against the Sangre de Cristo Mountains, and Picuris, *within* those mountains. Downstream toward Española, the Rio Grande Gorge opens out, and from here south lie the other Rio Grande pueblos. First comes a northern cluster in the rift between the mountains—San Juan (now known by its Tewa name, Ohkay Owingeh), Santa Clara, and San Ildefonso. Just north of Santa Fe, the pueblos of Pojoaque, Nambe, and Tesuque lie on eastern tributary creeks of the big river.

Where the Rio Grande flows out into desert basins south of Santa Fe, a sequence of villages (Cochiti, Santo

Ancestral Pueblo potsherds, 1986. Potters tuned their methods to local clays, fuels, and weather, creating endlessly inventive designs.

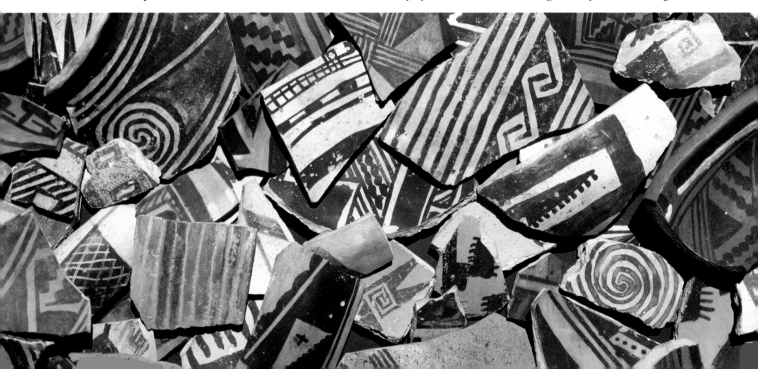

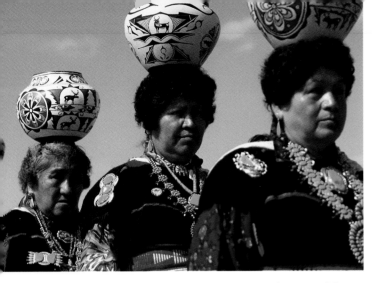

The Zuni Olla Maidens, shown here in 1992, dance at celebrations all over the Southwest.

Domingo, San Felipe, Sandia, and Isleta) stands on its banks. Santa Ana, Zia, and Jemez pueblos fringe the southern mesas of the Jemez Mountains on the Jemez River, tributary to the Rio Grande from the west.

Heading west from the Rio Grande Valley at Albuquerque, angular desert mountain ranges give way to mesas cut through by squared-off canyons faced with red and golden sandstone cliffs. Here and there rises an island of mountain forest. This is the Colorado Plateau, the prehistoric Pueblo heartland, home to the Pueblo ancestors we have called Anasazi.

On the Rio San José just off Interstate 40, Laguna is the first living pueblo encountered on the trip westward. Farther west—farther from the highway, from water, and from familiar worlds—lie the pueblos of Acoma and Zuni. The "sky city," Acoma perches securely atop a mesa south of Mount Taylor. Zuni Pueblo stands at the western foot of the Zuni Mountains on the edge of the sweeping desert grassland known as Navajo Country. Finally, deep in the remote plateaus of north-central Arizona lie the Hopi villages. All but two of the far-flung Hopi farming communities stand on or near three arid and rocky mesas that jut like ships' prows above the plains that lead away to the Grand Canyon and the San Francisco Peaks.

Sacred arrays of mountains, lakes, and mesas bound the world of every pueblo. The land is stark, as sharply delineated as life and death. The health of each pueblo depends on rain to nourish its fields and on ceremonies and dances to ensure adequate rainfall. Guided by the sun, the people plan their ceremonial calendar around planting and harvest. Solstices bring times of extremes; equinoxes bring order and balance. The Pueblo world, mundane and spiritual, reflects these unequivocal dualities: winter and summer, solemn ritual and outrageous clowning, weak and strong, life and death, Father Sun and Mother Earth.

Pueblo pottery captures the people's refined sense of order, opposition, and balance. Black-on-white. Paired figures. Symmetry. When potters outline designs on a slipped and polished vessel, they see with a perspective honed by every aspect of their existence. In every task, Pueblo people start from the boundaries of their world and work toward the center. Again and again, Pueblo potters say that they let the clay take whatever shape it wants, without their conscious control. They listen, and then paint and shape designs dictated by the form.

Pueblo: Village, Language, People

An Acoma potter is an Acoma Indian, a Pueblo Indian, and, linguistically, a Keresan. A Picuris person is Pueblo, from the Tanoan linguistic group, and speaks Northern Tiwa. No wonder travelers in the Southwest keep asking for clarification: just who are the Pueblo Indians?

Traditionally, these native people live in stone and adobe towns, farm nearby fields, and share distinctive arts and religion. The word *pueblo* means "village" in Spanish and refers to a town and to its people. But many subdivisions exist within this category.

Language, the anthropologist's favorite method for distinguishing between cultures, proves both useful and confusing in the case of the Pueblos. The Hopis speak a

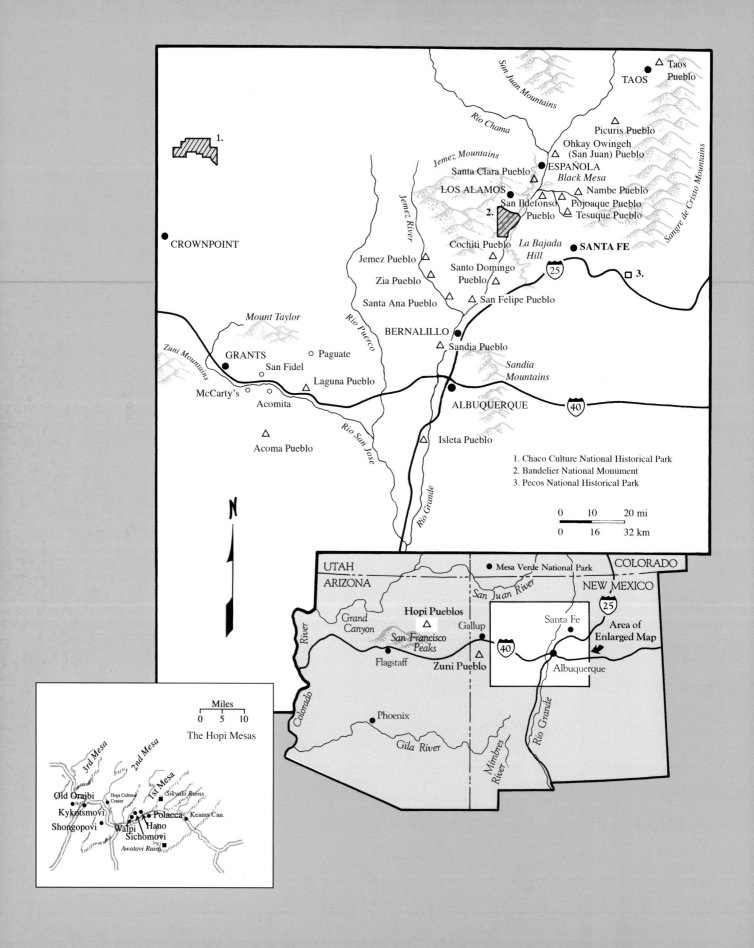

1.

TAOS

● Taos
△ Pueblo

San Juan Mountains

Rio Chama

Picuris Pueblo △

Ohkay Owingeh
(San Juan) Pueblo

Jemez Mountains

Santa Clara Pueblo △ ESPAÑOLA
 Black Mesa

LOS ALAMOS ● △ Nambe Pueblo

San Ildefonso Pojoaque Pueblo △
Pueblo △ Tesuque Pueblo

Jemez River

2.

Cochiti Pueblo △ *La Bajada* ● SANTA FE
 Hill

Jemez Pueblo △ □ 3.

Zia Pueblo △ Santo Domingo
 Pueblo △ 25

Santa Ana Pueblo △ San Felipe Pueblo

● CROWNPOINT

Rio Puerco

Mount Taylor BERNALILLO ●

Zuni Mountains △ Sandia Pueblo

GRANTS ● ○ Paguate *Sandia*
 Mountains
 ○ San Fidel

McCarty's ○ ○ △ Laguna Pueblo ● ALBUQUERQUE 40
 ○ Acomita

Rio San Jose

△ △ Isleta Pueblo
Acoma Pueblo

1. Chaco Culture National Historical Park
2. Bandelier National Monument
3. Pecos National Historical Park

| 0 | 10 | 20 mi |
| 0 | 16 | 32 km |

N

UTAH ● Mesa Verde National Park COLORADO

ARIZONA *San Juan River* NEW MEXICO 25

Grand
Canyon **Hopi Pueblos** Gallup ● Santa Fe ●

San Francisco **Area of**
Peaks **Enlarged Map**

● Flagstaff **Zuni Pueblo** △ 40 Albuquerque

Colorado *Rio Grande*
River

● Phoenix

Gila River *Mimbres*
 River

Miles
0 5 10

The Hopi Mesas

3rd Mesa *2nd Mesa*

Old Oraibi ● Hopi Cultural *Sikyaki Ruins*
 Center ● *1st Mesa*

Kykotsmovi ● ● **Polacca**

Shongopovi ● **Walpi** **Hano** Keams Can. ●
 Sichomovi

 Awatovi Ruins

Hisi Nampeyo (as she signs her pottery), shown here in 1985, is also proud to be known as Camille, daughter of the great Hopi-Tewa potter Dextra Quotskuyva.

language related to that spoken by Ute and Paiute people farther west. The Hopis' nearest Pueblo neighbors, the Zunis, speak a language that stands alone, with a remote connection to one Californian Indian linguistic family. Acoma, Laguna, and the Rio Grande Pueblos of Zia, Santa Ana, San Felipe, Santo Domingo, and Cochiti speak Keresan (or Keres), a language that also stands by itself.

The rest of the Rio Grande Pueblos speak Tanoan —also spoken by the Kiowa, Plains Indian people. Even among Tanoan speakers, substantial differences exist among Northern Tiwa (Taos and Picuris); Southern Tiwa (Sandia and Isleta); Towa (Jemez); and Tewa (Ohkay Owingeh, Santa Clara, San Ildefonso, Pojoaque, Nambe, and Tesuque).

To further complicate matters, the Western Pueblos of Acoma, Laguna, Zuni, and Hopi differ in social organization from the Rio Grande Pueblos. When such confusing variety exists in contemporary people (with whom we can talk), imagine the task of the archaeologist trying to untangle the prehistoric story.

Archaeologists speak of four main prehistoric Southwest peoples. The Mogollon lived in highlands across central Arizona and New Mexico and southward; the Anasazi dominated the Four Corners plateau country and the upper Rio Grande. Two other desert cultures, the Salado and Hohokam in southern Arizona, were neighbors but not direct ancestors of the Pueblos (though some Hopi Water Clan people say otherwise).

As Mogollon and Anasazi cultures blended and evolved over 1,500 years, changes came—but the people did not disappear. They live on in today's Pueblo people, who are their inheritors and descendants. This is why scholars and Pueblo people now avoid the word *Anasazi*, a Navajo word meaning "enemy ancestors," and instead speak of "Ancestral Pueblo" culture.

In prehistoric times, the Southwest was more densely populated in places than it is today. Across the canyons and mesas of the Four Corners lie thousands of ruined, abandoned villages. We differentiate prehistoric regions by what we can excavate: villages, houses, jewelry, and—more than anything else—pottery. Some archaeologists spend so much time analyzing pottery fragments (potsherds) that pottery almost becomes synonymous with culture.

Pueblo languages have no word for "art." Tewa people do speak of the concept of an artful, thoughtful life. Prehistoric peoples made ceramic vessels for cooking, carrying water, and keeping food safe from insects and rodents. "It wasn't something they had to write about or research or study," says Jemez artist Laura Fragua Cota. "They just did it. It was life." These useful objects also happened to be beautiful, and potters worked even harder to create beauty when making ceremonial vessels.

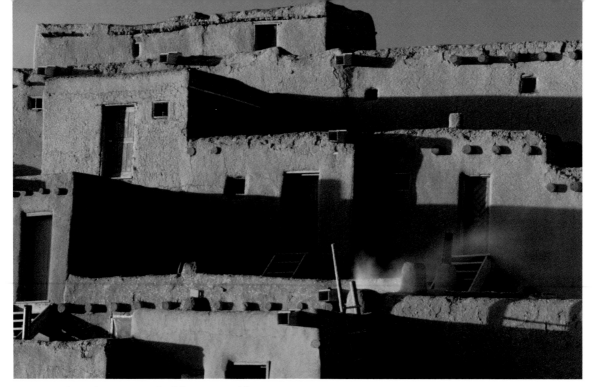

Piñon smoke and sun-warmed adobe, Taos Pueblo, 1985.

Mogollon people first began depending on pottery instead of baskets about AD 200. After another three centuries, potterymaking had spread across the Southwest. Zuni potter Josephine Nahohai described these times: "We took care of pots, and they took care of us." Indeed, in Tewa a single word (*nung*) means "people," "clay," and "earth."

By about AD 500, the southwestern people had become farmers, nurturing fields of corn, squash, and beans. In the seventh century, they began to paint their white and red pottery with black designs, and later with multicolored polychrome. In southern New Mexico around AD 1000, the Mimbres people, within the Mogollon tradition, painted some of the most artistically remarkable pottery in the prehistoric Southwest.

The Ancestral Pueblo people had abandoned the Great Houses of Chaco Canyon by the late 1100s and Mesa Verde and the San Juan River drainage by 1300, leaving behind many other traditional homelands by 1450. The people simply moved on. Scholars devote lifetimes to untangling the evolving pottery styles as they follow the Ancestral Pueblo potters tuning their methods to local clays, fuels, and weather in new homelands. The experts marvel at the inventiveness of painted pottery traditions, teasing out influences of Salado pottery from south of the Mogollon Rim, tracing Hopi yellow pottery through time. The continuity between prehistoric artists and their descendants in today's Pueblo villages is astonishing.

Each modern pueblo tells stories about how its clans gathered from many places to come to the one place where they should live and where they do live today, the "center of the universe" for each. Each clan had migrations to complete, a spiritual quest that depended on religious leaders who announced when it was time to move on. Oral traditions recognize many ruins as ancestral sites. Marcellus Medina's grandparents at Zia always told him, "We are descendants from Mesa Verde."

When Coronado arrived in 1540, some 130,000 Pueblo people lived in about 150 sizable villages. Diseases brought by the Europeans wiped out entire communities in terrifying epidemics—with up to 95

percent of the population lost. Pueblo people abandoned dozens of villages when population dropped too low for farming and proper ceremonial life to continue.

After decades of oppression, the Pueblos revolted in 1680 and exiled the Spanish from the Southwest until 1692—and from Hopi permanently. Many Rio Grande Pueblo people took refuge with the more isolated Hopis, and a village of Tewa-speaking people remains on First Mesa to this day. Keresan and Towa refugees founded Laguna in 1697. The last seventeen Pecos Indians, remnant of what had been New Mexico's largest pueblo, moved to Jemez in 1838. With these changes, the number of pueblos stabilized. The villages that exist today have survived through the centuries against daunting odds.

With the return of Spanish colonists, the work of Pueblo potters became a bedrock layer in the New Mexico economy. Villagers of all ethnicities relied on Pueblo pottery well into the nineteenth century, until the railroad finally brought metal pots and pans in sufficient quantity to begin replacing clay cookware.

Today ancient traditions live on among the Pueblo people, though they steadfastly shield their most sacred ceremonies from eyes of inadequate understanding. At the same time, Pueblo people inhabit twenty-first-century America, where they confront one last duality—the difficult search for a path between the old ways and the new. Tessie Naranjo from Santa Clara believes that "pottery, participation in dancing, extended family—these are all generational things. Social activity is one of the most important parts of potterymaking. It's intimate and nurturing. Only in that way does culture survive. Only in that way is culture active." And, always, potterymaking is a relationship with the earth. Tessie sums up this interdependence: "Without the human, the clay can never be the pot. Without the clay, the human can never make the pot." Max Early at Laguna believes that the skills and aesthetics of potterymaking are now embedded in the genes of the Pueblo people.

Pottery helps bridge the gap between worlds, between humans and clay, springing from old ways but generating an income in a wage-based society. Pueblo potters carry on with the grace, intuition, and eloquence of their ancestors. They build their designs and contemporary lives—their "stories"—into this pottery. Along with the southwestern landscape and the traditions of the people who settled here, preserving their language and identity for seventeen centuries, each Pueblo pot contains a part of the potter's spirit—all joined together, people and place, in a "single story" embodied in clay.

The late Louis Naranjo of Cochiti and his bear storyteller: "They're just like my grandkids to me," 1986.

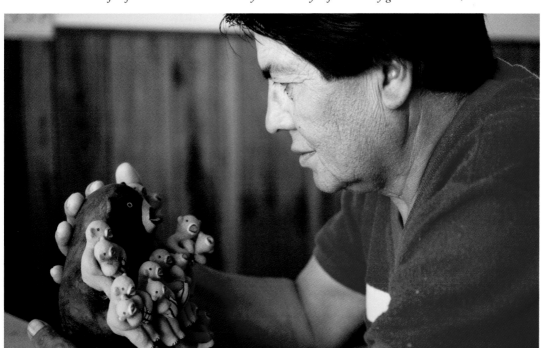

Talking with the Clay
Technique

B LUE CORN SAID of her fellow San Ildefonso potters, "Doing this potterymaking in the traditional way—with their hands, without using a machine at all—it's really a miracle. To them and to me too." Hopi Tracy Kavena learned pottery from her grandmother Rena. Her judgment: "It's harder than it looks."

This difficult miracle starts with clay, a material most of us dismiss as dirt. The young Santo Domingo potter Harlan Reano revels in "how you can make something beautiful out of nothing. It all comes from the earth, it's all natural, and you're not paying for it." Hopi potter Garrett Maho calls his materials "Mother Earth's tools." Because clay can be made of many kinds of minerals (usually hydrous aluminum silicate), geologists define it as a naturally occurring, fine-grained material with "plastic properties." This generalized phrase sums up miracles. Wet it and shape it and fire it, and, as specialists would say, "its particles soften and coalesce upon being highly heated and form a stony mass on cooling." Clay becomes pottery.

Facing page: Lois Guiierrez's polishing stones, Santa Clara, 1986. Facing page, inset: Thomas Natseway's miniature Laguna pots on his studio workbench, 2006. Right: Zuni potter Anderson Peynetsa shaping a bowl, 2006.

Picking Clay

Pueblo potters often speak of "picking" clay as they would flowers. Clay is a gift from Mother Earth, and like all her gifts, it is sacred. Potters must thank her for the gift. According to Caroline Carpio, "Our Pueblo culture is an articulation of prayers and gratitude."

Potters pray before taking the clay. They make an offering of cornmeal (or dollar bills, or whatever valuables come from the pockets of their jeans), asking

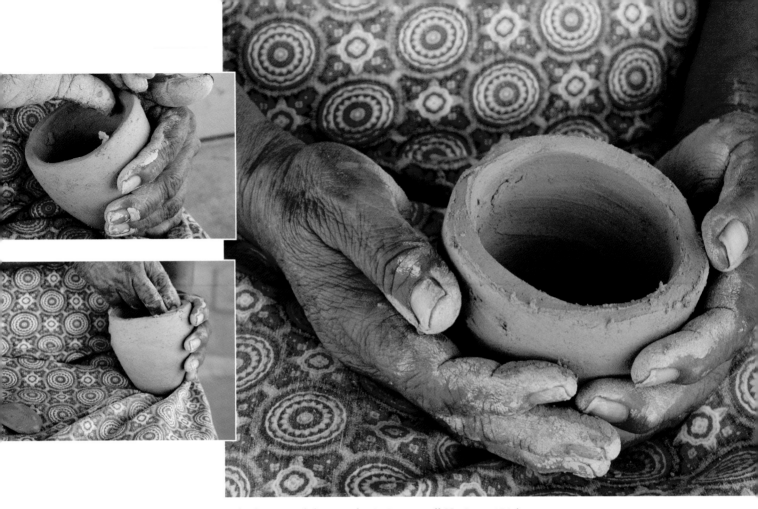

Above and facing page: Bessie Namoki shaping, polishing, and painting a small Hopi pot, 1984.

permission from Mother Earth to take part of her body to use for pottery to support themselves and their children.

Hopi-Tewa Dextra Quotskuyva says, "You have to offer something in order to get it. You just don't go out there and dig. 'I want this. I want that.' You just get the amount you are going to use." Dollie (White Swann) Navasie says that Hopi potters are not allowed to dig clay in winter, when "the earth is renewing itself." Bernice Suazo-Naranjo from Taos has learned to respect the clay: "And I think that comes natural because we are all raised in an environment so that we're in tune with nature. It's a cycle."

Not every woman continues to leave behind a cornmeal or turkey-feather offering after digging clay, but all speak with reverence of their medium. Some potters keep special clay sources secret. Elsewhere, everyone uses the same clay pit, and some potters lament that not everyone takes proper care.

Clarence Cruz from Okay Owingeh teaches a Pueblo pottery class in the Fine Arts Department at the University of New Mexico. "You begin by digging," he says. "Give her a blessing before we open up that wound, and then we cover that, like dressing a wound after a fall. Once you lay your hands on the clay, on Mother Earth, you become the guardian. You become the creator of this child-to-be." When Max Early walks the half-hour trail to gather Laguna clay, he knows that only "if one has said their prayer correctly, then Mother Clay will be willing to depart with the potter."

Digging clay is hard physical labor. You need a truck to reach the pits and haul the clay home. Men often help their wives and daughters with this task, making it a family outing. Derek de la Cruz helps his wife, Santa Clara potter Lois Gutierrez, gather clay. He says, "If you look hard enough, you can find clay here and there all over the mountains. But you got to look for it. It doesn't just jump out at you. It's beautiful when you dig in it. The white clay looks like candy, white chocolate. When you're digging it, you don't want to stop, it feels so neat!"

After hiking around Santa Clara looking for new colors, Jennifer and Michael Moquino arrive home with their faces painted with clay—red, yellow, purple. "She tests them on me," says Michael, "to see what colors come up." Kathleen Wall tried clay from the ditch near her house in Santa Fe while attending the Institute of American Indian Arts (IAIA), hoping that no inquisitive drivers would pass by while she was digging! Kathleen remains partial to Jemez clay for her clown figures because she loves the "nice skin tone."

Dollie Navasie tastes Hopi clay when scouting for new sources: "If it's salty, it's alkaline and not good." Many potters test new clays with a pinch pot tucked into a firing of finished pieces. As Santo Domingo potter Will Pacheco says, "Pueblo people are natural scientists."

Potters guess that they spend half their time processing materials for potting, just preparing for the creative act. After the lumps of rough clay are brought home, the preparation begins. Nathan Youngblood of Santa Clara estimates that mixing one cubic foot of clay takes twenty-four to thirty hours. His sister, Nancy, figures that clay preparation takes three to four weeks out of her year. "Potters are the most careful people you'll meet," says Sharon Naranjo Garcia from Santa Clara.

At Jemez and Hopi, some families have created a new economic niche by selling prepared clay to potters who choose to hire out this labor. Other potters want to retain control over the exact feel of their clay, so they themselves go through every time-consuming step. Pam Lujan-Hauer believes that Taos clay cannot be sold or hoarded but it can be traded: "It is a part of Mother

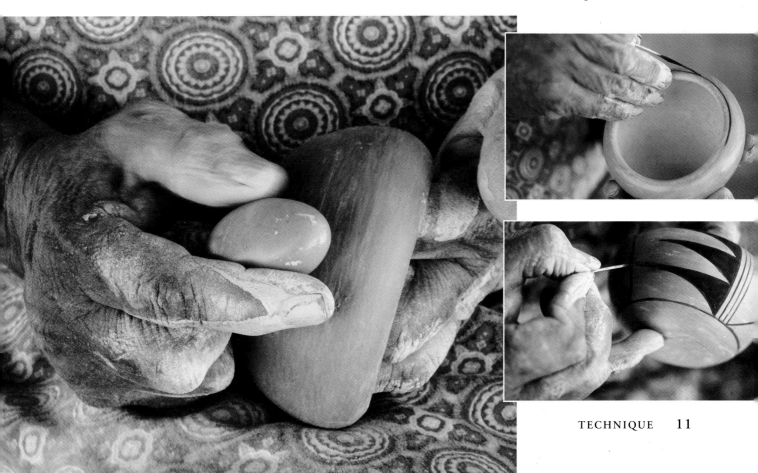

Earth, in use for the religion." Caroline Carpio's teenage son earns spending money by straining her Isleta clay, but she tells him, "You have to have a good heart when you are working with the clay. If you are in a bad mood, don't touch it."

The raw clay is dried before soaking and sometimes cleaned by grinding and sieving. In his younger days, Ivan Lewis pounded his Cochiti clay with a sledgehammer, "like a drummer." Clarence Cruz used to crush his clay by driving a car back and forth over it.

If you do not dry the clay, insists one potter, it will have a "rotting smell" when you soak it. Another explains that it will stay lumpy unless you dry it completely before soaking. While the clay soaks in washtubs or barrels, the potters change the water several times to purify the clay, dissolving out stray minerals. They sift out the impurities. "Taking the sticks and stones out of the clay is like things that don't belong in my heart. That's the way the Lord searches our hearts," said the late Santa Clara potter Teresita Naranjo.

If potters use pure clay, their pots shrink and crack as they dry. Outside surfaces and edges dry faster than the inside, tearing the vessel to pieces with the same force as mud curling along a dry riverbed. Adding a stable temper of sand, ground rock, or potsherds makes for slower, more even drying, enabling the pot to "breathe."

Preparing temper can be just as time-consuming as picking clay. Northern Rio Grande Pueblo people temper their clay with ground volcanic ash and tuff. They have done so since 1200. Zia potters have used finely ground basalt for six centuries. At Acoma, Laguna, and Zuni, the artists manufacture their temper by grinding old pottery sherds to add to fresh clay (though some Zuni clay is strong enough to work without temper). Clays at Taos, Picuris, and Hopi need no added temper; these already contain the right amount of sand or gritty mica. When potters search for clay, they look for color first; they can adjust texture by tempering.

Mixing the clay and temper is a crucial step. Santana Martinez of San Ildefonso called it mixing the "dough" and found it the most difficult part of making pottery. Bernice Suazo-Naranjo and her husband, Tito, learned the technique by trial and error. Their first attempt at making Taos pottery with micaceous clay was a disaster. They collected a beautiful red clay, but it was mostly sand and all Bernice's pots fell apart. Later, they learned to recognize rich veins of fine clay, which was "just like striking gold."

Angie Yazzie passed through the same Taos micaceous-clay learning curve; some clay turned out to have "too much blood, the sticky red, and too much sand is

Stella Chavarria carving Santa Clara pottery, 1986.

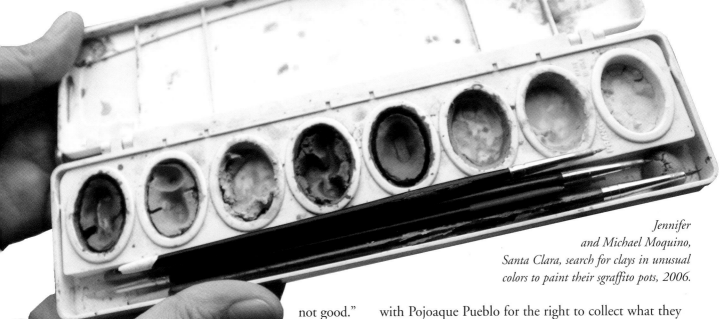

not good." Taos clay is "hard on your hands. The mica is like little pieces of glass." But Yazzie's work depends on her material: "It's all in the clay."

Potterymaking in winter is also hard on your hands, and the potters have trouble drying their pots. Max Early prefers to make pottery in summer, when his Laguna clay is not so cold.

Dolores Garcia of Acoma felt that she had "steel gloves" on her hands the first time she mixed clay. Now, after mixing the clay with her hands, she wedges it with her feet—much easier. Juana Leno concluded that modern Acomas have tender feet. Her younger relatives may have strong legs, but they wear tennis shoes when kneading clay.

Occasional crises occur in accessing temper sources. For instance, when Santa Clara began charging other Pueblo people to hike and fish in Santa Clara Canyon, Pojoaque responded in 1968 by closing its sand quarries, temper sources that Santa Clara potters had used for forty years. It took a full season for the Santa Claras to find a new volcanic tuff deposit and readjust their clay mixture to perfection. Eventually, the people of both Santa Clara and San Ildefonso negotiated a fee with Pojoaque Pueblo for the right to collect what they call sand.

Experience teaches an instinctive certainty about the right consistency in the mix of water, clay, and temper. Some potters say that pots can pit if they add too many ground sherds. When Jemez potter B. J. Fragua was having problems with cracking, she asked her sister Glendora to feel the clay—*feel* it, not look at it—to figure out what was wrong. At Laguna, Max Early has his proportions down to a T. He has drawn lines on a five-gallon bucket to combine his dry ingredients predictably before mixing them with rainwater.

The most refined clays can be shaped immediately. Rougher clays become more workable with aging. Tewa clay is alluvial, decomposed, and ready for work. "It seems a little wimpy," says San Ildefonso potter Erik Fender, "but I'm used to it, so I'm able to build with it."

Taos micaceous clay is a "primary" deposit, so the potter must take charge of aging the material. Bernice Suazo-Naranjo keeps her coarse Taos clay in plastic bags for three to four months, maturing it to a "wonderful plasticity." Glenn Gomez ages his micaceous Taos clay for a year. Pam Lujan-Hauer speaks of accelerating the aging with beer, yeast, or the "blessing from the river—enzymes released by algae as it dies, breaking up the platelet size of the clay."

Once mixed, many clays not only smell good but

also taste good. Stella Shutiva's grandchildren would sneak up behind her when she was working and take little pieces of Acoma clay to eat. Ruby Panana loves her Zia clay: "I don't have to use drugs—just the smell of the clay, that's my high, a fresh earthy smell after a rain."

Men have always helped in the hard work of mixing clay and in carving or painting. Today many men make fine pottery. Nambe-Pojoaque potter Virginia Gutierrez believes that men make better potters than women: "They have more of an artistic ability." Stella Shutiva said, "Men are strong. They make big pots, pots shaped the way their bodies are shaped, narrow at the base and wider at the top. Women make pots that are plumped." Rainy Naha sees the fine lines and intricate work on her Hopi pots as "the feminine touch. But pottery is not a ladies' thing or a man's thing. It's a *self* thing."

Traditionally, men did not shape pots. That was woman's work, part of the feminine reservoir of intuitive knowledge. In Alice Marriott's *Maria: The Potter of San Ildefonso,* Maria Martinez's mother taught her daughters that "it was the woman's part of living to hold things together. Men could build up or tear down houses and ditch banks, but women put clay and sand together to make pottery. That was part of a woman's life, to make things whole."

This was nearly a century ago. Now, both men and women potters "make things whole." Because "time changed the gender roles" at Laguna, Max Early decided that "working with the Clay Mother would be respectable." Burel Naha keeps a picture of his mother, the great Hopi potter Helen Naha, on the wall behind him to watch over him while he works.

Art is integrated with life. Hopi potter Karen Abeita says, "We are always working on something for

Glenn Gomez, Taos potter, 2006. Right, Hopi seed jar by Nona Naha, 2006.

ceremonies, designing something, painting something." Maria's great-granddaughter Barbara Gonzales believes that "whenever an Indian gets involved with art, they do it with their whole being—that's what makes the art unique." The past, present, and future, all are captured and united in the act of making pottery.

The Selfish Clay

Rose Naranjo of Santa Clara said, "The clay is very selfish. It will form itself to what the clay wants to be. The clay says, 'I want to be this, not what you want me to be.'" But if the potter has "a good intention," is "one with the clay," the pot will please both the clay and the shaper. It will be an extension of the potter's spirit.

Coiling, more than anything else, defines Pueblo pottery. Coiled pots are built by hand, never thrown on a wheel. Pueblo clay *cannot* be thrown on a wheel. It doesn't have the necessary plasticity. Ernest Tapia of Santa Clara said, "If we use a wheel, that's not art. That's the white man's way—too perfect. A woman can make anything, any kind of a shape with her own hands." When newcomers ask Dollie Navasie whether she has a wheel, she says, "Yep, I've got four of them—on my vehicle!"

"These pieces will *never* be perfect," says Nancy Youngblood of her fine Santa Clara pots, "but that's what I'm working toward. When I get that 'cookie-cutter' comment—that my pots look too perfect to be hand-coiled—I just say, 'Thank you.'"

First, the potter pats out a base from a cone of clay, much as she would pat out a tortilla or work with bread dough. If she plans a piece larger than palm size, she will need a shallow base known as a *puki* to support the growing coils. Typically, only small pots and figurines are pinched from a ball of clay without coils or a puki; children begin with these simple forms. Pam Lujan-Hauer makes remarkably tall, narrow forms from her Taos micaceous clay by allowing the base to dry and strengthen before building upward —without a puki. Pam worked with her aunts as a kid: "Their pukis were in use, so I started making strong bases."

Potters used to make pukis from the broken bases of old pots, sometimes lined with homemade plaster of Paris or compressed wood ashes. Today they may use china plates, pie tins, cereal and salad bowls, anything that works. Hopi-Tewa potter Mark Tahbo sweeps a hand around his kitchen, indicating the bowls and dinnerware he uses as pukis: "These are my wheels." Thomas Tenorio uses a huge, shallow basket lined with cardboard as a base for Santo Domingo plates more than two feet across.

The potter pinches out a rim at the edge of the puki-supported clay foundation, then rolls a first coil of moist clay and presses it along the inside edge of the round base. Coil by coil— each coil up to an inch in diameter, sometimes flattened to a strap—the potterymaker constantly turns the growing pot, maintaining just the right moistness of clay to ensure that new coils adhere. The piece begins to rise. Constant kneading works out air bubbles that would ruin the pot in firing. Some potters spin the pot on a

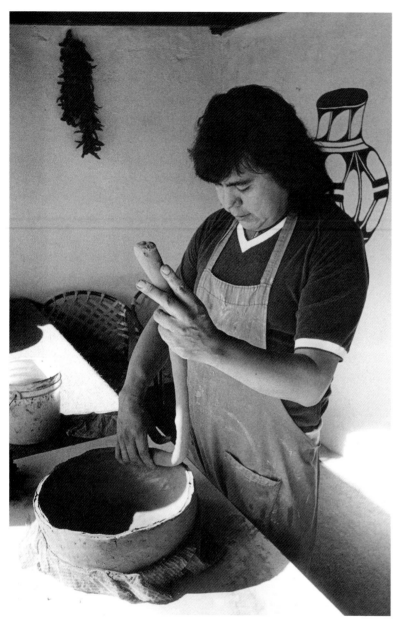

Robert Tenorio adds a coil to his Santo Domingo pot, 1986.

stages. Each section is shaped to its final proportions, and the base is allowed to dry and strengthen before the next series of coils (often four at a time) is added. Robert Tenorio of Santo Domingo lets the base rest when the wall of his forming pot starts to "jiggle." Ruby Panana supports her large Zia water jars with an Ace bandage wrap as they dry. Angie Yazzie pushed the limits of Taos micaceous clay when she was learning: "I had a high collapse rate. Once, I had to stand for two hours holding a pot when it started to collapse, until someone came to help me."

A large piece may require a few hours to a full week of careful, on-and-off work. Small pieces can be built up with straight sides, like buckets, then pushed out into the smooth curves of a jar or bowl. Santana Martinez even started her plates this way. Lisa Holt builds her Cochiti circus figures from the feet up, gradually adding coils to make a fully formed clay being. "There isn't a day that goes by that I don't have my hands in clay," says Zuni potter Noreen Simplicio. "I'm potting ten to fifteen hours a day sometimes." As a result, she does "a lot of physical therapy!" When Tammy Garcia is asked how long it takes her to make one of her large, dramatically carved Santa Clara pieces (in real time, these can take several months), she answers, "Twenty years!" She says, "It's the *experience* that's gotten me to where I am today."

Shaping and scraping rough out the form. Hopi potter Garrett Maho calls this process "straightening the clay." Pueblo people have long used potsherds or pieces of gourd rind for scrapers. Today they also use an assortment of coconut shells, tongue depressors, paring

Lazy-Susan and feel for asymmetry; others frown on this aid.

Small vessels can be made complete—built up, smoothed, and shaped—and the potter can move right on to the next piece. Vessels large enough to approach the limits of the clay's physical strength must be made in

knives, wooden spoons, discarded eyeglass lenses (especially "big sunglasses, like they wore in the sixties"), car-windshield ice scrapers, can lids, and tops from candy, tobacco, and aspirin tins. Anderson Peynetsa of Zuni favors rubber spatulas because they "feel more alive." Ivan Lewis "spanked" his Cochiti figures, "pushing the clay with a wooden paddle." Larson Goldtooth carves his Hopi figures with X-ACTO knives: "I feel a little like a kachina doll carver. I wet the whole thing down and shave the clay away."

Emma Mitchell of Acoma jokes that her family has kept Argentine corned-beef companies in business by using so many of their tins as scrapers and trimmers. Lilly Salvador has a special long-handled wooden tool for the inside of her Acoma wedding vases: "If I'm not careful, I put a dent in it, and there's no way to put your finger in there. So I put this in there and push it out."

The clay has a will of its own, and its shaper must be in tune with that will. You can pursue "flawless stability and wholeness," in Max Early's words, but Karen Abeita knows that "you can't force the clay to make what you want. It will just go crazy on you." Dextra Quotskuyva "just waits on the clay. It seems to mold itself. It's the mood that you're in. Your heart is right there with the clay." Blue Corn did not make a pot just because she liked it: "I have to make a pot that will like me—and looks like it's talking to me too. At the same time, I'm talking to that pot, too, or to the clay that I'm working with." Says Erik Fender, "There's a pot that's meant for everybody. Sometimes when I'm making a pot, that shape may not appeal to me, but it will be exciting to somebody else."

Teresita Naranjo came to her Santa Clara pottery-making as a devout Christian. When sitting down to

Jacob Koopee painting pottery at his home in Sichomovi at the Hopi Mesas, 2006.

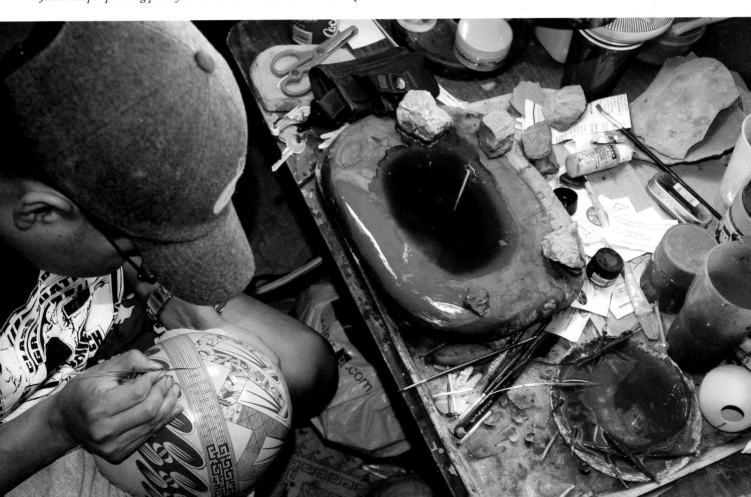

work, she would say, "Lord, here I am. And Mother Clay. There's three of us here together." As Teresita molded her pots, she would say, "I am the clay. The Lord is working in me. My pottery is the handiwork of God."

Many potters like company while they work—either the impersonal audio of television and videos or the chatting of friends around them. They apologize for rarely responding. "Sometimes I listen. Sometimes I don't," says Hopi-Tewa Jake Koopee, but he adds, "If someone is talking to me, I move a whole lot faster." Larson Goldtooth warns people: "Don't be offended if I don't talk for a while. I'm communicating with the clay." In his experience, "once you get it in your hands, it captures you. It takes you. It's like a trance." Rebecca Lucario listens to Indian music: "Whatever puts me in the mood."

"So much of me goes into the pot," says Gladys Paquin of Laguna. "Even my thoughts are in the pot. I have to tell the pot how to be. The stubborn ones I give the okay to be that way. You have to realize which one wants to be and which one you should start over again." At San Felipe, Hubert Candelario says, "Every pot I make is everybody in my life. I put myself into the pots, who I know, who I wish was still around. My mind just goes to everything in my life, and before I know it, I'm done."

Dora Tse-Pe of San Ildefonso believes, "If you're angry and if you are

making pots with bitter feelings toward others or toward something, your pots will act accordingly." Jody Folwell of Santa Clara agrees: "My pieces start out somewhere deep down inside of me. I feel that, physically, I just make what comes out of me spiritually. The pieces seem to mold themselves. I never really mold them."

Some potters strive for ever-thinner walls. When people ask Annette Raton at Santa Ana how she can make her walls so thin, she answers, "Can't you *feel*?" Annette can. "I can feel how close the gourd is getting to my hand when I turn my pot. I truly believe all of it has to do with how you feel at that moment."

Some prefer thicker, more substantial walls. Usually, the scraper smoothes away all evidence of the coils. For corrugated pottery, the artist leaves each coil visible and decorates it with rows of scallops and indentations, using her fingertips, the pointed metal tip of a can opener, a carved juniper tool—or chopsticks brought home with Chinese take-out. Handles, lugs, and appliquéd animal or corn sculptures are added during shaping, with the clay still wet and pliable.

At this stage, as the pot dries to "leather hardness," potters carve designs—as simply, deeply, or ornately as the pot can withstand. For Nancy Youngblood's intricate Santa Clara designs, she may spend one hundred hours carving a single pot.

"The only tools I have are my hands and a piece of gourd," says Karen Abeita. The possibilities of shape that come from these simple tools are infinite.

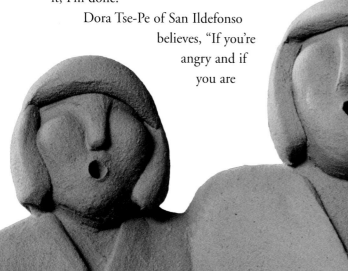

Tradition, convention, and each artist's sensibilities combine to make the rules. Even at this stage, every pot is unique.

A Turn of the Sandpaper

To avoid cracking, some clays require slow drying after shaping. Other clays can withstand sun drying, even a warm oven. Larson Goldtooth props bamboo skewers under the delicate, outstretched arms of his drying Hopi figures: "They look like they are skiing!" Glenn Gomez hardens his Taos pots on a table in a corner of his workroom at Pojoaque, turning them twice daily to ensure even drying: "You talk to them. 'Good morning. How are you guys doing?' You have to check on them and make sure they are behaving." If Glenn misses several days, all his pots will need carving at the same time: "Some clays are demanding. If you let this one clay go too long, it will crack."

When the clay has dried, the potter refines or even resculpts the shape by sanding and scraping. Not one potter says that sanding is her favorite part of the art. It is dirty, dusty, and tedious. It makes the worker sneeze; some potters blame long-term allergies on sanding. Many wear masks. Even in winter, the rest of the family may insist that the potter sand outside. But in this laborious step, each piece achieves its final form. And, like every step, sanding has its spiritual side. Dextra Quotskuyva hears music in the sound of sandstone rubbing against her Hopi pots as she sands and shapes them. Hopi-Tewa potter Dorothy Ami says, "Even the sandings, I cherish and recycle back into my clay."

In addition to the corncobs and chunks of rough lava rock or sandstone that potters have always used, they now work with metal tools, window screen, steel wool, or commercial sandpaper. They must take care not to sand the walls too thin and sand a hole right through a pot. Rims are particularly fragile, and a chipped or cracked rim on a large jar may mean that the whole neck must be taken off the dried pot, converting a jar into a wide-mouthed bowl.

Sanding eliminates the ridge left at the top of the puki. Also, if the potter carved designs in the drying pot when it was leather hard, she will refine the carving during sanding. Again, a delicate task. The artist creates a soft haze of pottery dust with her sandpaper. Gradually, a line of smooth, earthy forms accumulates on the table or floor nearby, looking more like sculpture than ceramics, any trace of the coiling process gone. After sanding, Nancy Youngblood dusts her carefully carved pot with a damp sable brush, striving for a perfectly uniform surface. When Ivan and Rita Lewis worked together at Cochiti, they would laugh as the pieces took shape: "This one's coming out crooked. This one has a big belly." But Ivan always told Rita, "I can fix anything in the sanding."

Throughout the drying and scraping phases, the potter watches for cracks and air bubbles. Minor imperfections can be repaired with fresh, wet clay and by rubbing the pot with a wet cloth. Major flaws mean that the pot must be broken and merged with the next batch of molding clay. Bernice Suazo-Naranjo admits, "Sanding the sculptures is not the most joyous part of making pottery, but sanding is crucial for me

Facing page: Unpainted, unfired clay figures by Maxine Toya, Jemez, 1986. Right: Santa Clara lidded vase with sculpted shells by Nancy Youngblood, 2006.

because that's when I refine. Just the turn of your sand-paper will determine whether you have a very traditional pot or a very contemporary one."

Polishing with Heirlooms

Bessie Namoki holds out a smooth, gray pebble: "A man from Second Mesa found this polishing stone at Awatovi Ruin and gave it to my mother, maybe in about 1937. We've been using it ever since. I don't know what I would do if I ever lose it." One of Laura Gachupin's polishing stones had been handed down for generations in Jemez Pueblo. She did lose it, somehow, and says that she will never forgive herself. Her sister Maxine Toya observes that polishing stones seem to disappear in mysterious ways.

Pueblo pottery can shine like river cobbles after a rain shower. It shines not from a glazed finish but from a hand-rubbed polish—in Max Early's words, "a glossy, sleek, mirror reflection of slipperiness that feels wonderful to the touch." At Hopi, the unmodified pot can be polished. In most pueblos, though, a thin solution of clay called a slip is painted on and, while still damp, rubbed carefully with a polishing stone or clean rag to achieve the lustrous final finish. Santa Clara potters make thicker pots now to allow for the increased pressure they need to apply with their polishing stones to achieve the high polish that buyers prefer.

Slips accomplish several things. They smooth the surface with a coating of finely ground clay. They add color. Some contribute to turning the plant-derived paint black in firing. They provide the base layer for polishing and a blank ground, or "canvas," for painting or incising.

Acoma, Zuni, and the middle Rio Grande villages use white slip. To cover a pot takes many thin coats of the creamy white Cochiti slip, and each must dry before the next is applied. Today potters sit in front of their ovens with the heat on low, for the pot must be warm to absorb each layer of slip. In former times, they sat by

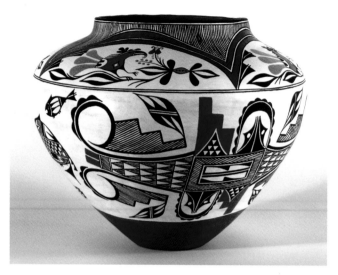

Acoma water jar by Lilly Salvador with Acoma, Zuni, and Mimbres designs, 1985.

their fireplaces, rotating the pots toward the coals.

"We just have magic!" say Emma and Dolores Lewis at Acoma, explaining what makes their pots so white. They laugh and proudly claim that they use so many layers of slip, their pots are not just white, but "white white." Like Acoma potters, Gladys Paquin polishes her red- and white-slipped Laguna bowls with a stone: "Polishing puts a brightness and softness to it. With a rag, it is rough."

Dextra Quotskuyva uses just one polishing stone, given to her by her mother, but her daughter Camille (Hisi Nampeyo) favors another. Many potters use several stones, each suited to a particular task: rims, sides, fluting, or tiny stones for miniatures. Not everyone has an heirloom stone found in a ruin or passed down through family; some buy polishing stones in rock shops or pick up river pebbles. Barbara Gonzales jokes that polishing stones are "pet rocks." When Dollie Navasie begins frantically searching for a lost polishing stone, her kids say, "Check your pockets, Mom!"

The complex incising called sgraffito owes its name to an Italian term for the technique of carving

through the polished slip to expose the color of the clay beneath. Pueblo potters call this technique etching. After polishing, they sculpt three-dimensional scenes on the sides of "etched" pots, both before and after firing. That's a convenience in a busy world. One of Maria's great-granddaughters at San Ildefonso, Kathy Sanchez, admits that painting is difficult: "We make the etched pots, the sgraffito, because they are easier. We can fire them and then just put them on the shelf until we have time to decorate."

Glendora Fragua carves sgraffito designs on her Jemez pots. She has found that dull blades chip the polished slip, so she must take extra care in preparing her clay. With her fine lines, the tiniest pebbles in the clay pop out and ruin the design as her knife slices through the polished surface.

Particularly on burnished black and red Tewa pottery, polishing is crucial. At San Ildefonso, Maria Martinez and her sister Clara established an ideal in the early twentieth century, and the family's high polish became a standard. Polishing takes a precise touch: press too hard with your stone, scratch the slip, and you must sand it off and do the whole thing again. Belen and Ernest Tapia at Santa Clara judged artists by how many times they were willing to sand off the slip and start over to get it right.

While Nolan Youvella polishes his Hopi pots, he "thinks of shiny stuff, like chrome." After polishing the slip once, potters may apply a layer of grease, lard, or margarine and polish the pot a second time. This not only increases the shine but also helps keep the clay slip from shrinking. Teresita Naranjo polished her slip layers four times. Juanita DuBray takes care to avoid overburnishing her Taos pots; she doesn't want to "torture the clay, to try to make it something it is not."

You must finish polishing while the slip is damp,

or scratching is inevitable. As Dora Tse-Pe puts it, the slip "should be drying and shining at the same time." Carnation Lockwood of Ohkay Owingeh takes the phone off the hook to avoid interruption when she polishes. If her friends try to call and repeatedly get a busy signal, they know that "Carnation's polishing today." Sharon Naranjo Garcia takes about four hours to polish a sizable Santa Clara pot: "It has to be done all at once. You can't have a draft." No opening and closing of doors allowed: "I love to work around my grandchildren. But when I'm polishing, they have to stay in or out."

When Mary E. Archuleta and her sisters were growing up at Santa Clara, their mother, Margaret Tafoya, would give one of them her pot to keep polishing

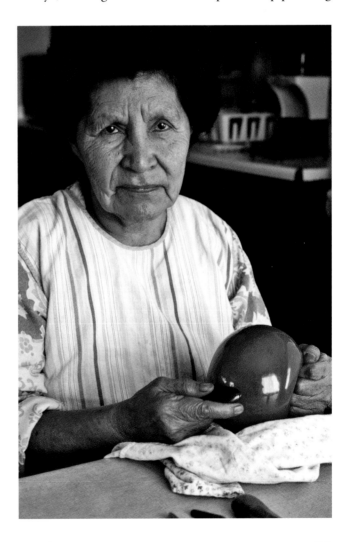

The late Santa Clara potter Belen Tapia polishes a pot freshly slipped with "Tewa red" clay, 1985.

when someone came to buy pottery and needed her attention. Mary says, "We tried to do the best we can when we did that. We didn't want to let her down and let the pot dry out. It gave us a feeling of trust, of confidence. When I started doing my own pottery, I felt like I could do it already. Mom said, 'A pot might not be perfect, but the finish is what makes it.'"

Painting Stories

A slipped, polished pot gleams in the potter's hands. How does she decide what to do next? Emma Mitchell lines up two or three pots and looks at each one, wondering which design to use, until she *knows*. "Sometimes I'll just spin the pot," says Hopi Karen Abeita, "just thinking about what to put on there." Robert Tenorio does not plan: "Once I start my lines, after I paint the base lines, the design just comes to me. Just go with it, and before you know it, I will have a finished painted pot." Bernice Suazo-Naranjo leaves some of her Taos micaceous pots smooth and elemental; their form is so exquisite that they need no design. Others look too plain to her, and she carves a design before firing.

Wilfred Garcia believes that the more respect he has for his designs, the more successful he will be. He tells his son, a high school junior who makes Acoma turtles, "Always respect your turtle. It's the one who's going to put you through college!"

Dextra Quotskuyva rises from bed when she has dreamed of designs, to sketch what she has seen: "The plants, the rocks, everything in the earth inspires you, and with me, everything seems to have life." Hopi-Tewa potter Dorothy Ami jots designs on napkins, receipts, envelopes, "anything that's handy."

The legendary Hopi-Tewa potter Nampeyo taught her granddaughter Daisy Hooee to paint freehand, without using a pencil to trace the design on the pot. Daisy learned by "watching her, watching her, watching her."

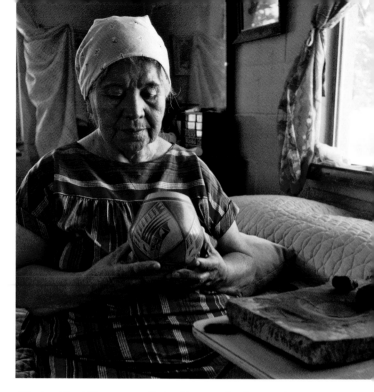

The late Hopi-Tewa potter Daisy Hooee in her home at Zuni, with her grandmother Nampeyo's paint stone, 1985.

Eighty years later, Daisy still painted designs in her grandmother's style, as well as designs of her own inspired by prehistoric potsherds: "There's where we get the ideas. There's where we get the stories from."

Pueblo people paint their designs—their "stories" —with a combination of bold intuition and careful thoughtfulness. Wayne Salvador was amazed at how his wife, Lilly, painted the inside of one deep Acoma jar: "You almost have to stand upside down to do something like that. That's how much patience they've got." Jean Sahme at Hopi has been having carpal tunnel problems; her doctor tells her to get up every fifteen minutes when she is painting. Some potters work late at night. Others paint only by daylight to save their eyes. As Mary Archuleta points out, "Haven't you noticed how many potters wear glasses?"

Potters may make brushes with strands of their own hair. Many use brushes made from dried yucca leaves, chewed so that exactly the right number of fibers extends from the tip, usually from one to twelve. Often

they do the fine work with old-style yucca brushes and fill in with commercial brushes. Yucca lets them paint places that are difficult to reach with long-handled commercial brushes.

Tracy Kavena tried commercial paintbrushes first, but Hopi paint ate away the hairs. She could make finer lines and longer strokes with yucca: "The yucca knows just where you want to go with the paint. The paint that is already on the pot is like a magnet. The yucca goes right back to the right spot." Max Early credits childhood piano lessons for giving him the "dexterity, concentration, precision, and control" needed for painting.

Mixing paint is another of the many preparatory steps every potter must attend to. Black paint usually comes from what the artists call wild spinach, or *guaco*, the boiled-down residue from Rocky Mountain bee plant or tansy mustard. It keeps for years and returns to a workable dilution whenever mixed with water. At some pueblos, guaco acts as a binder when mixed with ground mineral pigment. Some Zia potters use black mineral paint with no guaco binder. If the mix—and the match with the clay—is not exactly right, paint may flake off in firing or fail to turn dense black. Paint also must be free of lint and dust to transfer smoothly from brush to pot.

Some potters cook only the leaves of the bee plant; others use the whole plant, roots and all. Zuni potters have used yucca fruit, and some potters find that almost any plant will yield the same black paint base when boiled down to thick syrup.

Zuni plate with kokopeli turtles, by Marcus Waseta, 2006.

Every potter fine-tunes her materials. Santo Domingo potters mix sugar with their "spinach juice" so that the paint will stick better on the white slip. Red and yellow paints come from ocher or iron-rich mineral pigments, ground rock, and clay.

Painting demands concentration. Max Early has to clean his kitchen, take a shower, put on Vivaldi or Bach: "I need good feng shui. I have to get into my higher consciousness." Emma Mitchell says, "When the telephone rings, you take off for two or three minutes, and when you come back, it's not the same." If Robert Tenorio makes a mistake, he cannot erase it: "So I usually expand the design or turn it into something else. Maybe add an extra petal or leaf." His spinach-juice paint sinks into the white slip of the Santo Domingo pots: "Sometimes I go over it twice so that I know where the lines are." For other colors, he experiments with boiling down everything from wild onions to cactus.

Isleta potter Stella Teller does her best work alone: "I can't talk and paint at the same time." Noise does not bother Lilly Salvador. When her five children were small, they were "always screaming." She says, "I guess I'm used to it."

Each pueblo has a set of traditional designs that give a pot its character, and each potter paints these in an individual way—"as if dressing a child," as Max Early poetically puts it. In the old days, before Indian artists signed work, they had to be able to recognize their own pieces in a large array of pottery after a ceremony. Potters from the Tafoya family can recognize unsigned Santa

Garrett Maho warming his Hopi pots in the oven prior to outdoor firing, 2006.

Clara pottery in museum collections by telltale polishing strokes.

Every style has inexhaustible variation. Randy and Milford Nahohai find inspiration in looking through a kaleidoscope, watching new designs evolve with each small turn, thinking about how to apply these nuances to their Zuni pottery. Even something as simple as corrugated Acoma whiteware varies from potter to potter. The Shutiva family's pieces are instantly recognizable by their particular texture, achieved by nearly complete corrugation from top to bottom using a unique tool.

Pueblo people respect the old designs. One collector told Zuni potter Travis Penketewa that he would have bought his duck canteen for the story alone! "I was just telling him what the designs mean to me." Tessie Naranjo speaks of the power of Tewa designs to communicate "the connective breath of the universe." But a fine potter cannot help putting her own stamp on them. Gladys Paquin's customers comment that her pots "all look different." She replies, "Yes, I'm not a machine."

Anthropologists looking for easy classification sometimes lament this unending personal nuance. To the potters, however, variability in design is not a problem but the mark of each person's gift. It is art.

Baking the Potteries

Rose Naranjo called firing Judgment Day. After all the work of making pottery, Pueblo potters carry their pieces outside, carefully build a fire of wood or manure (an outdoor kiln to be used just once), and take the ultimate risk in potterymaking—"baking their potteries."

A gust of wind at the wrong time can abruptly

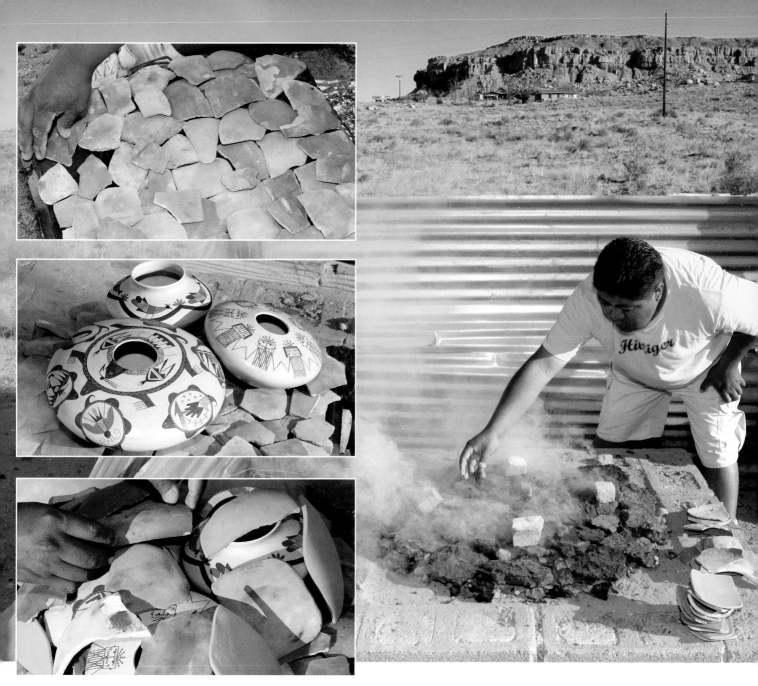

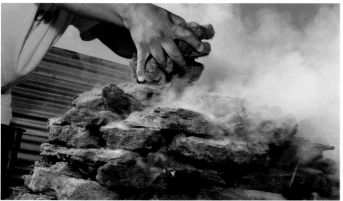

Garrett Maho firing his Hopi pottery at his home below First Mesa. Background: Building the dung-fueled fire. Insets: Arranging a bed of potsherds for pottery to rest on; arranging pots and shielding them with potsherds; stacking dung, 2006.

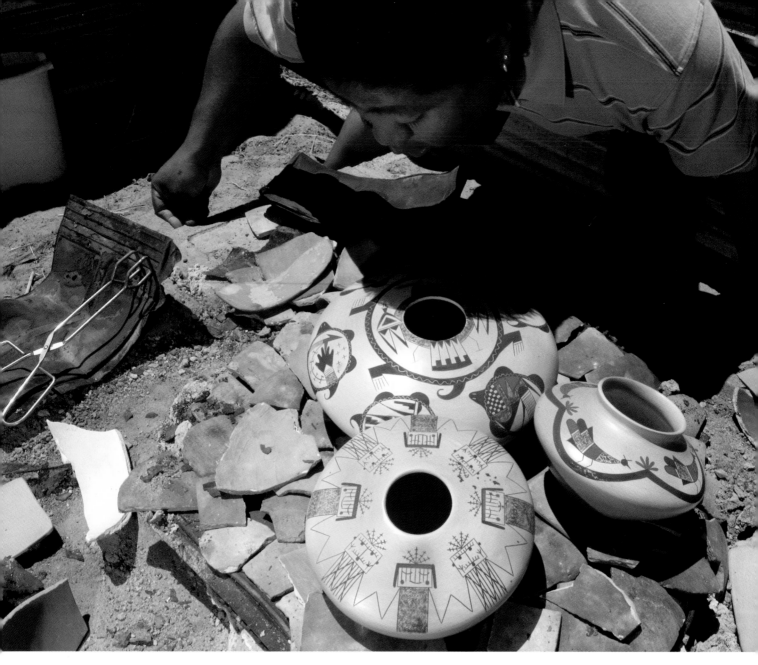

Garrett Maho's successfully fired Hopi pots emerge from the ashes, 2006.

alter the temperature and make a pot explode. Air bubbles in the clay can also make a pot "pop." A piece of manure falling on the polished slip can smudge the pot with "fire clouds." Clarence Cruz teaches his university art students that "bringing it through the last stage, the ring of fire, is a *process*. Some make it. Some don't. It's a learning stage, like life itself." Indeed, Robin Teller

Velardez also sees pottery like life: "You kind of stumble your way through and figure it out." Her mother, the Isleta potter Stella Teller, never sat Robin down, "but she has always just kind of been there."

Even the most experienced women find a successful firing exciting and satisfying. Angie Yazzie loves to fire her Taos pots at night: "The night air is so compati-

ble with the pot. They embrace each other." When a pot comes from the fire, "the whole thing is red, like a coal itself."

Only then is the pot finished. Max Early accepts no compliments on his Laguna pots when he is shaping and painting: "Save that energy for later. It's the ugly duckling at that stage. After the metamorphosis of firing, you breathe on the pot and give it life. They are their own little beings."

Bernice Suazo-Naranjo says, "When you lose a pot, you lose yourself. Sometimes you have a special feeling for a pot, and you hate to fire it because you are so afraid it will break. But that's part of the beauty of firing outdoors. You have got to learn to cope with it. I like the idea that not everything is going to survive, because that's the way it is—part of being a potter."

Pueblo people build a kiln from scratch each time they ground-fire their pots, usually behind their houses in a flat, protected place where they always fire or in an enclosed firing shed. A grate a few inches off the ground supports the pots, with room for kindling underneath. Angie Yazzie fires her large, thin-walled Taos pots right on the coals.

Juniper, slabs of bark, or cakes of cow and sheep dung (and even sheep bones) fuel the fire. Pieces of broken pottery (or clay slabs made specifically for this purpose), roofing tins, flattened stovepipe, old bed-springs and barbecue grills and bread racks, flywheels and shock absorbers from junked cars, all serve as grates and supports to shield pots from the burning fuel. Santana and Adam Martinez complained of cheaply made New Mexico license plates that melted onto their pots during firing.

Stella Teller protects her figurines in tin cans that she gets from the Isleta school cafeteria; her large figures fit perfectly in pumpkin cans. Virginia Gutierrez fired

Taos potter Bernice Suazo-Naranjo and son Jensedo at their home in Mora, 1985.

her polychrome pieces in army-surplus ammo cans or between two little red wagons that she found and joined together into a box: "Sometimes I go to the dump, and I find little containers that I can use like that. My husband looks at them and says to me, 'Where in the world have you been!'"

At Hopi, potters prefer to fuel their firings with sheep dung (in slabs hard-packed in corrals). These they buy from enterprising Navajos who bring their wares to the mesas. As fewer families keep sheep, dung is becoming the rarest of essential pottery ingredients. Even cow pies have become precious; locked gates make many pastures inaccessible. Jake Koopee frequently checks the tarps covering his dung pile, protecting his "gold" from weather. Dung varies in quality—"stronger" from sheep

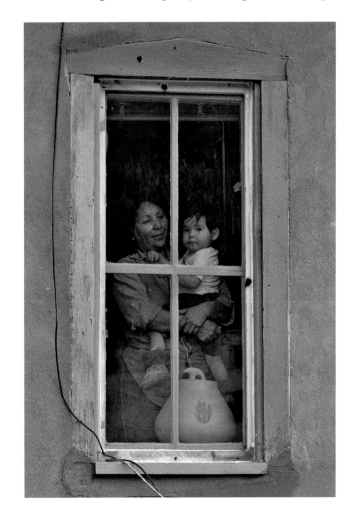

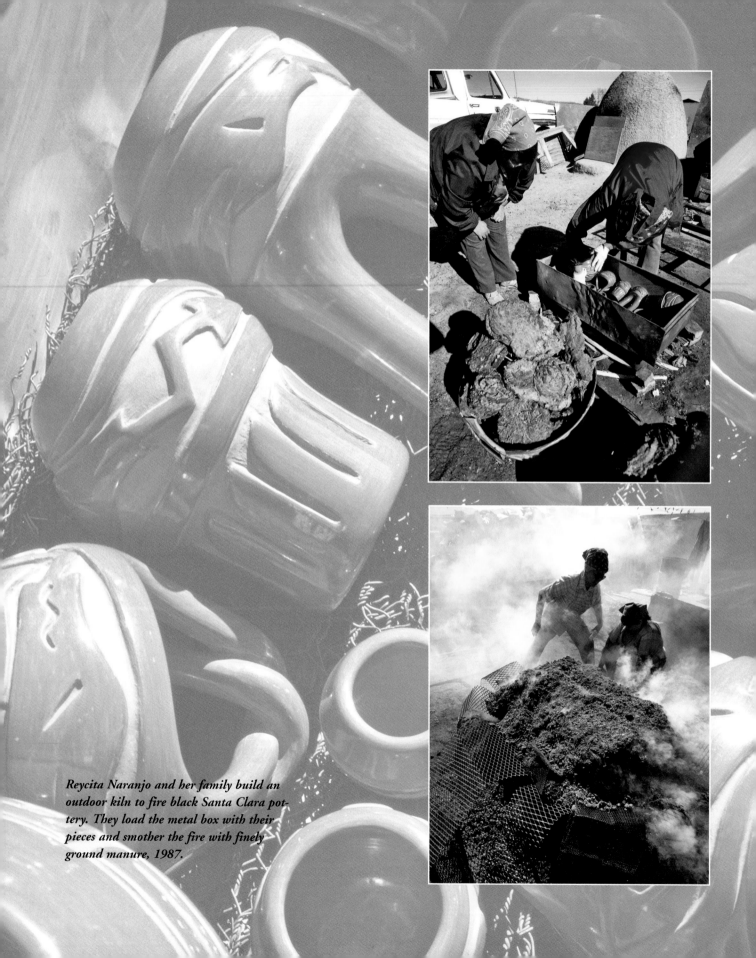

Reycita Naranjo and her family build an outdoor kiln to fire black Santa Clara pottery. They load the metal box with their pieces and smother the fire with finely ground manure, 1987.

that eat wild herbs, lighter from sheep that eat hay (sometimes too "weak" for good firing). Juniper varies too. Nathan Youngblood makes sure that his "cedar" slabs have no green knots, no moisture.

Tracy Kavena's little girls asked her why she smelled so strong when she came in from firing. She told them, "That's the smell of money." Whenever she would fire after that, her daughters would announce with glee, "Mommy smells like money!" Tracy's grandmother Rena always reminded her to wear her oldest clothes for firing, in case the smell did not wash out. The Tafoya family at Santa Clara jokes about wearing the not-so-subtle scent of "Corral No. 5."

At Ohkay Owingeh, Carnation and Bill Lockwood can hear neighbors' doors slamming shut on the days the Lockwoods stoke up their cow-chip fires. Pam Lujan-Hauer fires in her side yard in suburban Albuquerque. The thirty-foot-high column of smoke and sparks once prompted a neighbor to call the fire department. The firefighters politely asked Pam to avoid using wet wood.

Firing is one aspect of potterymaking that tribal governments sometimes regulate. Acoma and Jemez potters have been told not to fire because of air pollution. At other pueblos, firing may be prohibited during wildfire season.

Firing, like every step in the art, is sacred—and risky enough that even less traditional people make an offering before lighting their fires. Some potters use a firing ground blessed by a medicine man, a secret and sacred place. Yet the sacred never lies far from the humorous in Pueblo life. As Max Early arranges his pile of cow dung around his Laguna pot, inserting crumples of newspaper to help the fire catch, he smiles and calls it a "big piñata."

A kiln is built with great care, sometimes with a barricade to shield the fire from the wind. Firing days are dry and calm; a hot, clean fire is critical. In summer, potters try to fire at dawn, when the air is still and cool. Says Mary Archuleta of hot summer days, "If we're a little bit late, we suffer. Firing really takes everything out of you." To dry out the earth thoroughly, some potters build a small fire the night before, though some Hopi potters will not fire at night because "that's when dead people are about." Dora Tse-Pe says, "Rainy weather is bad firing weather but good polishing weather."

They tend the firing until they know that enough time has passed, then let it burn down, perhaps peeking into the fire to determine when the glowing, red-hot pots are done. Some pots must be taken out at precisely the right time to prevent overfiring, which turns them dull. To remove the pots and their racks, says Mary

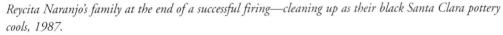

Reycita Naranjo's family at the end of a successful firing—cleaning up as their black Santa Clara pottery cools, 1987.

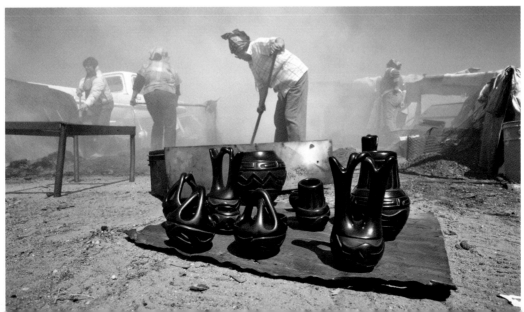

Archuleta, "you have to be an expert with a pitchfork."

With a good draft and plenty of oxygen throughout the process, most firings burn clean. Glenn Gomez says, "If the flame goes straight up, it's like a signal to me that it's going to go well." Zia potter Elizabeth Medina starts her fire with sheep dung, letting it smudge the pots. Then she adds cow chips, stoking up the fire to burn off the smudges. Damp manure turns Acoma pots blue instead of the desired white.

To achieve the lustrous black surface so famous at Santa Clara and San Ildefonso, potters smother the fire with fine horse manure toward the end of firing. This prevents oxygen from reaching the pots and creates a reducing atmosphere, as well as considerable smoke. In the reducing fire, the black, oxygen-depleted oxide of iron forms instead of the red, oxygen-rich iron oxide that turns unsmothered pots red. After years of firing, Nathan Youngblood believes that his Santa Clara pots turn black from a combination of at least thirty minutes of smothering and the black soot (carbon) absorbed by the pottery surface.

Ashes heaped on the manure keep in the heat and smoke even longer and prevent thermal shock. At the end, however, potters have no more than thirty seconds to get the pots out without a color change.

Everyone hates to hear the sound of a pot "pop-

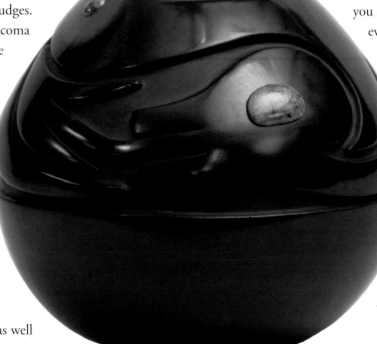

High-polish two-tone San Ildefonso jar by Dora Tse-Pe, 2006.

ping," going off like "a bomb." Dora Tse-Pe remembers what her mother, Candelaria Gachupin of Zia, would tell these pots: "If a pot cracks or a piece of it pops off in the firing or it just pops to pieces, she simply said, 'Well, you weren't meant to be.'"

"When I'm firing and a pot pops," says Dora, "I get upset. The girls would tell me, 'Mom, don't let Grandma hear you say that.' Many times, even before the firing, some step just doesn't do well. And I redo it and I redo it, and it does not come out. I know it wasn't meant to be. And maybe I should leave it at that point, but I keep trying. I keep trying, and I don't say, 'You weren't meant to be.' I just say, 'Hey! You better be!'"

If firing goes badly, Nancy Youngblood tells her family, "Don't talk to me. Don't ask questions. In a couple of days, I'll be able to talk." Emma Mitchell doesn't feel bad about the pots lost in firing: "Because we recycle the ones that blew up in the fire. We use it as temper, and it just goes right back into the clay." Bernice Suazo-Naranjo has her own belief: "To me, there is a beauty in losing a few pots. There is a beauty in doing the procedure, of going through the whole, old, traditional way." Tammy Garcia's grandmother, Mary Cain, watched Tammy lose pots during her trial-and-error years at Santa Clara and would say, "Your ancestors liked that piece so much, they wanted it."

At Hopi, Larson Goldtooth learned from his uncle, Mark Tahbo, who told him, "It's going to test you, to see if you are strong enough to be a potter. It's going to break, it's going to pop, it's going to burn!" Goldtooth has learned that "when a big pot blows up just before Indian Market, you don't have time to be disappointed. You look at it, cry, turn around, and walk away—and then sit down the next day and just keep going." Firing, he says, is the "easiest but scariest" moment in potterymaking. Easy because it's not as labor intensive as earlier steps. Scary, of course, because of the risk. Goldtooth says, simply, "The pot belongs to the fire."

When part of the surface pops off in firing, Glenn Gomez salvages some of his Taos-Pojoaque pots by "going in scratching with a dental tool," carving "little pueblos" in the rough, micaceous spall exposed by the pop. "It's an opportunity," he maintains.

To some people, firing problems mean that something bad is happening in their families. Rondina Huma at Hopi went through a time of "not getting good firing." One of her aunts died soon after, and "then it started firing okay again." Nona Naha had to fire her Hopi pottery four times to get the color right during the week she went to a friend's funeral.

Nearly every potter holds on to a few cracked pots, pieces she cannot sell for a good price. All feel great affection for these "failures." Candelaria Gachupin told her daughter, Dora, that pots are like people. Dora remembers her lecture: "We people have imperfections.

Do we destroy them because they are blind or deaf or have lost a limb? She told me that pots are the same way. You don't destroy a pot because it has an imperfection. You love it as much as you would a perfect pot."

Shortcutting the Traditions

Daisy Hooee said, "Nowadays they want everything easy." She would chide young potters, "If you make them with the commercial clay, how can you tell that story? There's no story on it." Even if you do not believe that such commercial shortcuts make the potteries "lose their stories," shortcuts may or may not work.

When Robert Tenorio of Santo Domingo made the transition to the old Santo Domingo methods, he experimented with combinations of new and old techniques, but they didn't work together. Electric kilns burned off his spinach-juice paint and turned the white slip red or terra-cotta. Cochiti slip would not stick to commercial clay. Zia white, Acoma white, Laguna white, and Jemez white—none turned the spinach juice black. Only Cochiti white seemed to work.

"We take our clay and slips for granted," says Erik Fender of his San Ildefonso materials, but he has learned to marvel at how "everything works in concert." Nona Naha at Hopi says, "Our ancestors were very smart to come up with all these techniques that work almost to perfection. I stand with tradition all the way." Candelaria Gachupin would not use any modern things

Rebecca Lucario's seed jars with Mimbres-style designs, Acoma, 1986.

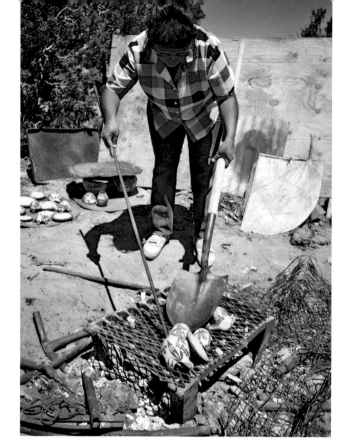

Elizabeth Medina removing her Zia pots from a successful firing, 1986.

in making her Zia pots. Her daughter, Dora Tse-Pe, remembers, "She wouldn't even keep her slips in a bowl, only *metates*. And she used only wooden sticks for trimmers, no knives—and no commercial brushes."

Each pueblo has worked out the combination of materials and techniques that distinguishes its pottery. Yet all modern pueblos interact with a much larger world. Intermarriage between tribes and with Anglos is common. A potter may have parents from two different pueblos and be raised in a third. Navajo, Apache, and Plains Indian people may marry into a pueblo: do they make "Pueblo" pots?

More artists add a little commercial paint or clay or begin their work at the design stage, using commercially molded pots. Nolan Youvella cannot understand it. The young Hopi potter says, "Why pour it in the mold? You're losing all the fun of doing the coils, and

the respect for it too. The heart wouldn't be there."

The marketplace demands perfection, however. As potters invest more time in each piece, they are less inclined to risk the "sacrifice" of outdoor firing. At Acoma, Zuni, and Jemez pueblos, where collectors value clear whites and look askance at fire clouds, nearly all pottery is now kiln-fired. Those still taking the risk of losing some 20 percent of their pots in a pit firing find that galleries pay more for these pots—tested by the outdoor kiln. Some double-fire, first hardening their pots in the electric kiln and then adding life to them in a second, outdoor firing.

Kilns turn up less frequently in the workrooms of San Ildefonso and Santa Clara potters (who must use manure-smothered fires to produce the atmosphere required for black pottery). Artists making classic Taos micaceous and Hopi pottery—with "imperfections" of blush and fire clouds integral to the design—fire outdoors. Burel Naha values "the blessing" of those blush marks on his Hopi whiteware. Dorothy Ami refires her Hopi pots if these come out too pale, trying again for the lovely fire clouds she sees as the strong mark of tradition.

Nathan Youngblood points out that you can always recognize potters who fire traditionally—by the burn marks on their arms and their singed eyebrows and hair! Helen Cordero believed that "Grandma Clay doesn't like it" if Cochiti pots are taken to the big electric kiln in Albuquerque. For Dora Tse-Pe, kiln-fired pots "lose their meaning." Her daughter, Candace Tse-Pe Martinez, says, "For my family, tradition sells." Larson Goldtooth believes that firing is "where Hopi clay makes the big statement of being traditional." His neighbor at Hopi, Garrett Maho, dislikes electric kilns because they "burn the shine off." Garrett says, simply, "Once something is started, it has to be finished."

In 1986 Grace Medicine Flower said of her etched Santa Clara miniatures, "Now, they call this contemporary. Years from now, they may call this traditional."

Her pots still go by "contemporary," but her family has been creating them for nearly fifty years. When will we relent and call sgraffito a tradition? Says Erik Fender, "In one hundred years, all the pottery that we've done in the last thirty years, no matter what the technique, will *all* be traditional."

Perhaps more than anything, tradition comes down to the way the pottery *feels,* how it communicates the potter's intent. All ethical potters agree that they must be honest, that they must tell the truth about their materials. The pottery itself expresses much of this truth. "It's the joy of it," says Nona Naha.

Returning home after years of parochial school and college, Milford Nahohai found himself "becoming a Zuni again." He did so, he believes, through his pottery. Rebecca Lucario worked for years as an Acoma Head Start teacher. But "the pottery just kept calling me back. It makes me appreciate life. It takes me back in time."

Dextra Quotskuyva makes some pots with minimal painted designs. She hopes that "people are able to touch it, have the feeling that there's something there, instead of just looking." What people feel in the pottery is love. They often tell Dollie Navasie exactly that—in her pots they see her love for the work: "A friend of mine involved with medicine men touched my pottery and said, 'I felt like I was flying there for a moment.' He could feel what I'd put into it."

An Albuquerque psychiatrist advises his patients to buy Pueblo pottery and *feel* the pieces. He doesn't know why, but it makes them happier, more connected (as it does the doctor himself when holding his own pottery). Santa Clara potter Jody Folwell suggests why: "There is so much incredible goodness that comes out of the pueblos and out of the people. It exists there a hundred times more so than in any other community. Anything that comes out of those villages has that particular power, spiritual power. So it's a very exciting kind of a feeling, always to be able to pick up a piece and say 'I love this piece. I'm going to take it home.' Because that's where all of that power exists then."

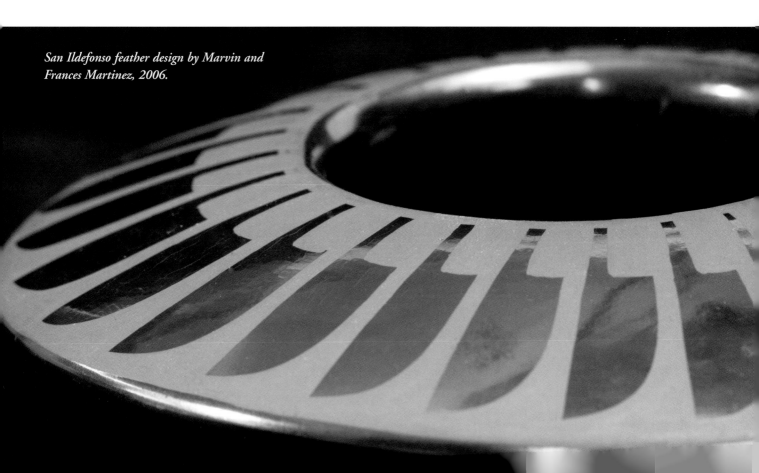

San Ildefonso feather design by Marvin and Frances Martinez, 2006.

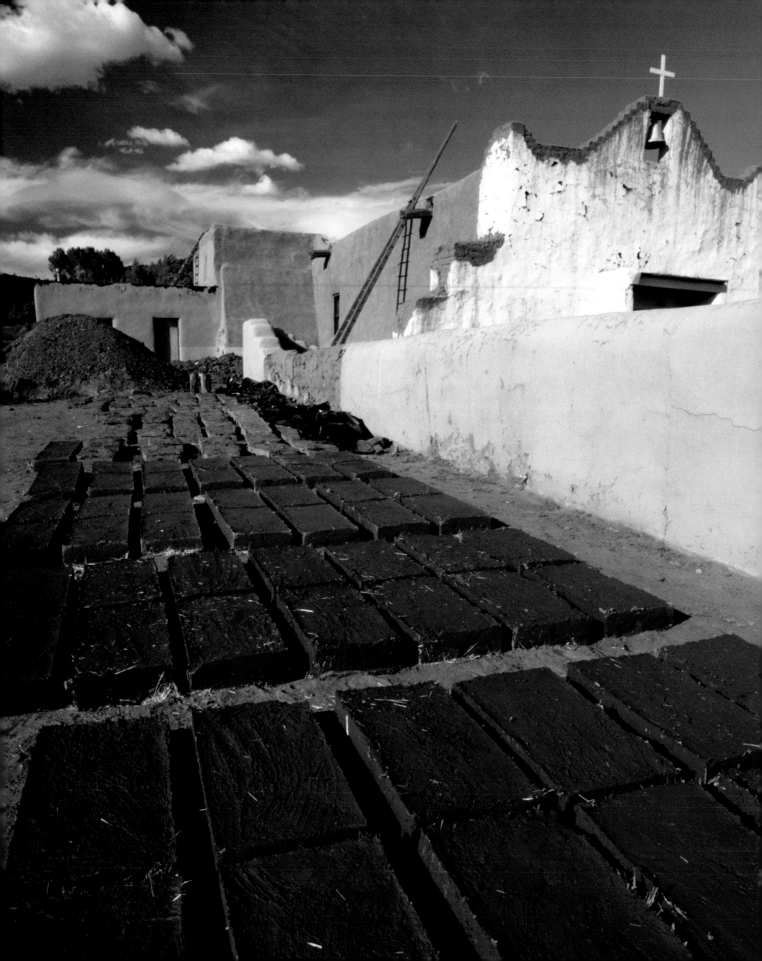

Mountain Villages

Taos, Picuris, & the Micaceous Revolution

MOUNTAINS DEFINE the eastern boundary of the Pueblo world. At dawn, the sun rises over the Sangre de Cristo range of northern New Mexico; the mountains glow blood red at sunset. On this frontier of Pueblo village life stand Taos and Picuris.

Taos looks up to Pueblo Peak, where Blue Lake, most sacred of all Taos holy places, nestles high in spruce and fir. Picuris people live *in* the mountains. They say that they dwell in a hidden valley: "The only way to get to Picuris is to climb a hill." Mountains dominate these settings as at no other pueblos. The people of Taos and Picuris also share distinctive ceremonies and dress, close historic relations with nomadic hunting tribes, and pottery.

The Tender Mica

Instead of weathering from the sandstones and shales of deserts and plateaus, Taos and Picuris clay decays from ancient Precambrian gneiss and schist, rich in mica. This mineral peels off in glittery sheets of silver and gold, and its grittiness gives most of the local clays enough leavening to require no additional temper. Micaceous pottery has dominated at Taos since the 1500s. Indeed, says

Facing page: Drying adobe bricks, Picuris Pueblo Church, 1985. Right: Virginia Romero, Taos pottery elder, with her micaceous pots, 1985.

Pam Lujan-Hauer, the Taos religion acknowledges micaceous clay: "Everybody who goes into the kiva has to eat and cook with micaceous clay. One of their aunties will trade for or make their own bean pot. The grandmas will lend you skillets."

Twenty years ago, two elderly women, Virginia Duran of Picuris and Virginia T. Romero of Taos,

The mica comes from a different place, in blocks like gold. Then we soak it, and it gets slippery."

Virginia Romero added nothing to her Taos clay: "It's just one clay. It has a little bit mica in it already." She cleaned and ground the raw clay: "I grind the clay fine. That's why I never lose pots in firing." Then she soaked it overnight until the mica was "tender." When she divided the clay into the ten or fifteen pots she would shape in a day, sometimes all the mica seemed "to go in one pot."

Left: Virginia Duran of Picuris with a favorite bean pot, 1985.
Below: Taos pot with bear lid by Bernice Suazo-Naranjo, 1985.

embodied the pottery traditions of these pueblos. They lived twenty miles from each other, worked in different styles, and spoke with a friendly rivalry. Virginia Duran insisted that Taos people learned how to make pottery from Picuris people: "The Taos people pick it up from here. It's not their job. Picuris pots are thin, not heavy like Taos." Over at Taos, Virginia Romero spoke proudly of never losing a pot in firing from the time she started making pottery in 1919. Years before, Virginia Duran had asked her how this could be. Mrs. Romero demonstrated her firing methods, using only wood, no manure. After that, said Virginia Romero, Mrs. Duran did it "the Taos way."

Both women spoke with affection of the mica that makes their pots unique. Picuris clay is micaceous, but Virginia Duran gave her pots their sparkle mostly with a slip of mica rubbed on before firing. She said, "Around here, there are two or three kinds of clay, but only one is good. We are strict with the clay and with the work too.

Taos pots seem the simplest of Pueblo pottery. Even the firing is simple, for smoke stains (fire clouds) suit the style. Virginia Romero agreed: "I just shape them and smooth them. I don't polish them. I just scrape them with a file, and then I make them smooth with my hand. That's all." Taos pots belie her humility. The mica glows as gold as sun-warmed adobe.

Picuris pots can be bronze or even reddish orange, and Picuris potters favor oxygen-rich firings that produce an especially luminous surface. Subtle modeling decorates many pots: a sinuous ribbon of extra clay, a band of small knobs, the soft curves of a lizard bulging through the pot's surface. The shapes are distinctive too: tall, round-bottomed vases similar to Apache and Navajo pots, bean pots with handles and lids.

Not Just for Pretty

Micaceous pots were the last of purely utilitarian, unpainted Pueblo pottery. Virginia Duran took pride in this, categorizing Tewa and Rio Grande pieces as "just for pretty. A long time ago they made good pottery, but not now." To a classic Picuris potter, "good" pottery meant useful pottery. Mrs. Duran judged Picuris pots "very handy in any way." One fundamental northern New Mexico truth continues into the twenty-first century: no beans taste better than those cooked in a micaceous bean pot.

The high-fired micaceous clay vitrifies and becomes waterproof, but local cooks still seal the inside of a bean pot with oil to keep food from tasting too earthy. Virginia Romero said that you could set one of her pots right on a stove-top burner: "It's real done, so you could use it any way you want." Virginia Duran recommended covering an open flame with a piece of metal to protect the pot from direct heat. The heated pot keeps food hot for hours. The key: it steams rather than boils.

Taos and Picuris people made both painted and unpainted pottery before the Pueblo Rebellion in 1680; in the centuries since, they have specialized in utilitarian

Pottery by Cora Durand and her grandson Anthony on the mantel at her Picuris home, 1985.

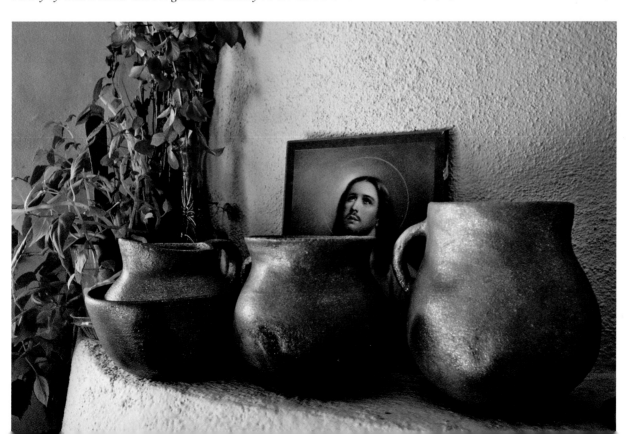

micaceous pottery. Jicarilla Apache potters made micaceous cookware in those same centuries and introduced new forms to micaceous potters at the nearby pueblos; today they often sign their pieces "J.A.T." for Jicarilla Apache Tribe. One micaceous potter working in the Jicarilla tradition, Felipe Ortega, has taught many classes that have inspired Pueblo potters to work with the clay. Tewa potters have made micaceous pottery as well, usually by adding a mica slip to their more refined, nonmicaceous clay to give their pots the surface glitter of Taos and Picuris pottery.

The tradition continues—long independent of the management or encouragement of collectors and dealers, who mostly ignored the micaceous cookware in favor of more "artistic," painted pieces. This left an opening, and the endlessly creative Pueblo potters filled it.

Angie Yazzie's Taos water jars testify to the strength of micaceous clay, 2006.

The Micaceous Revolution

The revolution began outside traditional Taos circles. In the 1990s Lonnie Vigil at Nambe and Christine McHorse, a Navajo potter married into Taos and working with micaceous Taos clay, began thinking of their micaceous pottery as art. The awards they began to win inspired Taos potters to follow their lead.

When Angie Yazzie began making micaceous pottery at Taos, she took her pieces around to galleries, and "they rejected it. Micaceous had a bad reputation. Everybody liked the black painted stuff." The rejection motivated her "to do it so good that they would take it." She ran across Acoma pots in books and wondered, "Why can't we make it that thin? Mother Earth won't mind if we show off the clay."

Angie succeeded. Her big, thin-walled pots testify to the strength of micaceous clay. At twenty-nine, she was included in the School of American Research's Micaceous Pottery Artists Convocation in 1994, the youngest of ten invited artists. Thrilled, she felt surrounded by people whom she thought "were gods, like Lonnie and Christine." She is more confident now: "I've been experimenting for twenty years. My grandmother told me, 'This is your path. This is what you are meant to do.'"

Pam Lujan-Hauer has been experimenting as well. While working full-time at a microchip fabrication plant in Albuquerque, she became intrigued: "Every time we took the silicon wafers out of the metal, there would be flashes of trace minerals. The metal draws trace minerals from the air." Watching the chips, she thought of inlaying

silver wire on the surface of her Taos pots: "The silver inlay in the clay does the same flashing in pit firing. It's the minerals in the smoke. Blue-green comes mostly from cedar, red from piñon needles." Her designs ("I do a lot of dragonflies because I'm Water Clan") pick up a smoky iridescence from this technique.

Lujan-Hauer believes that *traditional* is just the continuance of what potters have been given: "*Contemporary* means that every potter puts their own stamp on it." Even after fine-art ceramics training at the Institute of American Indian Arts (IAIA), she favors "utilitarian ware, not fine-walled pieces that can't be used." She sees her unusual shapes as part of an old continuum: "A tall vase would be a cornmeal storage jar." She pit-fires her pieces, for "the fire does something different to every piece. You can't get that finish in a kiln."

Made in Taos

Just what makes a Taos pot? Is it "that finish"? The micaceous clay? The old style of making and firing it? Does it have to be made by a Taos Indian? And do Taos and Picuris have the unwritten copyright on micaceous pots?

Sharon Dryflower Reyna makes sculptures in a style she calls micaceous raku, using commercial clays and micaceous slip, along with ceramic glazes. She smothers her pieces when she fires, achieving a dark gray finish: "The dark pots with glittery mica in them remind me of the stars in the night sky." Like many potter/educators, she teaches potterymaking classes to non-Indians. She most definitely thinks of her work as Taos pottery.

Taos pots on Bernice Suazo-Naranjo's kitchen counter await their turn to be sanded, 1985.

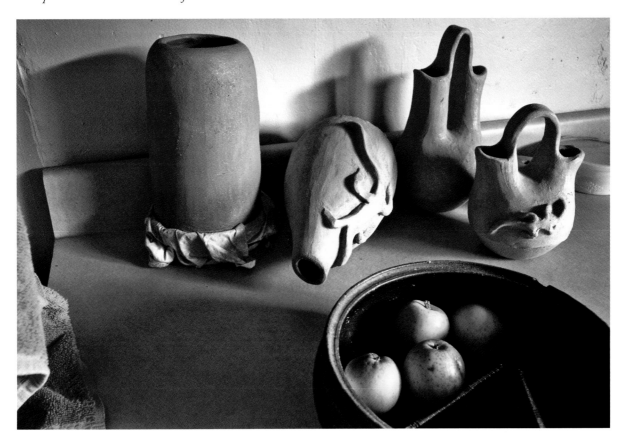

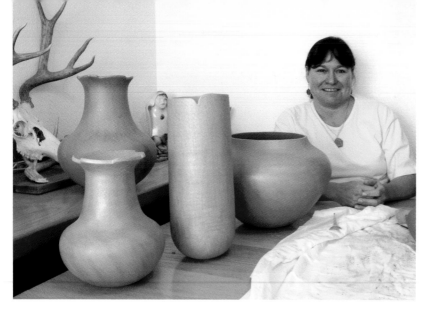

Pam Lujan-Hauer, shown here in 2006, favors unusual shapes for her utilitarian Taos pots.

Jeralyn Lujan Lucero, a Taos potter who sculpts appealingly Rubenesque Pueblo women draped in flowing micaceous dresses, counters with the most conservative approach: "We live the clay. It is ours." She feels that no potters outside Taos and Picuris should work with micaceous clay.

Where does that leave Glenn Gomez? His father is from Taos, his mother from Pojoaque. He grew up around Virginia Romero's pottery at Taos. Now he lives in Pojoaque with his mother, Cordi, who learned potterymaking from her aunt, Rose Naranjo from Santa Clara. Recruited to attend IAIA the first year he showed his work at the Eight Northern Pueblos Show, Glenn took classes from cutting-edge Hopi potter Preston Duwyenie. Now he makes contemporary micaceous pieces, often with lids, many with a whimsical peaked top he calls Seed of Life, after "the first little sprout that comes out." Cordi's pots look more like traditional Taos pots than Glenn's.

Gomez loves to experiment. He throws sawdust at a freshly fired pot to see what colors the heat may create as it burns off. He puts pine needles and leaves inside a pot, hoping for fire clouds from "those flames between the lid and jar." His two-tone, black-and-bronze style developed when he forgot to put the lid in with a vase he was refiring in a reduction fire: "My mistakes pay off, one way or another."

Bernice Suazo-Naranjo provides another set of answers to these questions about identity. The pottery, she says, is an extension of who she is: "People from other pueblos and tribes can borrow the clay. There are many potters who are non-Indian who make beautiful micaceous pots. But Taos Pueblo is a unique pueblo. My work becomes unique because I was born and raised in Taos. When people accept my work, they are accepting a lot of me."

Bernice began making pottery in 1981. She had lived away from the pueblo for many years, and in some ways she saw pottery as a way to reenter her traditions. Both she and her husband, Tito, came from "pottery families"—Bernice from Taos and Tito from Santa Clara. They had the "outline" of potterymaking in their minds, from gathering clay to firing, but learned the fine points by trial and error. At first, Bernice was overwhelmed by the amount of information her grandmother gave her: "The way grandmothers express themselves, you've got to be there and do it. They are not going to explain step by step."

After learning from many hundreds of pieces, Bernice makes large micaceous pots free of fire clouds, with her bold, distinctive designs carved into the clay and painted with red slip. She works with Santa Clara clay as well, especially for sculptural and sgraffito pieces. Bernice believes in the old way, using pure micaceous clay, and speaks with excitement about probing the boundaries of shaping this coarse, difficult material: "I think the clay calls for simplicity. When I go overboard with a design, it just doesn't satisfy me."

"I want to let other people know pottery is not

dead in Taos," she says. "When you see the pot come out of the firing, it's unbelievable, the high you get because you know that you've done it yourself. It's something that you just created out of nothing, just the clay, all made by hand. If I and other Taos potters don't do pottery, pretty soon we will only be seeing pottery in the books."

Potterymaking can, indeed, die within a pueblo. The primary clay source at Picuris, on land just outside the reservation, has been destroyed by road construction and mining. Older potters do not have the energy to search out new clay pits. They simply quit potting.

Younger potters can revive the traditions by searching out new clay sources. On feast day at tiny Picuris, Anthony Durand keeps the "Pottery for Sale" sign in his window facing the plaza, in the house where he lived with his grandmother, Cora, and where he learned to make pottery. A stack of ponderosa pine bark in the yard sits next to a grill, ready for firing bronze-colored bean pots, cookie jars, creamers, and sugar bowls—all with the Picuris trademark twinkle of mica. Pottery remains one of the few means of support in this isolated valley, and the enterprising young people of Picuris will see to it that the traditions continue.

Taos micaceous bowl by Glenn Gomez, master experimenter, 2006.

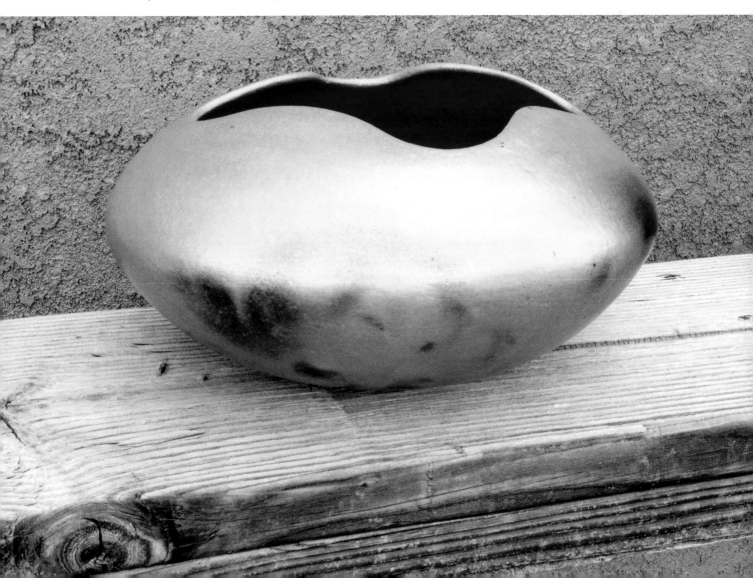

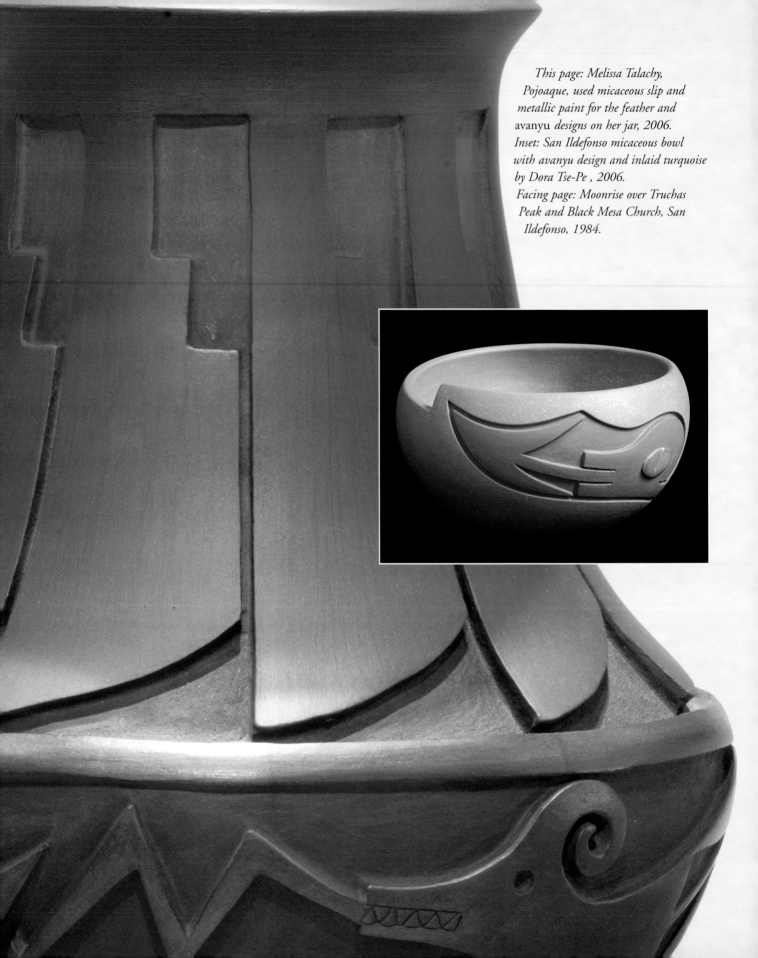

This page: Melissa Talachy,
Pojoaque, used micaceous slip and
metallic paint for the feather and
avanyu *designs on her jar, 2006.*
Inset: San Ildefonso micaceous bowl
with avanyu design and inlaid turquoise
by Dora Tse-Pe , 2006.
Facing page: Moonrise over Truchas
Peak and Black Mesa Church, San
Ildefonso, 1984.

The Red & the Black
Tewa Pueblos

LOIS GUTIERREZ PUTS four black terraced symbols on the rims of her Santa Clara bowls to represent the four sacred Tewa mountains. Says her husband, Derek de la Cruz, "Our clays, our paints, all come from within those four original mountains, so we put them on our pottery—San Antonio Peak at the north, Sandia on the south, Tsikomo at the top of the Jemez on the west, and Lake Peak or Truchas Peaks on the east in the Sangre de Cristo."

Embraced between these sacred mountains, within a great bowl created by the barriers of the Jemez and Sangre de Cristo ranges, the Tewa pueblos lie in the Rio Grande badlands between Española and Santa Fe: San Juan (called now by its Tewa name, Ohkay Owingeh) and Santa Clara, just north and south of Española, respectively; San Ildefonso, on the Rio Grande north of the Los Alamos highway; Nambe and Pojoaque, more loosely knit and dispersed among the Hispanic ranches along the base of the Sangre de Cristo; and proudly independent Tesuque, just north of Santa Fe. Every stepped, terraced, ceremonial Tewa bowl symbolizes this mountain-ringed Tewa world.

These small villages (Ohkay Owingeh is the largest, with some 1,300 resident members) are among

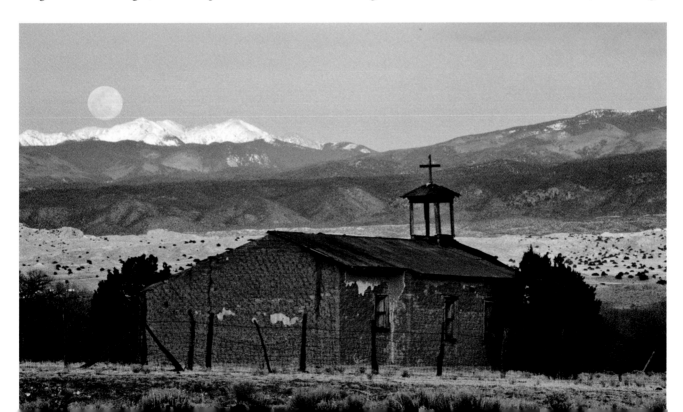

the best-known pueblos, partly because of their long association with the centers of Hispanic and Anglo colonization in New Mexico, partly because of their pottery. The two larger northern pueblos, Ohkay Owingeh and Santa Clara, traditionally made polished pottery without designs. In a freely burning, oxidizing fire, their pots fired red; a smothered reducing fire yielded black pottery. In former times, Tewas traded with Hispanic people from near Canjilon, north of Ohkay Owingeh, for the red clay painted as slip on both red and black pottery. "Tewa red" now comes, ironically, from Santo Domingo. But, as Derek would point out, Santo Domingo still falls within the area defined by the four sacred Tewa mountains.

Historically, the other four Tewa pueblos made both undecorated and painted pieces, but these traditions turned topsy-turvy in the early twentieth century when potterymaking became an income-producing profession. The force behind the change was the little pueblo of San Ildefonso, in the center of Tewa country. The drive came mostly from one exceptional woman, Maria Martinez.

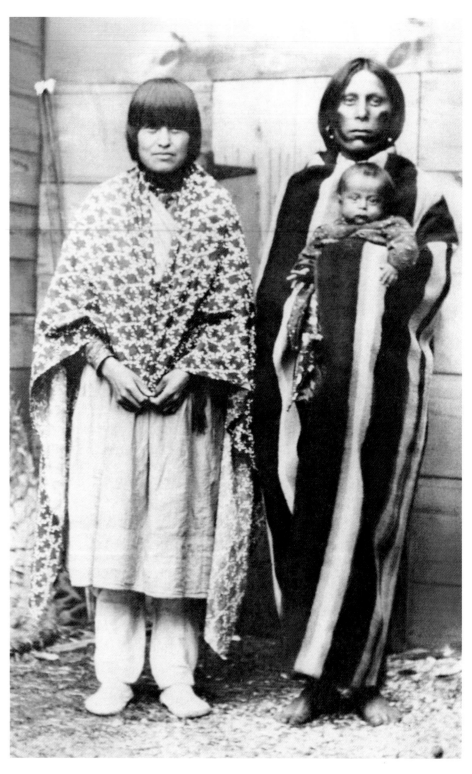

Maria and Julian Martinez with their son, Adam, St. Louis World's Fair, 1904. Photograph courtesy of Maria Poveka Martinez and Richard Spivey.

Maria's Legacy

In 1918 only eighty-three people survived an influenza epidemic at San Ildefonso Pueblo, just twenty-five miles north of Santa Fe. Now, it is hard to imagine how isolated the pueblo was in those days—and how poor. With much of their land taken by neighboring Hispanic and Anglo people, with their fields troubled by drought and too few men to work them, and with the tribe's watershed losing its trees to logging, San Ildefonso people were in trouble. The other Tewa pueblos had similar problems.

Two talented people, Maria and Julian Martinez, were among the survivors of that epidemic. Maria and Julian had been making pottery to sell for ten years.

They started with polychrome in the style popular with San Ildefonso potters in the late 1800s, made for use in the pueblo and for the tourist market that came with the completion of the railroad to Santa Fe in 1880. Maria shaped and polished the pots; Julian gradually mastered the art of painting them.

Inspiration surrounded the couple. Great potters within their families were working in the pueblo. Archaeologists excavating nearby ruins (in what would become Bandelier National Monument) asked Maria to produce vessels styled after broken pots they had dug from the Ancestral Pueblo villages. And Julian spent years working at the Museum of New Mexico, where books and collections introduced him to pottery from all over the prehistoric Southwest.

San Ildefonso plates by Adam and Santana Martinez, 1971.

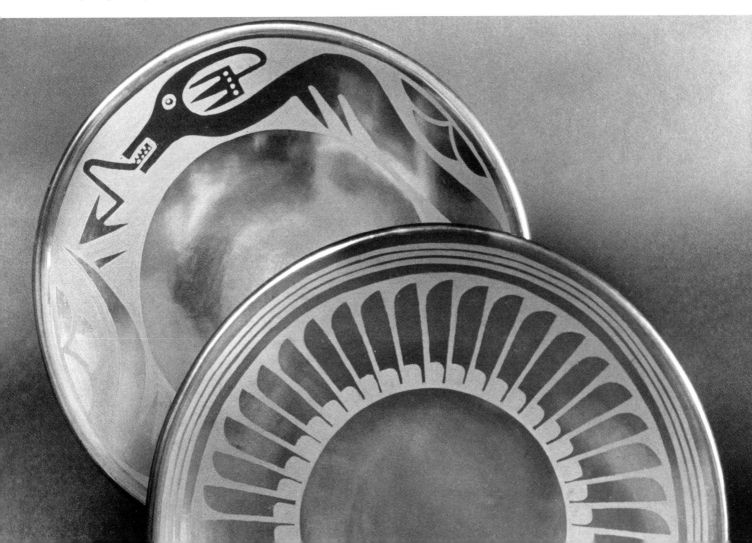

The late Adam and Santana Martinez, San Ildefonso, 1985.

Maria and Julian began to experiment, first with black pottery fired in manure-smothered blazes, as Santa Clara, Ohkay Owingeh, and San Ildefonso potters had done for many years. One day in the winter of 1919–1920, Julian tried painting a design on one of Maria's pots after she had polished it, using the clay slip she had used for polishing. A new kind of pottery came from that firing—matte black (where Julian had painted) on polished black (where Maria's carefully rubbed slip still showed).

Julian's invention and Maria's incredible polish caught on immediately. San Ildefonso black-on-black pottery became so popular that by 1925 several families in the pueblo supported themselves with money from "two-black" pottery sales. With a slightly cooler firing, they sacrificed a bit of hardness but gained a jet-black finish deeper than the chocolatey black favored at Santa Clara.

Julian kept a notebook of ideas gathered from pots that caught his fancy. He revived ancient designs and transformed them to match his artistic vision: the old Mimbres radiating-feather pattern and the plumed water serpent (called *avanyu* in Tewa, drawn with feathers at San Ildefonso and horns at Santa Clara). Julian likened the water serpent to the leading edge of a flash flood pushing down an arroyo. When Maria spent their pottery money on a Model T, Julian even painted the new car with his hallmark matte-black designs.

Julian's creativity and Maria's skill and determination combined to make Pueblo pottery more than useful. Working alongside other great early-twentieth-century potters from San Ildefonso, they transformed it into an individualized art and a profession. Julian died in 1943, but Maria continued making pottery until 1972. Her daughter-in-law Santana decorated Maria's pots until 1956, when Maria's son Popovi Da took over.

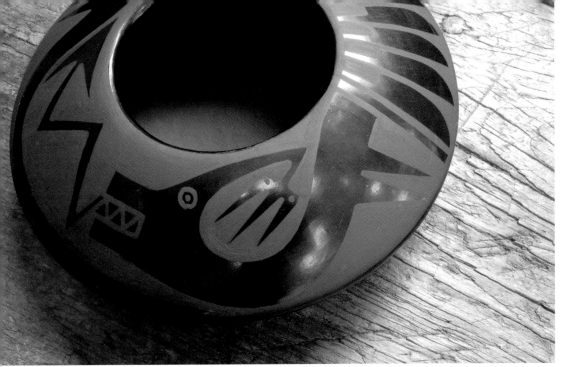

Maria and Julian's designs, three generations later: San Ildefonso bowl by Marvin and Frances Martinez, 2006.

Martinez tradition of black-on-black pottery. Marvin was raised by his grandparents, Adam and Santana, until he was twelve; he traveled with them and danced to Adam's drumming in many places far from the pueblo. He speaks of the elders with enormous respect and affection, especially Adam, who was "always teaching him." While Marvin would be watching TV in the front room as a kid, Maria and Clara would be polishing pots in the back room. When he came back to "touching clay again" as a young adult, he remembered everything he had learned.

Popovi died in 1971; Maria in 1980. Throughout these years, Maria's youngest sister, Clara, specialized in polishing.

Maria was the first Pueblo potter to sign her work consistently, yet she always said that what mattered most was that it was San Ildefonso pottery, not that a particular woman made a particular pot. Later in life, she attempted to shift attention to other San Ildefonso potters—mentors and relations who made pottery just as innovative and beautiful—but the myth of "Maria, *the* Potter of San Ildefonso" had already taken over.

Maria's real legacy survives in the rejuvenation of potterymaking at San Ildefonso and other pueblos and in the creation of a livelihood earned at home, where the old traditions can be nourished. Santana and Adam (Maria's oldest son) made pottery in the style of Maria and Julian for decades. Now, a cohort of their daughters, granddaughters, and great-grandsons, as well as an assortment of cousins, makes pottery.

With prolific enthusiasm, Marvin Martinez and his wife, Frances (from Santa Clara), carry on the

Marvin and Frances sell their work under the portal of the Palace of the Governors in Santa Fe, especially in the spring.

Marvin loves to tell stories about people who discover his connection to Maria: "Their parents met Maria and Julian, met Santana and Adam. They inherited the pottery, and they have come to see where it came from. They have been told, 'I don't think you'll find anybody from the family doing the traditional black-on-black.' And so they are thrilled to find us, right where Maria and Julian were in the 1920s."

Frances emphasizes, "We don't say, first thing, 'Yes, he is the great-grandson of Maria.' We want the pottery to speak for itself. The most rewarding part is making long-lasting friendships. You welcome people to your house. You welcome people into your heart."

Barbara Gonzales, one of Santana and Adam's granddaughters, makes incised pots but also continues the painted polychrome revived by Popovi Da in the 1950s and 1960s. Cavan, her son, is now known for his polychrome as well. For sgraffito pots, Barbara often works with the two-tone style developed by Popovi: the pot is fired more than once, with successive firings selectively burning off the black to let the red, transformed to sienna, show again. Popovi's son Tony Da crafted spectacular sgraffito pots before returning to his first love, painting.

Barbara credits Maria with being the "major force behind getting clay recognized as an art form" and calls herself a clay artist instead of simply a potter: "As an artist, if you let yourself go, you will find yourself doing different things."

In a small pueblo like San Ildefonso, many potters remain connected to Maria. Erik Fender could say, "Buy my pottery, because Maria was my great-aunt and Carmelita Dunlap was my grandmother." But, like the other potters, he wants his pottery to stand on its own: "I talk with the clay in the building. Then, completed, the clay talks to the people. It says, 'Take me home!'"

Erik spent his childhood in California and his summers at the pueblo: "All we saw was pottery, pottery, pottery. My grandma didn't *teach* us. She encouraged us. You can watch— you can't be taught. You have to develop your styles and techniques." After moving permanently to the pueblo at thirteen, Fender's first love was two-dimensional painting. Gradually, he grew bored

and turned to pottery. He worked on contemporary pieces with his uncle, Tse-Pe, and his mother, Martha Appleleaf. But he realized, "Traditional work was being pushed aside, and that was an area where I could excel." Erik decided to pursue larger pieces like his grandmother's: "I'm willing to take that risk." The largest piece so far measures twenty-two inches tall. Next he hopes to perfect traditional, stone-polished polychrome.

Earth Colors & Carved Serpents

Of all the pottery families at San Ildefonso, Blue Corn claimed that hers was "the noisiest." She began making pottery when she was three years old: "My grandmother had persuaded me how to make pottery. She was blind, and she used to feel my hand and feel my face. And she told me I was going to be a potter. So here I am."

At first Blue Corn made only black pottery, but one day she and her husband found a sherd from a prehistoric pot—a polychrome pot. She said to him, "Why don't we try and do this?" Her first experiments came out lavender and bright green: "'Oh my gosh, what am I doing here?' I said to myself, 'Gee, these colors don't look right to me.'" She kept experimenting, going to Black Mesa for white slip, up toward Los Alamos for clays that yielded gold, pink, and dark red, avocado, rust, and beige: "All of my pots has that earth color."

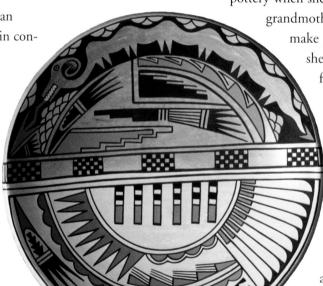

San Ildefonso polychrome plate by Blue Corn, 1986.

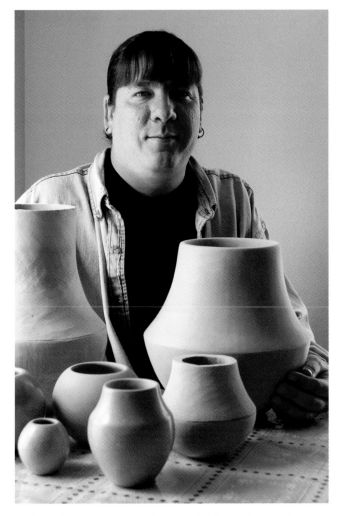

Erik Fender with an array of his San Ildefonso pieces ready to paint, 2006.

Before Blue Corn's death in 1999, she summed up the way she felt about pottery: "I don't work to bring a lot of award to my pueblo or to my house. I just like to make pottery. Sometimes, when my pottery cracks in the firing, I feel like quitting. But then I'm going to make the kids feel bad. They'll say, 'My mom is not making any more pottery, and maybe I better not make any more.' And I think, if they carry on the potterymaking, that they have a lot of hope."

Rose Gonzales was another innovator at San Ildefonso. In the 1930s Rose made the first modern, carved pottery at the pueblo. While out deer hunting, her husband had found a potsherd decorated by carving, and she "just started from there." Rose carved her pottery with distinctive rounded edges. Her black and red, polished and carved pots spanned some fifty years.

Rose taught her art to son Tse-Pe and his wife, Dora. Working first with Tse-Pe and then on her own, Dora Tse-Pe has carried on Rose's traditions: "I love her work, and I love carving. And I love the water serpent. It depicts water—rain, thanksgiving, and prayer for water. It's a San Ildefonso trademark. I like to make my serpent really simple and graceful. You'll notice that Santa Clara serpents look almost oriental, all the curves on the backs and all. Mine are very plain." The water serpent, avanyu, remains a powerful Tewa symbol. With clouds attached to his body and a tongue of barbed lightning, "Storm Serpent Old Man" is the guardian of precious water resources.

Dora grew up at Zia, the daughter of potter Candelaria Gachupin. She made a few pots with Candelaria and, after marrying into San Ildefonso, a few with Rose Gonzales. Dora has taught her own daughters potterymaking: "I tell them, 'Make one good pot instead of ten bad pots.'" She makes carved black, red, and unslipped pottery, but also black-and-sienna pots. Sometimes she adds micaceous slips and, after firing, turquoise inlay and sgraffito: "If I add anything from Zia, it's just shapes, like the water jar shape."

Dora freely admits to using a blowtorch to oxidize the light areas in her two-tone pots: "There's an art to that too. It takes many times going around the rim, letting the pot cool down each time. Gradually, the black color changes."

She says, "When I sell a pot and pack it and I'm giving it to a person, I say words to it from my heart. I say, 'Well, I'll see you again sometime.' If today were a hundred years ago, the pot wouldn't be going anywhere. It would be at the kiva. It would be sacred. And I would see it often, and I would feel like there is a part of me

here. And I feel that way about the pots that go away now. I feel like something special in my life is going to Florida or California, or wherever it goes."

Of Dora's daughters, Candace Tse-Pe Martinez is the most prolific potter. She works in her parents' style but has also taken what she learned from her grandmothers and her mother and has "moved on." She explains, "I can do something using traditional methods but with a little twist on it, like Zia designs carved in black. No potter ever perfects everything, but I wanted to concentrate on something exceptional. I really concentrated on polishing."

Russell Sanchez also learned a lot from watching his great-aunt Rose Gonzales, as well as Dora. He includes in his work two-tone black-and-sienna jars with bear-effigy lids, inlaid stones, and green slips. Russell says, "I feel my work is very traditional, but because of the designs, they are called nontraditional. People forget that ceremonial pots have had stones set in them for a long time. And colors fascinate me. You can use traditional techniques and materials and still come up with something far-out and a little different. You really can't define tradition."

As Erik Fender says, "San Ildefonso black-on-black wasn't traditional. It was an innovation. Traditions evolve. Pottery is a living art."

The Home of the Black

Santa Claras speak wistfully whenever San Ildefonso blackware comes up in conversation. They respect Maria Martinez for her revitalization of Pueblo pottery and acknowledge the other fine San Ildefonso potters. But it hurts them when people forget that Maria and Julian invented matte-black decoration, not blackware itself. San Ildefonso and Santa Clara potters had long made blackware, and Santa Clara has been its stronghold for three centuries.

Mary Cain says, "My grandmother has been

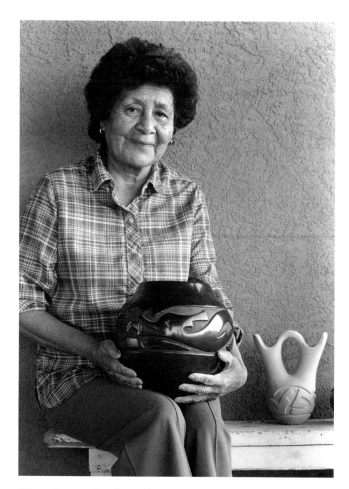

Mary Cain with a finished Santa Clara jar and an unpainted, unpolished wedding vase, 1985.

doing it, and her mother, and she learned from my grandmother's great-grandmother, all in a line, the black pottery, all through their lives." Black vessels, particularly large storage jars with an indented bear-paw design, are emblematic of Santa Clara pottery. For years, Mary Cain's aunt Margaret Tafoya made a huge, black storage jar each year, along with many smaller pieces. Several dozen Santa Clara potters in the Tafoya and Naranjo families trace themselves to the same grandparents that Mary Cain talks about—SaraFina and Geronimo Tafoya.

Many legends tell the story of the bear paw. According to one, a bear led the Santa Claras to water during a drought. In remembrance of this act of salva-

tion, Santa Clara potters began placing its tracks on their work.

Another distinctive Santa Clara shape is the double-spouted, strap-handled wedding jar. Many pueblos make this old form. Its popularity surged after the arrival of the railroad, and Santa Clara people used it in their weddings until recently. The late Rose Naranjo said, "I like to make wedding vases. It reminds me of how one of my uncles was getting married and my grandmother took a wedding vase and it was passed around to all family that was there and they drank out of it—the man's relatives on one spout, the woman's folk on the other. And then they make a holy water. And when they finish that, they just break it into many pieces. They say the marriage would last. I don't know how it would last in many broken pieces. That I couldn't understand."

Belen Tapia added, "Now, they hate to break it. If they use it, they just put flowers in it today, on the table. It's very hard to make wedding vases. Polishing them and the animals are hardest. When they don't come out good, we have to sandpaper them and do it over again. When we are getting ready for the annual

The late Helen Shupla was the master of Santa Clara melon bowls, 1985.

Tammy Garcia, Santa Clara, with a monumental bronze of her pottery designs on display at her Blue Rain Gallery in Santa Fe, 2006. Below: Carved red pot by Tammy Garcia, 1996.

Indian Market in Santa Fe, sometimes I have to sandpaper plates six or seven times." Plates are one of the ultimate challenges for Nathan Youngblood as well. He lost forty-six plates before his first successful one.

Belen Tapia called the bear paw and the melon bowl "the old folks' designs." When the late potter made melon jars, which have an even pattern of sculptured squash ribs around them, she started with extra thick bowls and cut the grooves when the clay was still soft. After drying and sanding, polishing inside the grooves took extra time. Her daughter, Anita Suazo, keeps that "old" design alive: one of her melon bowls won Best of Show at the New Mexico State Fair.

The late Helen Shupla was proud that the ribs of her melon bowls stretched nearly all the way from rim to base; the grooves could be felt inside and out-side while the pot still "held its shape." Sharon Naranjo Garcia, an accomplished potter, thinks that this form is the ultimate challenge; she is "still trying to make a successful melon bowl!"

Naranjo Garcia was raised by her grandmother Christina Naranjo and says, "I have no desire to change my grandmother's teachings." After making a living at pottery for twenty-five years, she still maintains, "No two pots are ever the same. I'll do a design. Then I'll move on. Sometimes it's whatever you see outside that day." Looking out her window, she muses, "Like today I see clouds. I might use that." Naranjo continually strives to live up to what she has read, that "Santa Clara potters were the masters of form."

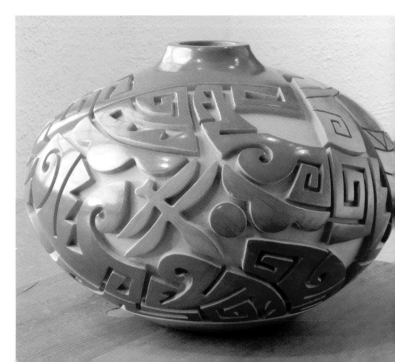

Deeper carving is another characteristic Santa Clara style, mostly in black pottery but in redware too. The carver cuts away the background, leaving the design standing in relief. The design and body are polished, and the background is matte-painted.

When the pottery is leather hard, the carver goes to work. Stella Chavarria uses woodcarving tools, screwdrivers, and a kitchen paring knife sharpened so many times that its blade sticks out only an inch or so from the hilt. She says, "I draw it out in pencil first. Everybody says that it looks easy for me to carve, but I guess after doing it for so many years, you don't really think about it. You just do it.

"You have to be careful as to how far along you want them to dry, then put them in a plastic bag. I'm very forgetful, and sometimes one dries a little bit too much. Then it's hard on your hands, and it chips a lot. But when they are just right, carving is my favorite part. I could sit here forever carving and let somebody else do the rest. The only thing is, when it's real quiet, it gives you too much time to think."

Tammy Garcia loves that extra time to think. She has taken Santa Clara carving to new realms of precision and refinement, and she has moved carving beyond the bounds of its single band to embrace the entire canvas of the pot with intricate designs. The key to "liberating" her work within the constrained space of the pot: "If there's not room, *overlap* your designs." She gives herself lots of room to design; some pots stand more than two feet high.

Tammy has pushed form to similar outer limits: "I started noticing shapes around me. If I was in a house, I noticed the shapes of lamps. I would go to museums. I looked at books. I *love* historic pottery and those classical forms. I also want to push the clay to find out where its limits are. When I make a body of work, half is symmetrical and half is asymmetrical."

Garcia has reached the elite of the pottery world, with her own gallery, collectors waiting in line for her

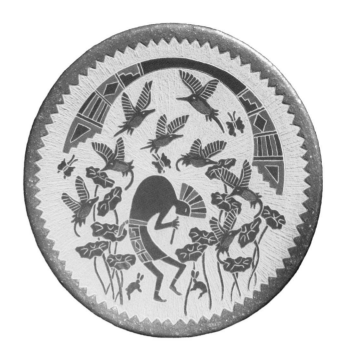

Santa Clara sgraffito plate by Debra Duwyenie, 2006.

next piece, a series of monumental bronzes and interesting collaborations, and lavish books about her work. But she still prepares her own clay, taking extreme care to produce the best possible raw material: "When you want to do something great, you have to begin at the beginning, with clay that's 99 percent pure." She finds inspiration in her "rebellious" great-grandmother Christina Naranjo and the unusual pots she saw her mother, Linda Cain, make when Tammy was a teenager. She remains "in awe" of the "natural simplicity" of a process that can yield such pots in the end.

Beyond the Red & the Black

Santa Clara potters have become famous as innovators. "An individualistic strand" runs through the pueblo, "a vitality," according to Rose Naranjo's daughter, Rina Swentzell. As long ago as the 1930s, for example, Lela and Van Gutierrez modified a polychrome method already in their family. The resulting style made pottery

Lois Gutierrez-de la Cruz, Santa Clara-Pojoaque potter, 1985.

we've got our own too. San Juan's got their own. People may say, 'Well, it's just all pottery.' But it's really not. It's the art that they put in. It's got to have a meaning."

Petra Gutierrez was the matriarch of another "polychrome family." Her daughters are half Santa Clara and half Pojoaque. Minnie Vigil and Lois Gutierrez live at Santa Clara; Thelma Talachy and daughter-in-law Virginia Gutierrez at Pojoaque. Another daughter, Goldenrod Garcia of Santa Clara, does sgraffito pots.

Lois Gutierrez began making pottery with her husband, Derek de la Cruz. Today she signs her pottery alone. Lois and Derek developed a distinctive slip by adding white to dark gold clay to make a buff background color. Lois takes lizards, hummingbirds, and humpbacked flute players and expands them into designs that encircle her large jars like murals.

Derek walks the hills in search of new clays. He says, "If you listen closely enough and pay attention to the earth, it really does speak. It tells you what's what. And you learn from it. But you've got to go out there and listen. It's taken us fifteen years to learn how to mix all our colors."

The hotter the fire, the better those colors. Lois and Derek have learned that the pots come out gray if

Jason Garcia, Santa Clara tile maker, 2006.

by the Gutierrez family unique. Margaret and Luther Gutierrez carried on the work of their parents, and with Luther's granddaughter Stephanie a potter, the style already spans four generations. On a tan background above a red base, they paint detailed designs in pastel colors. The Gutierrezes polish with a rag instead of a stone, giving their pots and whimsical animal figures a silky feel instead of the mirrorlike brilliance of stone polish. They keep their clay sources secret.

Belen and Ernest Tapia worked in the "traditional" polychrome style of Santa Clara. They made polished redware painted with white, buff, blue-gray, and matte red. Ernest said, "San Ildefonso's got their own, and here

the fire isn't hot enough but that a second firing burns off the smoke clouds and brings up the colors. Lois says, "When it fires good, you know that your time and your work has been worth it. There's nothing nicer than firing when it's really cold out and you're standing there drinking a hot cup of coffee and watching. It gives us a little time to ourselves too, when we are out of the house. I think the best part, though, is taking it down and finding that it fired good."

Jason, son of Goldenrod and John Garcia, has taken the Gutierrez family polychrome style into the twenty-first century. Jason studied photography at the University of New Mexico and admires Pablita Velarde's paintings. He uses mineral paints on tiles made from Santa Clara clay to "tell stories of the changing landscape of the pueblo," of what it means to be a young Santa Clara dealing with "violence, drugs, gangs, but still maintaining culture" in a society where "avanyu has become more a commercial property than a community property." Says Jason, "There is that paradigm of traditional work. I've chosen to stay within those boundaries, but I'm not limited by them." His interests range widely: "I'm a student of life, on the path to enlightenment! With art and work and cultural learning, I'm learning something every day."

Jason Garcia's tiles incorporate Catholic arch-

angels, the video game Grand Theft Auto, recognizable Santa Clara pots made by his friends and family, Edward Curtis photographs, self-portraits, feast day dancers, pickup trucks, Santa Clara street signs, and casinos: "I combine humor with family history, with social commentary. But, ironically, I still work for the tribe, and I'm influenced by the physical link to the past I see at Puye Ruins. The tiles are teaching tools. We are moving into the twenty-first century, but with our foot still in Puye."

Another branch of the huge Tafoya family strikes that balance between old and new. Inspired by the work of Popovi and Tony Da, Grace Medicine Flower and her brother Joseph Lonewolf popularized the sgraffito style in the 1970s. They make mostly miniatures in black and red. To create two-tone pots, they sometimes cover a portion of a piece during firing to keep it from turning black, a method called resist firing. Grace says, "When we realized that the younger kids were making two-color pots by burning off the color after firing with an acetylene torch, we thought it wasn't worth it for us to lose so many pots in firing. So now we make just the one color, black or red." Their designs are precisely incised: Mimbres animals (Grace's favorites are butterflies and hummingbirds) and scenes from Tewa mythology and life.

Jason Garcia based this Santa Clara tile on a historic Edward Curtis photo, 2006.

Sgraffito animal designs have spread throughout Santa Clara. Jennifer and Mike Moquino—both from pottery families—favor fish. On request, they have etched pots with bats, spiders, and diving beetles (commissioned by a beetle expert). Jennifer loves fish as a motif and in real life. Her pet largemouth bass lived in an aquarium in her home for four years, providing a living model (until he died, and then the Moquinos mounted him over the fireplace). Jennifer does most of the painting, in a wide array of natural clay colors including hard-to-find greens and blues. Because she must paint her fish after firing and carving, these decorative slips aren't fired, so owners must keep their pots away from water.

Another of Margaret Tafoya's granddaughters, Nancy Youngblood, began her career with miniatures in old-style black and red—tiny swirling melon bowls, for example, intricately carved in perfect proportion to full-size pieces. "I like detail. I love the play of light on the ribs of the melon bowls," she says. "I like a challenge." At the beginning, she would polish a piece and take it down to her grandmother for her approval: "One time, I took a piece down eight times before she said it was ready for firing. I have a polishing stone that I borrowed over and over from her. Finally, she said, 'Keep it.' I proved to her that I was good enough."

Nancy now has a wall covered with ribbons, 294 in the spring of 2006, thirty-three years into her full-time potterymaking. She has moved on from miniatures to larger pieces, but her heart's desire remains a melon bowl with 128 ribs: "When I start a melon bowl, I mark it out on top, halving each section. I've made 64, but with 128, I get them to the carved and cured stage, and then they crack. I know *someday* I will make this piece."

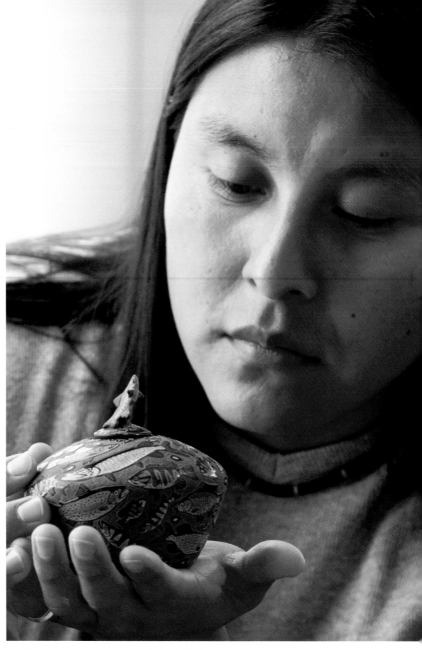

Michael Moquino with one of the lidded sgraffito Santa Clara jars he makes with his wife, Jennifer, 2006.

Rose Naranjo's daughter Jody Folwell created still another innovative style. She makes her pots in the old way but often sculpts them in asymmetrical shapes and uses unusual colors: "Not too far from the traditional pots, but enough so that I could start a different direction." Some of her incised designs are reminiscent of

prehistoric painted designs. Others tell a contemporary story. Jody explains, "I do not think of them really as pottery. I think of them as a piece of artwork that has something to say, statements in life. I think of myself as being a contemporary potter and a traditionalist at the same time. Combining the two is emotional and exciting." Her daughter, Susan Folwell, continues to link the family with innovation, using acrylic paints on her Santa Clara pottery to create challenging contemporary scenes. Jody's niece, Jody Naranjo, also carves contemporary stories on her Santa Clara pots. And the youngest of Rose Naranjo's daughters, Nora Naranjo-Morse, makes elegantly abstract figures.

Surrounded by her many potterymaking relatives in the Naranjo family, Roxanne Swentzell made pottery figures as a child. As an adult, she sculpts extraordinary clay people, usually women, with arresting faces and stylized bodies. Roxanne explains, "I couldn't talk well as a child because of a speech impediment. I use figures as a way of communicating." Her mother, Rina Swentzell, writes: "She is like the Pueblo Clowns that she sculpts and that remind us that our actions and feelings impact the world." Says Roxanne, "My figures are very emotional for me. So connected are they, that whatever I am feeling is what the figure is feeling. In order for the expression to look true on the figures, it must be what I am truly feeling."

Because Santa Clara clay isn't sufficiently firm, Roxanne works with micaceous and commercial clay for larger figures. One of her favorite clays comes from

Jody Folwell tells stories—both abstract and personal—on her carved Santa Clara pottery, 1984.

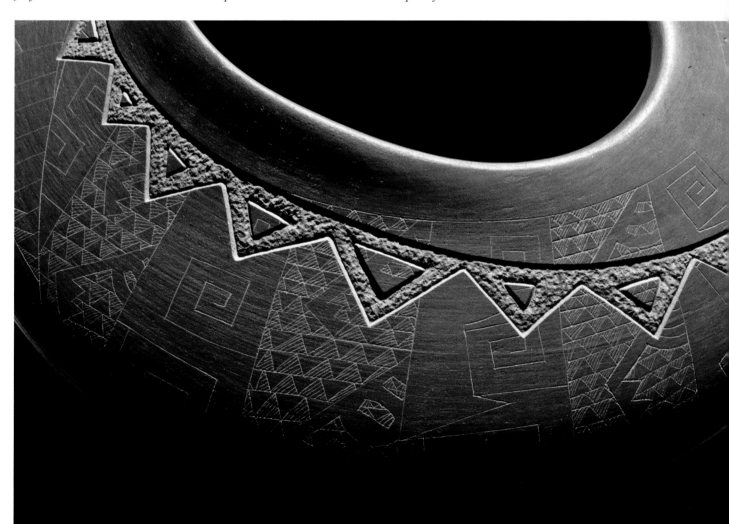

Minnesota. Only the fingers and toes of a figure are solid; the rest of the figure is coiled and hollow. The earthenware clay she prefers requires slow firing in an electric kiln at relatively low temperatures.

Through humor, Roxanne sneaks up on us with big questions (for example, "How do we face death head-on?"). A clown peels off painted stripes "to see what's underneath." A seated woman leans forward to add a coil of clay as she shapes her own leg. Roxanne says, "I make these little people, but in the process, I'm also growing. Because it's like making myself over time." She wants her pots to remind us of our connections to one another and to the earth: "It's a remembering story."

Clay sculptures by Roxanne Swentzell, Santa Clara, 2006. Smithsonian Mask (Original at the National Museum of the American Indian, Washington, DC). Inset: Making Herself (collection of Georgia Loloma).

New and Old Traditions

Ohkay Owingeh (San Juan) Pueblo, north of Santa Clara, has its own traditions. Like the pottery made at Santa Clara, the old Ohkay Owingeh pottery was mostly undecorated red and black. Typical jars were two-tone, polished red above unslipped tan, black above gray when baked in a smothered fire. This banded effect can still be seen in the two most common modern styles.

Modern is a tricky word. The new style is really a very old style. In the 1930s a group of Ohkay Owingeh potters led by Regina Cata sifted through the ancestral sherds and chose Potsuwi'i Incised, made from 1450 to 1500, for a "new" Ohkay Owingeh pottery style. They combined simple patterns of incised lines in unslipped tan on the middle band and a highly polished red rim and base. Micaceous slip, painted in the carved lines, gave them a familiar glitter. Several potters, including Rosita de Herrera, work in this style.

Clarence Cruz feels that he is continuing the jour-ney started by Regina Cata: "I want to bring it back and open the eyes of younger and older people. I want to bring the past to the present." In 2006 he tallied only about a half-dozen fellow potters at Ohkay Owingeh. Clarence lives in Albuquerque, where he is the sole University of New Mexico graduate student in three-dimensional ceramics working with natural materials. He feels that he is "bringing a living knowledge to the realm of education. It's alive." Cruz teaches his own classes in the Fine Arts Department and at Pojoaque Pueblo's Poeh Center.

Mary E. Archuleta, who was raised at Santa Clara but who married into Ohkay Owingeh, makes both Santa Clara–style and Ohkay Owingeh–style pottery. In some pieces, she combines the two, carving her incised lines extra deep to hold the mica or polishing Ohkay Owingeh–tan feathers on one side of a red Santa Clara water-serpent jar. The old Ohkay Owingeh bowls with plain polished red above unslipped, unpolished tan are "quite tricky." Says Mary, "You just have to know

Clarence Cruz, Ohkay Owingeh potter and teacher, 2006.

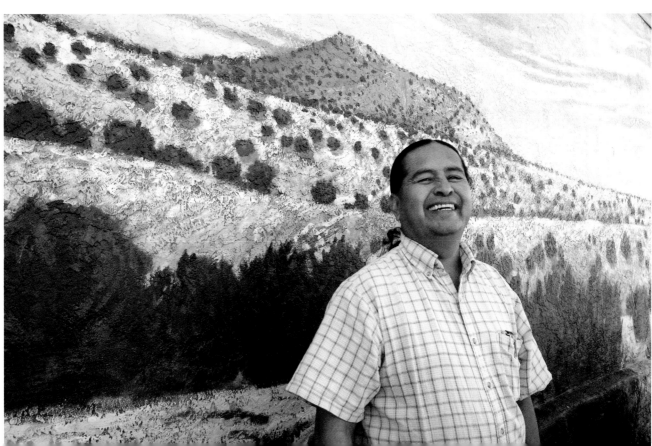

where to put the polishing stone on so it won't stick. You just have to know."

The Currans have perfected the banded Ohkay Owingeh style that fills the unpolished middle ground between the reds with polychrome designs, sometimes with colors outlined by incising or carving. The late Alvin Curran established the family reputation; his wife, Dolores (from Santa Clara), and their daughter, Ursula, continue to make both Ohkay Owingeh– and Santa Clara–style pottery. Carnation and Bill Lockwood also favor this polychrome style. Bill says, "It's work, but it's not real work. We have a real good time with it, and I think it shows in the pieces. It takes a combination of mood, knowledge, and patience."

Carnation makes bowls up to ten inches high without coiling—from a single ball of clay. She and her sister began making pottery after their mother died. When cleaning out her storage shed, they found her tools and said, "Let's make some pottery." Her son Bill sometimes incises designs on the rims of her polychrome pieces. Though Bill took his materials with him to college in Albuquerque, he could not work: "There's something about being home."

Home for Virginia Gutierrez is Pojoaque Pueblo, but she was raised in Nambe. Her aunt was the last working Nambe potter in mid-century, and Virginia learned from her. Influenced by the Gutierrezes of Santa Clara (her husband's family), Virginia developed her own complex polychrome style: "To me, the design is part Nambe and part my own."

"Nambe wasn't originally known for black pottery," says Virginia. "We're known mostly for the micaceous cooking pots, although they have in the past made pottery with designs. So I started into this polychrome, and I've had real good luck with it." Virginia Gutierrez did not polish her pottery. Until Parkinson's disease ended her potterymaking, she took extra time with sanding and smoothing to make sure that her paint went on easily. She maintained, "If you mix your clay the right texture, why, you can do just about anything, any form."

Those micaceous cooking pots Virginia mentioned have come back to life in Nambe through the hands of one potter—Lonnie Vigil. Vigil left his home in Nambe, venturing as far as Washington, DC, where he worked as a financial analyst in the Bureau of Indian Affairs. One night in 1982, at a Kennedy Center performance of *Night of the First Americans,* Lonnie suddenly realized it was time to go home. He quit his job and returned to Nambe. He was thirty-three. As he walked the hills, contemplating his future, the clay drew him.

Lonnie had been around pottery as a boy, but his real learning came directly from Clay Mother: "I knew it in my heart. The gift came through my great-

Ohkay Owingeh jar by Dolores Curran, 2006.

grandmother, but Clay Mother will select someone to take up her work." Unpredictably, that person was the retired financial analyst himself. He rediscovered micaceous clay in the Nambe hills, and his purpose in life became clear: "An exploration of myself, to serve as a guardian of the clay, to keep potterymaking alive in my pueblo, and to share it with the world." Lonnie always uses *we* when talking about potterymaking: "It's not just me, but all of my lineage is there with me, and my community and my brother. And my mother is always there for support."

At first, Lonnie's work included polished red and black pots, along with small micaceous pieces. As the micaceous pots grew larger, with ever-thinner walls (described by some not only as beautiful but also as engineering feats), Vigil joined Christine McHorse in bringing recognition to micaceous pottery as art. That new-found acknowledgment peaked when he won Best of Show at the 2001 Santa Fe Indian Market.

Recently, Pojoaque Pueblo has been generating an artistic energy that belies its small number of members and quiet pottery history. Income from the tribal casino funded the Poeh Cultural Center and Museum, where ongoing potterymaking classes inspire many younger potters. They often come with family backgrounds in clay and move on from there. Melissa Talachy is a prime example.

Lonnie Vigil at home in Nambe Pueblo with his micaceous pottery, 2006.

Melissa grew up with pottery through her family ties to Pojoaque, Santa Clara, and Ohkay Owingeh. Her parents, Joe and Thelma Talachy, are the bedrock of potterymaking at Pojoaque, and Melissa grew up next door to Virginia Gutierrez. She spent summers at Santa Clara with her aunt Goldenrod Garcia's family. As a child, Melissa made little pieces: "It was never forced upon me. I was drawn to making pottery because everybody around me did." As an adult, upon returning with a degree in museum studies from IAIA to work as curator at the Poeh Museum, she learned to make larger pots

Tesuque rain gods span more than a century. Left: Modern figure by Zita Herrera, 1970. Right: Historic figure from about 1907 (photo by Addison Doty).

from Santa Clara potter Shawn Tafoya in a Poeh class. Clarence Cruz introduced her to micaceous clay.

Now, Melissa makes traditional Tewa forms designed with ideas from whatever "surrounds" her at the time. When her husband, Cochiti painter Mateo Romero, was working with airplanes in his canvases, those airplanes made it onto Melissa's pots. The two have collaborated on pieces, made by Melissa and painted by Mateo. When the pueblo negotiated its gaming contract, Melissa began a Casino Series decorated with designs from cards and dice. Her young son, Rain, influenced her Shape Series ("Make a circle, Mama! Make my hands, Mama!"). She prefers outdoor firings because

"the colors are more vibrant." More than making "Pojoaque Pueblo pottery," her goal as a potter is simply to "bring a smile to someone's face."

At Tesuque, some black-on-white pottery is still being made, along with pieces brightly painted after firing, nativity sets, and solid figurines called rain gods. Lorencita Pino sculpts spectacular human faces on the sides of her micaceous ware. Manuel Vigil, with his wife, Vicenta, made exuberant nativities and storytellers, complete with woven clothing and rabbit-fur hair.

Rain gods became a specialty of Tesuque, probably because the pueblo is so near Santa Fe. Tides of tourists swept through Pueblo country, beginning with the arrival of the railroad in 1880 and continuing with the consolidation of the transcontinental highway along Route 66 in the 1930s and the marketing of Southwest Indians by entrepreneurs such as the Fred Harvey Company. Visitors wanted to take home souvenirs or buy curios—exotic curiosities—by mail order, and Pueblo potters obliged.

Working with Santa Fe traders who shipped vast quantities of pottery east by rail, the Tesuque potters standardized their figures. The traders helped make up names and "legends" and encouraged diversity. By the 1890s, micaceous-slipped Tesuque "idols" were marketed as "gods" of everything from fish to love, from choking to bellyaches. Rain gods, seated figures with pots on their laps, gradually took over.

Made by women (except for Manuel Vigil), rain gods became a "traditional art form" at Tesuque, evolving from small figures sold for ninety cents a dozen to cream-slipped "See No Evil, Hear No Evil, Speak No Evil" sets to the "poster paint aesthetic" developed after 1925. Tesuque potter Virgie Bigbee sees poster paint as "an innovation, the first economic development project at the pueblo!" Dismissed as tourist kitsch, Tesuque figures did not fit the mythic notions of "tradition" favored by gallery owners and scholars. Not until 2000 did a micaceous-slipped rain god, by Tesuque potter

Jen Moquino, win an award in figurative pottery at Indian Market.

Though today's galleries do not boast shelves full of Tesuque pottery, this could change at any time. A Tesuque woman or man, after living elsewhere, may come home intent on staying and start potting to make that possible. One potter from among the more than two hundred at Santa Clara may marry into Tesuque: a blast of energy from one determined artist could meld with the old traditions in a new way.

Virgie Bigbee, who does make pottery at Tesuque, uses clay to help her remember: "Clay makes me think about the past and how our ancestors must have been inspired, what they saw, what they've gone through. Clay awakens you."

Potterymaking traditions are strong, even when invisible. They can die away to a memory, to nothing more than broken sherds and a few pots in museum collections, and then come back to life through the art of a single potter. Dora Tse-Pe says, "I didn't know that I could do pottery. I didn't plan to make my living this way. It was just in me. It's a gift, and I'm grateful for it."

Melissa Talachy, Pojoaque, with her pot inspired by an Ohkay Owingeh water jar made by her great-grandmother, Luteria Atencio, who raised her father, Joe Talachy, Poeh Art Center, 2006.

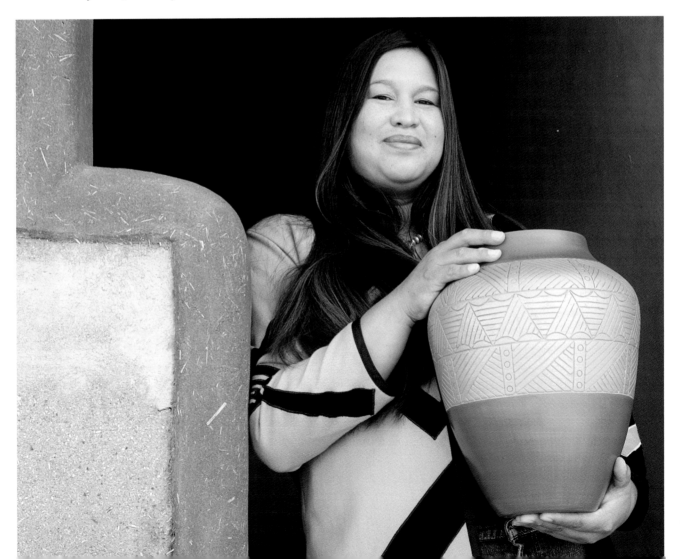

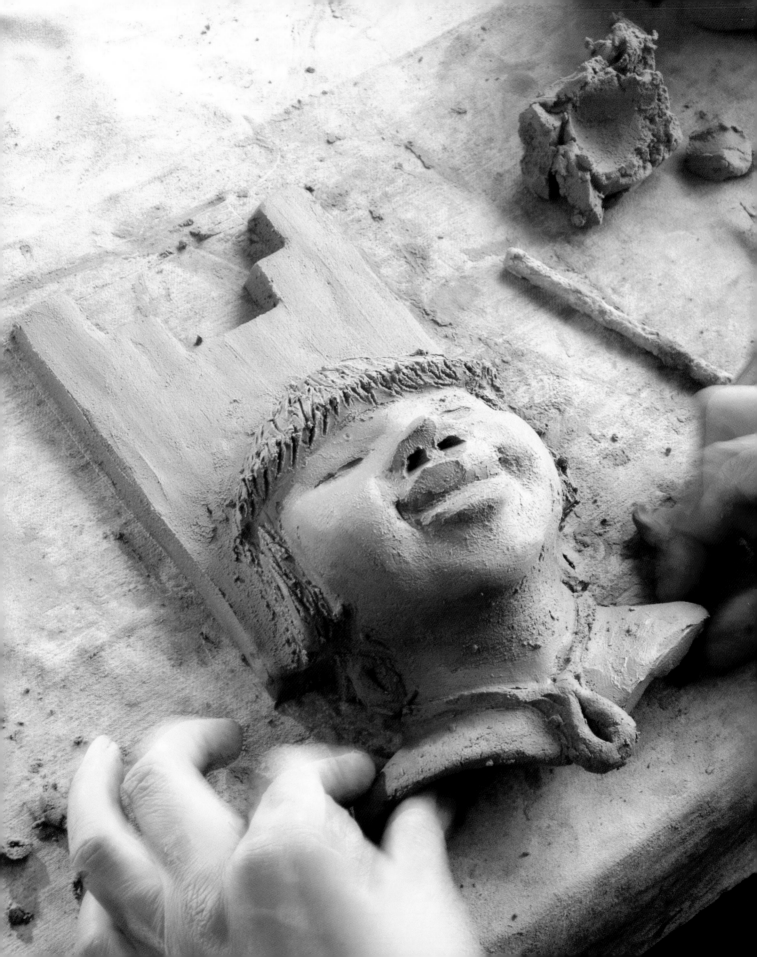

Telling Stories
Middle Rio Grande Pueblos

IN NEW MEXICO, La Bajada divides the Pueblo world in two. Here, some fifteen miles south of Santa Fe, the rim of the high desert plateau that connects the Sangre de Cristo and Jemez mountains drops 1,500 feet to the lower deserts. Rio Arriba, the upper river, gives way to Rio Abajo, the lower river.

North of La Bajada lie Tewa country and the mountain villages of Taos and Picuris. Southward, three Keresan-speaking pueblos stand along the river: first, Cochiti, at the foot of La Bajada, and then the large villages of Santo Domingo and San Felipe. The people of Cochiti and Santo Domingo think of Santa Fe, to the north, as "town," and both pueblos have been strongly influenced by Tewa potters.

Sandia and Isleta, where the language is Tiwa, flank Albuquerque on its north and south, respectively. On the eroding mesas sweeping around the southern Jemez Mountains, tucked in along the Jemez River at the brink of the Colorado Plateau, lie Jemez (the only Towa-speaking pueblo) and two small Keresan villages, Zia and Santa Ana.

The Rio Abajo begins with Cochiti, on the west bank of the Rio Grande. Above the village rise the rough mesas and cliffs of the Pajarito Plateau that shelter the

Facing page: Kathleen Wall working on a clay mask at her studio in Jemez Pueblo, 2006.

pueblo's ancestral homes, ruins preserved in Bandelier National Monument. Cochiti people have been generous in sharing their stories, and from them comes the best-known tale of the first Pueblo potters.

Long ago, Clay Old Woman and Clay Old Man came to visit the Cochitis. Clay Old Woman mixed clay with sand and began to coil a pot while Clay Old Man danced beside her. All the people watched. When the pot was some eighteen inches high, Clay Old Man danced too close and kicked it over. He took the broken pot, rolled the clay in a ball, and gave a piece to each woman in the village, telling them never to forget to make pottery. Ever since, when the Cochitis do not make pottery, Clay Old Woman and Clay Old Man come to the village and dance to remind the people of their gift of clay.

Round-trip from Stories to Storytellers

It is not an easy gift. Mary Trujillo says, "When you do Cochiti pottery, the art is in knowing how to put the slip on and in the firing. You have to have patience." Over the years, that white slip on Cochiti dough bowls acquires a patina. Bowls encountered today are likely to have developed that telltale finish, for few modern Cochiti potters make these functional forms painted

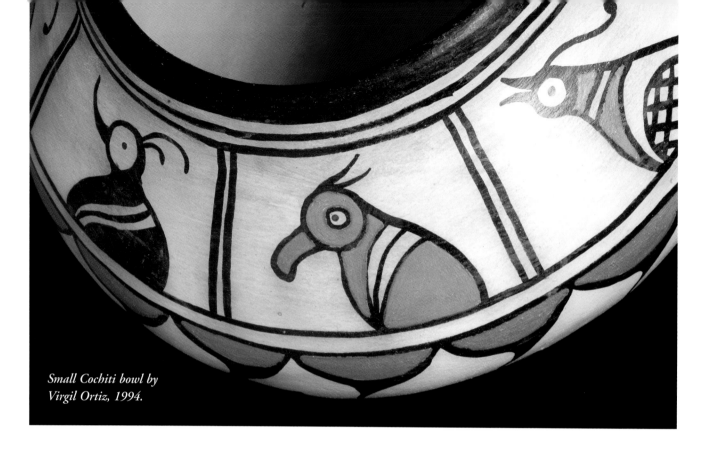

Small Cochiti bowl by Virgil Ortiz, 1994.

with black and red flowers, animals, clouds, lightning, and geometric designs, all on an open ground of white slip. Most Cochitis now create figures.

Prehistoric Pueblo potters occasionally made effigy vessels, fired and unfired figurines, duck canteens, and animal pitchers. Historic Cochiti potters shaped bird pots, with beaks as spouts, and painted a multitude of animal forms on pots. After the railroad came to New Mexico in 1880 and dealers had a ready market for curios, Cochiti potters created figures diverse enough to populate an entire village. These larger standing pieces included cowboys, tourist caricatures, priests, circus acrobats and sideshow performers, dancing bears, and the only female figure, a "singing mother"—a woman holding a child. These remarkable clay people had only a brief heyday. For decades, scholars and dealers dismissed pottery figures as *monos* (Spanish for "monkey," "silly fool," "cute," "mere doll").

A century later, the Cochiti world of clay people has regained its strength and wildly expanded its range,

with potters creating new forms every year. Most famous is the "storyteller." We use the word loosely today, but storytellers have been made only since 1964, when Helen Cordero invented them.

At that time, Helen had been making pottery for just a few years. Juanita Arquero, her husband's cousin, had taught her. In the beginning, Helen tried bowls, but they always "came out crooked." Juanita suggested figures, and for Helen, "it was like a flower blooming," leading to a stream of singing mothers and nativities. The latter numbered up to 250 figures, including cows marked with the Cochiti brand.

Folk art collector Alexander Girard (creator of the remarkable Girard Wing of the Museum of International Folk Art in Santa Fe) sparked the Pueblo figurine revival with enthusiastic purchasing and an influential 1962 museum exhibit of nativities in Santa Fe. When he bought one of Helen Cordero's singing mothers, he asked her to make a larger figure with children. Helen went home and kept thinking about

her grandfather: "That one, he was a really good storyteller, and there were always lots of us grandchildrens around him."

Her first storyteller, sold to Girard in 1964, had five children hanging from a seated grandfather. As many as thirty children perched on her later pieces. Helen's style was distinctive, always with a male figure: "His eyes are closed because he's thinking. His mouth is open because he's singing." Many other Helen Cordero figures followed: a drummer, Navajo storytellers, a turtle "taking children for a ride to learn the old ways," the "Children's Hour," with older kids grouped around the storyteller.

Cochiti potters, followed by potters from other pueblos, took Helen Cordero's lead, beginning an exuberant revival of figurative pottery. They have mixed their personalities with their clay more than in any other form of pottery, creating scenes from daily life, telling stories with humor, and painting the faces of their favorite people. At Cochiti, Seferina Ortiz makes lizard, frog, and owl storytellers; Martha Arquero makes kangaroo storytellers; and Dorothy Herrera makes cat, pony, and teddy bear storytellers. Both Tony Dallas (a Hopi-Pima married into Cochiti) and Tim Cordero (part Hopi) make mudhead clown storytellers. The possibilities are as varied as the potters' personal histories.

Mary Trujillo—daughter of Leonidas Tapia, one of the great Ohkay Owingeh potters—is married to Helen Cordero's adopted son. For many years, Mary worked as a counselor at the Institute of American Indian Arts (IAIA) in Santa Fe. When she moved to Cochiti in 1978, Ada Suina taught her to make storytellers.

Mary, too, takes inspiration from her grandfather for the faces of her storytellers. She has hung a drawing of him prominently on her wall: "When I do storytellers with braids like him, there really is something special about it." She says that her first storyteller "looked like Heckle and Jeckle." But from the beginning, they sold, "and that encourages you." Mary Trujillo's favorite time with her storytellers comes "as they cool after the firing and they are laying down on the grate with their little feet in the air."

"Everything that I do, I pray that it comes out right. I pray to my mother, I pray to Maria, to help me have their gift," says Mary. Working with the delicate white slip, she needs their blessing. Cochiti figures can be modeled from white or red clay, but red clay requires ten to fifteen coats of white. The slip goes on after the pot has been warmed in the oven. With each layer, the potter uses a clean, white rag to polish the chalky film.

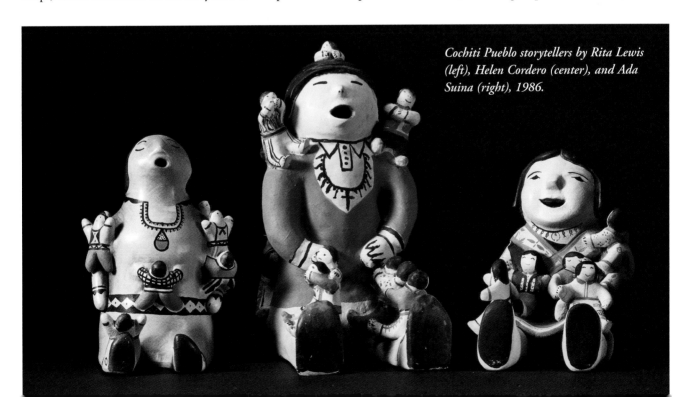

Cochiti Pueblo storytellers by Rita Lewis (left), Helen Cordero (center), and Ada Suina (right), 1986.

Mermaids & Dinosaurs, Tattoos & Piercings

Says Ada Suina, "Once you start a phase or style, it seems to stay the same. I can't change my faces. They just come." Ivan and Rita Lewis felt the same will in their clay: "We just start building, and something comes out." Both came from pottery families: Rita was from Cochiti, and Ivan is the son of Acoma potter Lucy Lewis. At first, Ivan helped Rita part-time, but she kept saying to him, "All your sisters and brothers are potters. You ought to be." When he retired, he began making his own pieces. Rita, who died in 1990, did the fine painting.

Ivan has revived some of the historic-era cowboys and caricatures: "The old ones just give you an idea. You can't really copy. It always develops and comes out your own way." He also makes mermaids: "Cochiti mermaids? Sure, they live up in Cochiti Lake!"

That same fierce Pueblo humor quickens the work

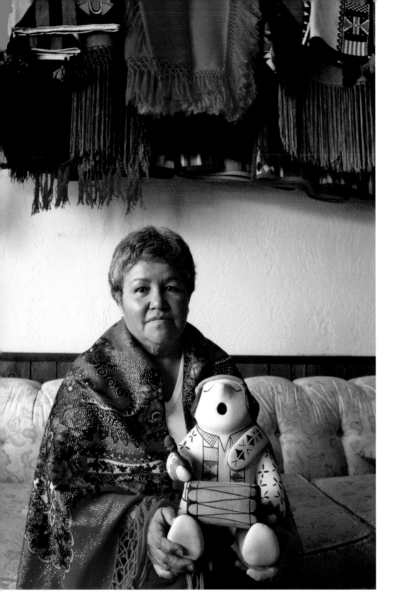

Above: Mary Trujillo and her Cochiti drummer, 1986. Right: Ivan Lewis of Cochiti and pottery he made with his wife, Rita, 1986.

Then, back in the oven it goes. Oily fingerprints on the slip appear only after firing. If a fly lands on the slip, only the firing will reveal the flaw.

Mary's teacher, Ada Suina, says that it takes "coats and coats" to slip the pieces properly: "I never even count." One piece takes a half day of sitting in front of her kitchen stove, set at 350 degrees. Earlier potters used woodstoves, and in the old days, Ada says, Cochitis slipped their pottery only in summer, using a washtub to create a makeshift oven heated by the New Mexico sun.

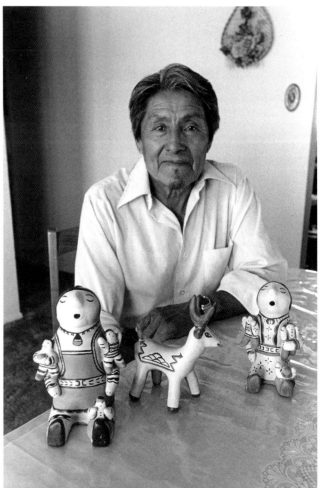

of Virgil Ortiz. He came from a family of potters, Ortizes and Herreras: "I'm so thankful I was born a Cochiti Pueblo pottery person." He has since become a phenomenon, a "brand name," an "intermedia innovator," "a walking piece of performance art," as his website describes him. Virgil began making clay figures before he knew about nineteenth-century figurines: "That old style was just flowing through me." As he learned more, he realized, "I'm not an innovator. I'm just reawakening the figurative commentary. My whole purpose is to see pottery go on, like a language."

Virgil's figures grow from traditional materials but explore modern culture. Tattoos and piercings embolden his pottery people. A priest figure has a saintly smile but bondage lacings in the back of his cassock—a comment on the revelations of sexual abuse within the church. Virgil's untitled figures are both beautiful and unsettling: "Priests broke the old standing figures, calling them false idols. They really weren't. My job is to give them their voice back, to reincarnate them."

Virgil speaks softly but, as an artist not yet forty, moves quickly: "The stuff that I did ten years ago is already becoming traditional now." When he began translating his striking pottery designs into leather coats and handbags, his high-end fashion caught the eye of designer Donna Karan. She sought out Virgil at Indian Market and asked him to collaborate on a DKNY line for the fashionistas. Now, Virgil commutes to New York, Beverly Hills, and Paris, but his roots remain deep in the dust of the Cochiti plaza. The jet-setting influences the pottery: "I go to a club and see a club kid and make a piece to immortalize that person." He comes home,

Cochiti figure by Virgil Ortiz, 2003.

working all night on pottery to "heal all the crazy stuff" he sees outside the pueblo.

Ortiz's commitment to his people burns as brightly as his creativity and humor. He loves tattoos but has none, because if he did, the Cochiti elders would not allow him to continue dancing in ceremonies. He plans to take on apprentices each year in his four-thousand-square-foot studio at Cochiti, showing them how "something traditional can be fun" and speaking his native language to teach pottery arts. Virgil wants to hire animators to create a superhero video game from his pottery figures to teach kids the Keres language: "I'll use my resources to open the doors to any art. I just want to give them that backbone of experience, teach them how to manage yourself as an artist, to let loose their creativity. I want the kids to know they are special, they are still tied to the community."

Virgil's family taught him to treat pottery as "traditional and sacred," not to profit too much from the work. So Virgil plays with his fashion money but invests his pottery money at home through the Ortiz Lighthouse Foundation: "There's nothing more important to me than the pueblo. It's not about one person. It's about everybody. I had *good* parents."

Ortiz revels in the success of his family. "Clay is always open to everybody," he says. His older sister, Janice, makes figures that rival his own. He is especially proud of his niece, Lisa Holt, and her husband, Harlan Reano. Lisa does the molding, and Harlan (from Santo Domingo) the painting. The young couple started with frogs and lizards, then bowls, then the bigger standing figures. Living in Albuquerque,

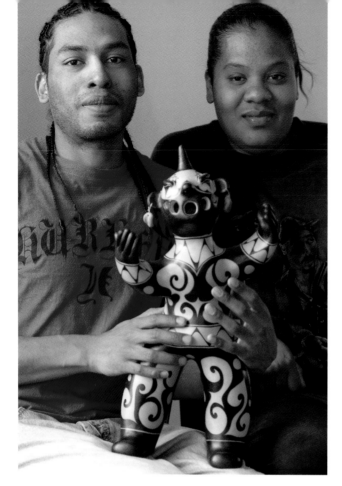

Harlan Reano (Santo Domingo) and Lisa Holt (Cochiti) with their prize-winning circus figure, 2006.

they take the big figures back to Cochiti for painting and firing, to the home of Lisa's grandmother Seferina Ortiz. Harlan says that "bowls are easy to paint—they are round all the way around! With the figures, you've got to paint the back, even if no one is ever going to see them." They don't name their figures ("We just call them circus figures"), allowing each one to tell its own story.

Cochiti potter Louis Naranjo, too, made modern versions of the historic tourist caricatures, as well as his own mermaids. He got his ideas on trips to Santa Fe, "seeing a little boy with his baseball cap to one side eating an ice cream cone, bikini ladies, a girl with a camera." He made an old padre ("a regular priest like you

see in the history books"). One of his Indian wedding sets included a pregnant bride and a chagrined groom.

Louis was best known for his bear storytellers: "When I was hunting deer in the mountains, I saw a bear down in the valley with two cubs climbing all over her. I started my bear figures after that—with one cub. Now, I'm up to twenty.… I love my bears. I really do. They're just like my grandkids to me. You have to put all your heart to it."

Louis's wife, Virginia, has carried on since his death. Besides bear storytellers, she makes snakes, kangaroos, giraffes, dinosaurs, and jackalopes (the fanciful western jackrabbits with antlers). When Virginia fired some elephants, she was pleased that "they fired gray, just like real elephants."

Cochiti Dam brought difficulties (as well as mermaids) to the village's potters. The massive construction project destroyed their primary sources of gray clay and white slip. They now use mostly red clay, which requires many more layers of slip to be covered, and their white slip comes from a single, dwindling supply at Santo Domingo.

These sources of materials at other pueblos are crucial. "Tewa red," the slip that makes both red and black Tewa pottery, comes from a roadside pit at La Bajada on Santo Domingo land—the same clay that some Santo Domingos use as red paint in their polychrome. In turn, Cochiti and Santo Domingo potters learned to use vegetal guaco paint from the Tewas. Pueblos to the south and west traditionally use mineral-based black, with bee weed for binder (if they use guaco at all).

No matter what crisis in sources may come, the Cochitis' energy and humor seem boundless, and the clay people respond in kind. Mary Trujillo says, "I talk or look at my drummer every day. I tell friends, 'Listen to him and he'll sing for you.'" Helen Cordero summed up the spirit of the figures: "They come from my heart, and they're singing. Can't you hear them?"

The Chongo Brother

Those Cochiti hearts just keep singing, and as with all songs, each singer's interpretation keeps evolving. Today's Cochiti potters epitomize the currents of influence affecting every twenty-first-century Indian artist.

Take Diego Romero, whose pottery tells stories from his childhood experiences in Cochiti and California. He spent his early years hanging out in Berkeley comic book stores. When living with his father's family at Cochiti, he absorbed Pueblo culture. Drawing and potterymaking always were part of Diego's life. Later, he learned from a series of mentors: clay sculpture from Hopi teacher Otellie Loloma at IAIA, high-art ceramics from Adrian Saxe at UCLA, and the business of art from Santa Fe gallery owner Elaine Horwitch.

Diego started with ceramic coyotes. After years of success, he rediscovered Mimbres pots. Pueblo pottery, he says, "has always been a narrative. It's a way of interpreting the world around you. Then, it was an interpretation of an agricultural society. Now, we're in the narrative of our time. The world around us has enveloped us and consumed us. Your kids go to public

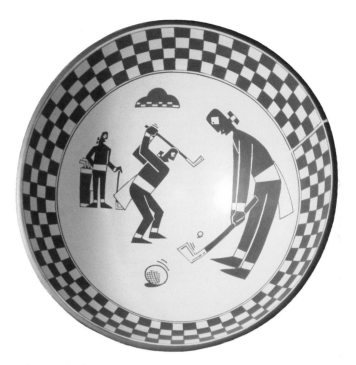

Above and below: Diego Romero's Cochiti bowls retell Mimbres narratives for the twenty-first century, 2006.

school, and BOOM! The walls of Pueblo culture have been breached."

To update the Mimbres hero twins with their shields, he put machine guns in their hands and painted them inside his bowls: "It all came together in this beautiful salad of biculturalism and intellectualism."

Diego paints three narratives on his bowls: "the stories of my people, the stories of my life, the story of us as a society." First came the "escapades of these two brothers that wind their way through Indian Country, to bars, powwows, and art shows—the Chongo Brothers. They're just two alcoholic bros that fight and love and hate and live life." Diego emphasizes that the "bros" are not equivalent to him and to his painter brother, Mateo: "There are elements in them that are very much us, but they are also my cousins and my uncles. They're metaphors for the disenfranchised.

"Then there is this brutal historical narrative of colonialism. You open any American history book and it talks about Christopher Columbus discovering America,

George Washington crossing the Delaware, the Battle of Gettysburg. But you don't find any references to the Pueblo Revolt, the martyrdom of Spanish priests, all these beautiful histories, untold histories. I went with Greek figures for these, to elevate the heroes to superheroes. It's one of my true loves, the prehistoric pottery from Greece, the narratives with Hercules and Odysseus and Agamemnon.

"I'm just glad I get to narrate these stories. I made a conscious decision to stay away from iconic or religious content. I don't portray sacred imagery."

Diego's love for his art and his culture keeps him going: "There will always be traditional Indian craft, and there will be people who want to take it farther. We made it possible for other Pueblo potters to have

an artistic freedom that barely existed twenty years ago. I'm just grateful for it. I'm one of a handful of people that I know who get to do exactly what they want to do in life."

Diego switched to porcelain for two years, when he lived in Oklahoma and couldn't get traditional clay. He came to appreciate the "high white bone polish" he could achieve. Now, he uses commercial clay for small pots, native clay for larger pots, and "traditional slip polishing and burnishing and mineral paint."

He draws constantly: "Even the drawings on the pots are like black-and-white woodcuts." Diego paints his designs by sketching them on paper and photocopying his original: "Then I cut it out like a paper doll and place it on the pot and draw around it with a pencil. I stencil it, paint it, and fire it." He loves the high-fired vitrification of the clay he can achieve in a 1,500-degree kiln: "You can drop it in the bathtub or the ocean. And I want them to last, to be around hundreds of years from now."

But he says, "No matter how far I've pushed with the porcelain and the cobalt and the Chinese style, it's still distinctly Indian pottery. Through undergrad and grad school, when we'd have our critiques, people would say Indian art was a craft and I was using it as a crutch. These negative views toward Indian art made me stronger and firmer in the belief that my art was Indian art and that's what it was about and it was going to stay that way."

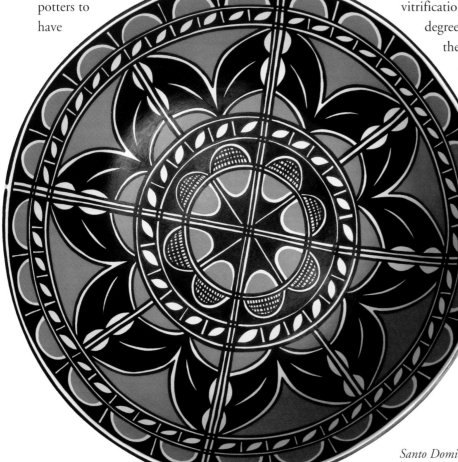

Santo Domingo dough bowl by Thomas Tenorio, 2006.

recent styles are subtle variations on formal traditions. "Negative painting" covers the pot in such big, bold swatches of black and red that only a few lines of the cream-slipped pot show through. Other Santo Domingo pots are freer, with birds and flowers, but rarely with mammals and never with humans. Unlike neighboring Cochiti, Santo Domingo religious leaders forbid representations of human figures and other sacred designs on pottery made for sale.

Santo Domingo birds are distinctive. Robert Tenorio says, "The Santo Domingo bird is usually in a still life, with maybe the tails painted with designs, or the breast area, whereas the Zia one is usually in action, in flight or jumping. And at Zia, their bodies are more likely solid colors rather than designed."

Santo Domingo pots continue to be used. On feast days, women crisscross the village carrying steaming bowls of food to the kivas. Even the pottery for sale has an air of usefulness—stew bowls and dough bowls, full-size water jars, and solid-looking storage jars. Says Robert Tenorio, "Most of my bowls are down at home. To see my things still being used in the village—'There goes a Tenorio pot or bowl'—it's really great. It's something that will be around for a long time, just like all the prehistoric potteries."

Firing was the hardest traditional technique for Robert to learn: "I'm to a point now where I know how to control the heat. The only opening I leave is from the top, where I will peek in to see what's happening. It's when it's red-hot down there that you know it's done. And then, when it cools back down, you will see the nice white and the black in there."

Robert's main concern is finding enough white slip: "It's the only thing that turns our spinach juice black." A new owner of the slip source noted the gaping hole left by potters quarrying the precious clay. Perceiving only a hazard, with no awareness of its importance, he blew it up to close the opening and protect himself from liability.

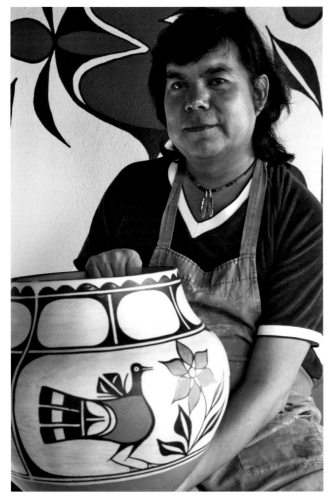

Robert Tenorio on his porch at his home in Santo Domingo, 1986.

Santo Domingo the Bold

Just a few miles south of Cochiti lies Santo Domingo, with its two pottery-producing extended families—the Melchors and the Tenorios. *Conservative* is the word most often linked with this pueblo, and its designs are often described as "simple geometrics." Simple perhaps, but these abstractions are also bold.

Frank Harlow and other pottery historians note that longevity of pottery styles reinforces Santo Domingo conservatism. Some popular modern designs have changed little since the 1700s. Even the more

Robert found one new clay source with "the same feel as the white, but when it fires, it turns yellowish or red." He has nearly decided to talk to a geologist:

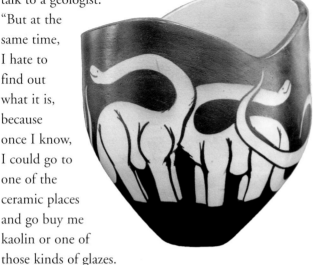

"But at the same time, I hate to find out what it is, because once I know, I could go to one of the ceramic places and go buy me kaolin or one of those kinds of glazes. It might be one of them."

When Robert's nephew, William Andrew Pacheco, was young, pottery was a family activity: "Every kid wants to play in mud and burn things!" Robert encouraged ten-year-old Will to paint what he liked. Says Will, "I liked dinosaurs, so I started and never quit." Pacheco's dinosaur pots don't tread on sacred Santo Domingo territory: "Dinosaurs transcend the culture." The elders had no need to prohibit depictions of these ancient animals. This frees Will to continue experimenting with clay and shape and design: "It's within the Santo Domingo tradition to do bold and big designs. And dinosaurs are bold and big!" He has gone on to create "more sculptural shapes. One buyer describes the pots as sensual."

The continuing connection with cooking and food that ties Santo Domingo pottery to daily life also stokes its sensuality. Ambrose Atencio's huge, round-bottomed bread bowls share that connection. It's easy to imagine the grandmothers kneading dough in his finely made pots, though a collector would hesitate to plunk them in the dish drainer! Atencio began potterymaking as a teenager. One afternoon, he was watching Robert Tenorio and Arthur and Hilda Coriz work, and Robert's mother said to him, "Don't just sit there. Get to work!" A few years later, Ambrose became a full-time potter.

Ambrose believes in the power of tradition at Santo Domingo. Accustomed to the natural paints, he remains acutely aware of how the slip absorbs the paint: "Once you put it down, it's there. When you make a mistake, you have to use your common sense, your brains. You have to put another design on. Sometimes it comes out much better. I tell people who are buying the pot, and they get all excited." It's that *story* again.

Thomas Tenorio stands as an anomaly, a com-

Left: Dinosaur pot by William Andrew Pacheco, Santo Domingo, 2006. Below: Ambrose Atencio with his Santo Domingo dough bowl, 2006.

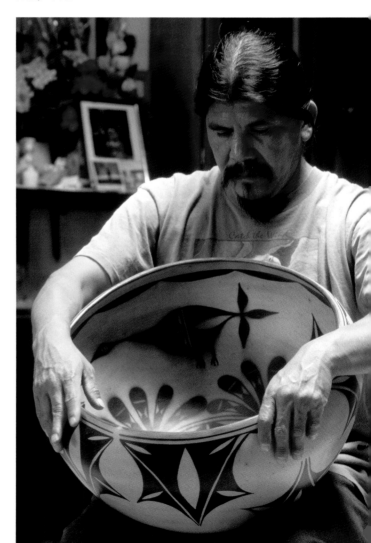

Hubert Candelario making a "swirl pot," San Felipe, 2006.

pletely self-taught Santo Domingo potter: "I used to sit with my grandma selling her pots under the portal in Santa Fe when I was a kid. I never imagined I'd become a potter." As a student in Farmington, New Mexico, Thomas did a research paper on pottery. He went on to discover everything on his own. He traded a case of beer so that a girl who had learned from her grandmother would show him the source of the white sand he needed for temper. To learn the Santo Domingo designs, he used Kenneth Chapman's 1953 book, given to him by an archaeologist after Thomas couldn't find the out-of-print classic. He laughs about his early pottery: "You could have used it as a doorstop or shot put!"

Tenorio follows his nose, "by trial and error and praying," assembling techniques and materials that work for him. He prefers a "more stable" clay from the Manzano Mountains to Santo Domingo clay. He uses a ceramic sealer to give his pots an extra shine. He uses a kiln most of the time and charges extra if an order for a traditional firing comes in. After failing twenty times ("Anything thin and flat is going to warp"), he developed a method of drying that enables him to make large plates: "I'm not telling anybody my trick. This one is mine!" Tenorio loves to create: "Everything I use is from the earth. Traditional, to me, is the clay. Once you fire it in a kiln, it becomes contemporary."

This self-taught, contemporary artist has become the primary teacher of traditional pottery at the pueblo. In the late 1990s he taught classes for two summers. When government money evaporated, his students, teenagers to elders, pooled their funds and begged him to continue. Once more, Thomas said yes, beginning another of his crash courses in pottery: "I didn't want it to die."

Tenorio attributes his success to participating in ceremonial life: "I get that positive energy, and then when I come back to Albuquerque and work, it's there."

For the Joy of It

South of Santo Domingo along the slow-moving Rio Grande, San Felipe people make few painted vessels, and Sandia Pueblo people, even fewer. Lying between them, Santa Ana has a long pottery tradition and a small cadre of active potters.

Hubert Candelario is one of only two or three people who can print "Potter, San Felipe Pueblo" on their business cards. When he started twenty years ago, selling to galleries was difficult: "They didn't have a 'type' of San Felipe pottery. They would ask, 'Who taught you?' and 'What family are you from?'" Eventually, the pottery world came around. Hubert says, "It's Hubert Candelario pottery, not really San Felipe pottery," yet his work has the connection to land and culture that defines Pueblo pottery.

Hubert was inspired by a video of Maria Martinez, which he watched again and again. He looked for clay in the hills and worked completely on his own, beginning

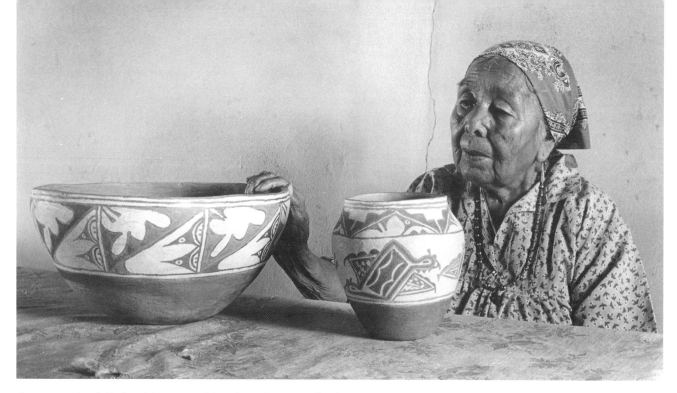

Pottery matriarch Eudora Montoya with her classic Santa Ana bowls, 1986.

with painted, red-slipped "eye dazzlers." Then he took a class from potter and teacher Felipe Ortega and fell in love with "elegant" micaceous clay. Now, Hubert works with red clay for the body and trades with Felipe for micaceous slip "from up north" in Jicarilla Apache country. He loves the "orange glow" the kiln gives his pottery, and galleries snatch up his distinctive work.

Hubert's "swirl pots" are melon bowls alive with "pinched and pulled ribs." A black line winds across the micaceous glitter of his "evolution pot," just as "someone's path of life starts from the ground and meanders and curves." He explains, "When they die, they connect. A person's life holds the world together. The pot is about myself evolving in my life." With training in drafting and architecture, Hubert "loves structure." He has been playing with circles and hexagons perforating his pots, wondering whether they will hold together: these "holey pots" are "hard to work with," but "there's nothing that really holds you back."

Santa Ana potters have the reassuring choice of cleaving to tradition. Most Santa Anas live near their farms on the Rio Grande just north of Bernalillo. The venerable pueblo sits quietly on the Jemez River, cared for but used mainly for ceremonies. Eudora Montoya single-handedly kept Santa Ana pottery alive for much of the twentieth century, until she began teaching classes to other Santa Ana women in 1973. A small co-op run for many years by Eudora's former student Clara Paquin still sells Santa Ana pottery and crafts.

Eudora and her sisters, whom she survived by fifty years, began making pottery when their mother died. Eudora's bowls and water jars maintained the old Santa Ana ways that have distinguished its pottery since 1800: gray and red clay, a temper of river sand, black paint, and considerable use of red on a chalky white slip. Eudora's husband became blind. "I work hard because he can't see," she said. "To make it good," a large and challenging water jar took three days to design. "I like to smell those water jars when you put the water in and pour it out," Eudora smiled. "The jar smells good, like

rainwater." She used the old designs: clouds, a hooked arc surrounding a circle (which she called turkey eyes). "When I look at the clouds in the sky, it seems to me there's a design on them," she said.

Eudora Montoya's role as teacher was carried on in the 1990s by Elveria Montoya (not related to Eudora), who taught a whole new group in the tribal education program. When Elveria's eyes began to fail, her daughter-in-law, Lucille Montoya (a Jemez woman married into Santa Ana), took over. One innovation has been the switch to volcanic ash as temper, which is easier to work with than river sand. In 2001 the classes acquired their own small building, now known as the Pottery House.

Elveria's granddaughter Annette Raton is a typical participant. In her forties and one of the youngest active potters at Santa Ana, Annette uses traditional techniques to create her work. She dreams of designs, and she has made ceremonial pieces for relatives. Raton had a pot

in the 2005 Pottery of Santa Ana Pueblo exhibit at the New Mexico Museum of Indian Art and Culture. For writing assignments in her business and psychology classes at the University of New Mexico, she nearly always wrote about pottery: "The *feeling* is there. I know that." She's given away the last few pots she has made. "I make it because I like to make it."

Laura Peña shares the same love of potterymaking: "Money is definitely not the driving thing for me. I love to do it so much that I work every day after my office work. I can't wait for the weekend. It's my relaxation." Laura learned the basics from her family. She learned refinements by trial and error, from pottery classes at IAIA, and from her classmate, Santo Domingo potter Robert Tenorio. She would love to make a living from her work.

Laura has found her own sources: "Clay just pops out at me. The community prefers the red clay. I prefer to use gray clay. It's not as rich." She uses "floating rocks" (volcanic pumice) for temper: "My grandmother said that's what makes the pot waterproof." An environmental educator by profession, she also teaches classes to tourists who come to the Hyatt Tamaya Resort at Santa Ana: "I have a love for teaching. My class is just a short entrance into pottery. The most important thing I want students to take away is an appreciation that it's not that easy."

Laura thought that she was doing unique designs: "But when I went to the School of American Research for the first time, I said, 'Oh my gosh, these look like some of the pieces I'm doing.' I always try to connect with how the Santa Ana potters felt. They had to enjoy creating too. Every time I go into a museum with pottery from our past, I get this tingle from the top of my head to the bottom of my toes. I feel the spirits of the past."

Laura Peña, Santa Ana potter and teacher, 2006.

Zia: Prayers in Pots

Basalt dominates both the small village of Zia and its pottery. Zia Pueblo sits on a basalt-capped mesa on the north bank of the Jemez River, commanding a fine view southeast to the Sandia Mountains. North looms the blue summit of the Jemez Mountains. A bridge did not reach the village until 1939. Zia potters responded to this new connection with the world by making smaller pots strictly for sale, in addition to full-scale, utilitarian water jars and serving bowls.

Zia pots are the only modern Pueblo pottery tempered with basalt. Elizabeth Medina says that the key to working with the hard volcanic rock is to use as much temper as possible when mixing the clay, more than half the mixture. That way, the pots will not pop in firing. Elizabeth sometimes buries basalt in sand for a full year to soften it before grinding. Her Zia pots are tough. When Marcellus Medina tried to drill holes in Elizabeth's pots, he had to use diamond-tipped bits.

"Rocks take all your strength. You have to crush it, step by step," says Zia potter Eusebia Shije. "I think Zia potteries are the hardest pots. I use the grinding stone—coarse, medium, on down." Ruby Panana says, "You get big muscles from all that work!"

When Eusebia first began making pottery, she did not use enough rock, and her pots kept "popping just like a popcorn" in firings. Eventually, she mastered the clay, but then the white slip was a problem: "My mom was always on the white, and I wanted to do that." Finally, she learned how to apply the white slip carefully and settled in to potterymaking: "I'm always with the clay. That's my income."

Zia has always had fine pottery but poor agricultural land, a situation reversed at pueblos such as Jemez and San Felipe, and one that invited trade—food for pots. The efforts of remarkably few people made this system work. Zia pottery scholar Michael Hering calculated that in the late nineteenth century, one of the most creatively impressive times at Zia, no more than twenty-five women (a majority of the village) could have been making pottery. The pots these women traded for food saved the pueblo from famine in the early 1900s.

Zia pottery is stone-polished and painted with black pigment (without bee weed binder) made from manganese-rich iron concretions that weather from the sandstone cliffs. Zia potters have used the same red, white, and black pigments since the seventeenth century. The Zia bird is their design hallmark. The New Mexico state symbol, a stylized sun, comes from an old Zia ceremonial pot.

Designs include abstract feathers and feathered prayer sticks, birds, vegetation, clouds, spiderwebs (to catch moisture), lightning, and the curves of drumsticks

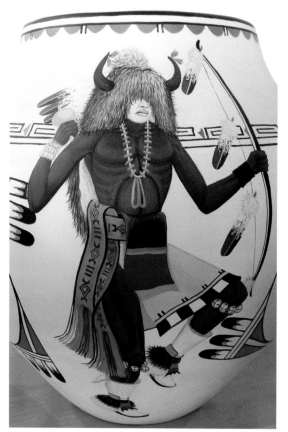

Zia pot by Elizabeth Medina, with a buffalo dancer painted in acrylics (after firing) by her husband, Marcellus Medina, 2006.

that make the sound of thunder. Marcellus Medina says that "many of the older pots have things hidden in the designs, shapes in the spaces between the painted colors that form clan symbols. They were trying to make things hard for the archaeologists!"

Zia potters identify their bird as a roadrunner, sacred symbol of speed, bearer of prayers—the bird that long ago saved the Zias from a drought. Pennsylvania Dutch or Jewish Moravian traders may have introduced the Zia bird design about 1850.

In making an everyday jar to hold water and nourishing foods, the potter creates a prayer for rain—a prayer manifested in clay. The preceding third world of existence forms the red base; the white fourth world (where we live now) forms the upper body. Each design element resonates with the symbolism of rain and new life. The pivotal spot is held by the bird messenger, swiftly carrying to the skies the people's prayer for rain. A red rainbow arcs across the pot, unifying its design and fulfilling its prayers.

Marcellus Medina says, "We have to maintain our culture in this way, but we can't live in the past. In order for an artist to succeed in this modern world, you have to change with the times. One side pulls each way. We can't choose. We live in both worlds."

Marcellus's wife, Elizabeth, makes Zia pottery painted with traditional designs on a beige slip, the family trademark. Carrying on a style created in the 1960s by his parents, Sofia and Rafael Medina, Marcellus also works with Elizabeth in a unique contemporary style. He uses her fired, unpainted traditional pots as a ground for highly detailed paintings of Indian dancers. At first, he used acrylic paints on dramatic white and black backgrounds. Now, he paints his figures with natural clay slips. Marcellus's paintings look much like framed works of art, but they have been painted on hand-coiled, ground-fired clay. "This is my way of showing that it is all right to change," he says. "It is good to change. These are the pots of the future."

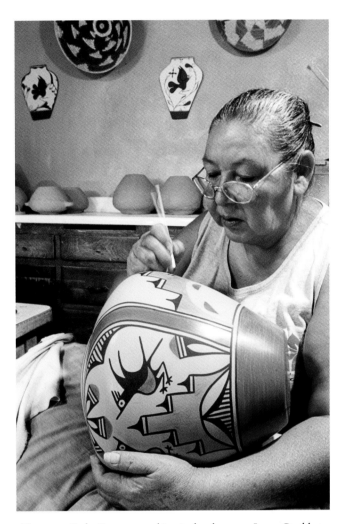

Zia potter Ruby Panana working in her home at Jemez Pueblo, 2006.

His wife might disagree. Elizabeth carries on the Zia tradition of water jars with classic designs. The Medina family—Marcellus and Elizabeth and their children, especially Kimberly—are the most active pottery family at Zia.

Pitting problems discourage some Zia potters. They believe that the tempering rock is to blame, but the clay can contain limestone or selenite inclusions that expand months after firing and spall off, leaving a surface pit. Spalling can be found on Zia pottery dating back to 1700. This is no consolation to Eusebia Shije,

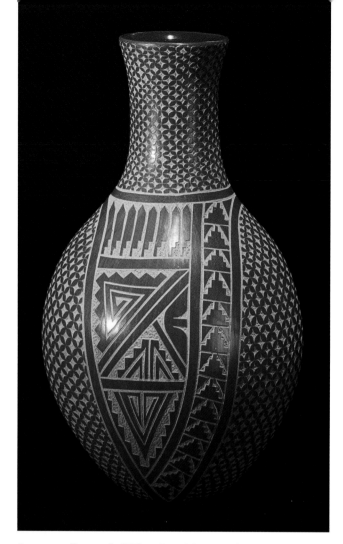

Jemez sgraffito pot by Wilma Baca-Tosa, 2006.

cleaner clay that doesn't have the crystals." Ruby lives at Jemez Pueblo, where she is allowed to "pick" basalt. She believes that this temper works better than basalt collected at a Zia source "just pitting off the mountain."

Ruby makes large water-storage jars, pottery with lids, ladles, and wedding vases: "I try to see which way I can stretch the clay. It's really strong." She uses a kiln most of the time. In fact, she has taught "just about everybody in Zia how to use a kiln." She saves precious sheep manure for native firings before Indian Market and "prays it doesn't rain!" With either firing technique, "it's a traditional pot. You are using the same old clays, paints, and designs."

Today Zia potterymaking rests in the hands of a small number of artists. Ruby Panana says, "For a while, there were only four or five women." So Ruby has been teaching younger people: "It's a pleasure to teach somebody to carry on the tradition." With the power of their prayers in the pots, the speed of the roadrunners, and centuries of continuity with their past, Zia potters surely will carry their legacy beyond this new century.

Jemez: The Problems & Privileges of Freedom

Jemez Pueblo abandoned its traditional styles after the Pueblo Rebellion. During this period of dislocation and turmoil, Jemez provided refuge for people from all over Pueblo country. For centuries, Jemez potters had painted fine-line, black-on-white designs, but after 1700 no one made such pots at the pueblo. Potters actively rejected certain prerevolt styles associated with Spanish oppression.

For years, Jemez people traded with Zia, exchanging crops from their fertile fields in the Jemez Valley for most of the decorated pottery they needed. They made their own plain cooking vessels. With the creation of a commercial market for pottery in the twentieth century, the Jemez people found that they had no living tradition

who has tried many years "to make a good pot." She worries, "I don't want people to come back and say, 'Mrs. Shije, you didn't make a good pot.'"

Eusebia says, "I really love making potteries, but when something goes wrong when I need money for my children, it's just depressing. I had a whole box of potteries that pitted, and I'll resoak those for a bowl for my own use. I take my time to be a good potter. Why should I have to quit? I hate to let my skill go."

Larger crystals can be picked out. If potters grind the small crystals fine enough, they no longer cause problems. Zia potter Ruby Panana and her sister solved their pitting problems by using a different pit of "much

to draw on. Individual potters began to experiment with a multitude of styles. One woman used melted pine pitch to make her designs resemble the glaze paints used centuries ago. Another used guaco paint on unslipped pots. Others made pots in the traditional way but, after firing, painted them with poster paint or acrylics. Such experiments arise from the absence of a continuous design tradition, what other pueblos call "the right way." But the lack of community tradition also frees any creative Jemez potter to develop her own style.

Kathleen Wall believes wholeheartedly in this freedom. Like her mother, Fannie Loretto, in the beginning she made storytellers: "It's very mechanical. You do what the family does in a group. But I wanted to be my own artist so badly. The storytellers gradually lost their babies and evolved into their own." Now, her large grinning clown figures are her signature pieces. With her own style, "supply and demand" is in Kathleen's favor. Still, she is respectful of the sacred clowns, the *koshares*: "I don't use the

Kathleen Wall, clay artist, in her studio at Jemez in 2006. "Each piece has its own energy," she says.

actual clowns as models. I don't do anything goofy. My koshares bring a lot of joy to people."

Kathleen attended IAIA, where she "tried everything" but never stopped working on her clay, paying rent with her pottery earnings. She now lives in Albuquerque but takes her young children up to Jemez every day for school and works in her studio there: "I keep tradition in my art by using the same materials that were given by my grandmother, but I don't conform to one type of work. I use underglazes. I use kilns. I do some acrylics. People say I'm doing something wrong. I say, 'What do you mean? Go to art school!'"

Kathleen revels in the diversity of artists at Jemez today. One of her brothers is a sculptor. Her younger brother, Marcus Wall, is one of the few Jemez potters who pit-fire, working in micaceous clay. "Doing whatever you want," Kathleen says, "that's part of being an artist. Every piece has its own energy. Every piece has the fingerprints of the person who made it."

Juanita Fragua may be from an older generation, but she echoes Kathleen Wall: "If I see an old pot, I hate to copy the design. I went to the museum in Santa Fe to see the old Jemez pots, but it's just simple lines. I would rather do my own. It's all up here in my head. I use corn designs because I'm in the Corn Clan."

Juanita makes pottery and figurines painted with soft tans, gray-blues, and chalky whites. She introduced melon bowls to Jemez, slipped with a gray clay that fires to buff, and sculpts ribs on a wide variety of pots, from jars to wedding vases. She says, "The big ones I push out from inside and groove them on the outside. Some I

Jemez melon jar by Marcella Yepa, 2006.

just sculpt on the outside. I have one I call my 'oval melon,' grooved only on one side."

"I'm always experimenting with anything I can get from Mother Earth," says Juanita. "For melon bowls, I use just a little more clay, so it's easier to polish. If there is too much volcano ash, it won't stand up. If I use too much clay, then it's hard to sand."

Kiowa writer N. Scott Momaday spent his teenage years at Jemez, where his parents taught at the day school. Juanita Fragua credits Scott's father, Al, with teaching her how to draw and to mix the paints: "I got all the straight lines from him." Scott Momaday described Jemez Pueblo in his memoir, *The Names*: "The village lies in all seasons like a scattering of smooth stones in a wide fold of the sandy earth."

Less metaphorical "smooth stones," found in the riverbed, polish Juanita's pots. First she polishes with a

new stone to break it in, then with an older, smoother stone to erase the scratches left by the first. If the stone is too polished, it doesn't work well: "It just picks up the clay."

Juanita opened a pottery shop at Jemez when the family moved back to the village from California in the seventies. After school, her teenage daughters Glendora and B. J. would work with her. Glendora remembers, "She pushed us. 'Get in here and help!' We didn't know how to outline, so Mom would outline the designs and put *R* for red, *W* for white, and we would fill in. She had her assembly line going! If it wasn't for Mom, I wouldn't be where I am now."

Glendora has been making jewel-like sgraffito pots for years, consistently working twelve-hour days. She first saw the etching technique when her brother, Clifford (now a prominent sculptor), came home to Jemez from his pottery class at IAIA with a vase on which he had carved a fine line of sgraffito around the rim and base: "I was totally blown away. BOOM! Something just hit me."

When she was married to Dennis Daubs, they collaborated on designs. In the years since, Glendora has moved into her own design

Jemez turtle pot by Glendora Fragua, 2006.

universe, creating delicate flowers and more intricate work, with more painting to outline her carving: "I'll lightly sketch the design with a dull blade, just barely taking off the polish. The blade just takes me from there." As a contemporary potter, she knows that "if you come out with something new, they *want* it!" One collector has twenty pieces of her work: "She calls it her 'shrine!' So each year, I try to come up with something new—lidded vases, tiles, two-tone seed pots.… I get bored with just one thing."

Jemez families like the Fraguas are islands of creativity, each member creating her own "Jemez tradition." In another of those lively family clusters, Maxine Toya and Laura Gachupin work together, along with their mother, Marie Romero, who made the first storyteller at Jemez in 1968. Maxine says that Laura is the innovator with paints and Maxine experiments with form. New ideas are "constantly changing hands."

Maxine makes figures: "I like to do something different each time I pick up the clay. I start with a flat base and start coiling. No matter how small the figure, I always coil and build it up to whatever I have in my mind. It's somewhere back there, ready to come out. So I have simplified my figures. I want to achieve the balance between traditional and contemporary."

Her pots resemble sculpture, with clay blankets that flow around the figures of flute players, singers, corn maidens, and mothers with children. Says Maxine, "People tell me that my pieces look like me. That makes sense—they are a part of you. Whatever you have put into that piece, it has helped make you a better person. Your hand sort of flows through the piece. When you are done and you hold it in your hands, to me, they come alive."

Years ago, Maxine and her family started with poster paints and acrylics painted after firing: "But we wanted to make the pottery uniquely traditional,

uniquely Jemez. We felt we were artists and we had a job to do. It was a releasing. Our whole attitude had to be changed." Beginning with the two basic colors, rust-brown and black, they slowly developed their clay paints. Maxine says, "They come from the earth. They're for everyone in the community to use. It's something we shouldn't lose." She teaches at the elementary school and takes her classes to clay and temper sites: "How are the children going to learn if we don't share the talents that we have? We're not taking it with us to wherever we are going."

Evelyn Vigil also worried about passing on what she had learned—and she had learned something remarkable. With the encouragement of the National Park Service at Pecos National Historical Park, this Jemez potter re-created the old Pecos pottery painted with lead-based glaze.

The last Pecos people joined their linguistic relatives at Jemez in 1838 when too few people remained at the old village to continue the full round of Pueblo life. No one knows precisely how everyone now is related to those seventeen Pecos immigrants. As Evelyn said, they are "all mixed in." Nevertheless, Jemez still has two lieutenant governors, one Jemez and one "Pecos." Pecos was known for glaze-painted pottery, though many pieces may have been made elsewhere and traded to the bustling pueblo. From about 1250 until the technique disappeared after the Pueblo Revolt, Pueblo potters painted designs on pottery with lead-based paint that melted to a shiny glaze in firing, though they never glazed whole vessels.

To re-create these old vessels, Evelyn Vigil searched around Pecos for clay, temper, and paint pigments. It took months, but she found the materials. She even found the place where the Pecos women had ground their sandstone temper; the metates were still there. Even then, she had to

experiment with firing techniques that would be hot enough to melt the lead in her paint: "I tried cedar, straw, manure. And none worked. I tried cottonwood bark, and that didn't work. Finally, I used fir bark, the only thing that will work."

She ground her paint from lead ore (galena) mixed with guaco. Pure lead without guaco, sand, or alkali requires a hotter fire to melt and tends to run. Red iron yielded her other color. But grinding her own galena turned out to be "kind of dangerous. It jumps at you when you grind it." Evelyn decided that she would have to buy her galena already ground.

In re-creating the tradition of an entire pueblo, Evelyn Vigil symbolized the powerful freedom of Jemez Pueblo potters to invent. Evelyn wanted to teach this ancient skill to another generation of Jemez potters. In 1986 she said, "I'm going to try as long as I can to do these things. You are never lonesome as long as you have clay. When I leave this world, maybe no one will do it. I'm just so anxious to teach somebody. I don't want to lose everything that I know, that I've learned. I am a person that believes in old things."

Evelyn has left this world, and no one has yet taken up her work with lead-glaze paint. But her love for "old things" has passed to her grandson, Joshua Madalena. Inspired by his grandmother's stories about re-creating the old Pecos-style pots, Joshua decided to revive the fine-line, black-on-white pottery that his Jemez ancestors abandoned in the eighteenth century. It took him six years.

For Madalena to succeed, he had to find the combination of slip and pit-firing that wouldn't vaporize his guaco paint. He was starting from scratch, searching for clay, temper, slip, and paints to re-create the ancestral tradition. He found keys to his search in the oral traditions and his grandmother's stories. Like Evelyn Vigil, Joshua Madalena takes his culture and traditions seriously: "Our language is our identity. Jemez Black-on-white is our identity." In re-creating the old pottery style, he is buttressing that identity for the twenty-first century.

Clay Made from History
Acoma, Laguna, and Zuni

IF TIME-TRAVELING PUEBLO PEOPLE from centuries past walked into an Indian art gallery on the plaza in Santa Fe or Albuquerque, many things would mystify them. Some of the pottery, however, would look reassuringly familiar: orange Hopi vessels, unpainted cooking jars from Taos, and, above all, black-on-white and corrugated pottery from Acoma.

Part of Acoma's heritage (along with that of other Keresans) lies in the abandoned villages of Chaco Canyon and Mesa Verde. The old pueblo on top of the mesa at Acoma—"Sky City"—dates from at least AD 1200 (and probably much earlier). If you walk up the old trail worn into the side of the mesa and stand by one of the rock cisterns, the sight of a shawled woman passing between the weathered adobe houses takes you from the twenty-first century back to the thirteenth.

Today, only a few families live year-round at Sky City. Most Acomas live in newer houses in the farming communities of Acomita, San Fidel, and McCartys, strung along the Santa Fe Railroad and Interstate 40 on the floodplain of the Rio San José.

Facing page: Kiva steps carved on pot by Wilfred Garcia, Acoma potter, 2006. Right: Rainbow over Acoma Pueblo, 1985.

Acoma's neighbor, Laguna, just to the east, was a traditional Acoma farming area until the 1690s, when, after the Pueblo Rebellion, refugees from several villages established Laguna Pueblo. In language, customs, and pottery, Lagunas have always maintained close ties with Acoma. A political split in the late 1800s sent displaced Lagunas to Isleta, south of Albuquerque, and Isleta pottery has been influenced by Laguna's pottery ever since.

Still farther west lies Zuni, with its unique language and distinctive ceremonial tradition. Acoma, Laguna, Zuni, and Hopi make up the Western Pueblos. Hopi has its own pottery traditions, but the other three have much in common, and their parallel traditions

can be seen in the bold abstractions and rosettes of their pottery.

Hard Clay & Thin Walls

Acoma clay is special. Dark gray and nearly as dense as shale, it must be ground to a powder before being mixed with temper. Clean, soak, dry, crumble, sift, grind, and soak again; the hours add up fast. If a potter does not take sufficient care—if she "rushes the clay," in Stella Shutiva's words—the surface of the fired pot will pit as tiny bits of alkali absorb moisture and spall off.

Acoma clay has the same pitting problems as Zia clay does, and these flaws have nothing to do with a potter's skill. Certain clays simply pit worse than others. Some potters minimize the problem with special cleaning techniques. Others have concluded that kiln firing prevents pitting. Some have even resorted to commercial clays, feeling that they have no choice when collectors refuse to buy Acoma pots that may pit. Santa Fe gallery owner Andrea Fisher buys most any traditionally fired Acoma pot brought to her by a potter, honoring the "risky business" of outdoor firing. Andrea estimates that more than 90 percent of Acoma pottery is now kiln-fired.

More and more Acoma potters are buying molded pottery ("greenware") and painting it for kiln firing. The late Stella Shutiva said, "They don't know how much they are throwing their art away. They are good artists. I feel bad when I see someone putting a fine traditional design on junk." Juana Leno summed up her own reasons for taking the long route: "I want to make pottery out of my own hands, create something that somebody else will enjoy."

Marie Juanico's Acoma pots drying in her living room/workroom in San Fidel, 2006.

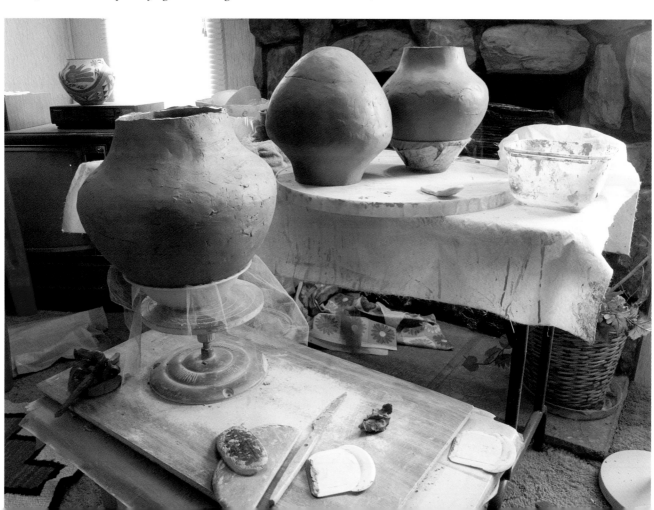

The traditional ways survive. Stella Teller from Isleta watches with amazement as the Acomas shape their clay: "It's so durable, they can pull it paper thin." Lilly Salvador, an Acoma potter who makes some of the thinnest of Acoma jars, does not sand her pots. Her completed walls come from shaping and scraping the wet clay: "You just want to keep on and on. Sometimes it gets too thin, and then it starts cracking or getting out of shape. And then I say it's time to quit."

Acoma and Laguna potters use ground pottery sherds for temper, recycling pieces of their own pottery that popped in firing. They also collect sherds from ruins at the base of the mesa, where, as Juana Leno said, "long time ago some ladies fired their pottery." The broken pots themselves were made with ground sherds, so today's pottery may contain several generations of pots within its clay. Max Early, Laguna potter and poet, values the sherds for what they give to his clay: "strength, durability, elasticity, recycling, renewal, continuance, and connection with the ancient ones." Rebecca Lucario prefers the old sherds to those from her pots: "Mine are too hard." She and her daughter walk out from her house at the base of Acoma Mesa gathering sherds: "The cooking pot sherds are the best because they are so easy to grind."

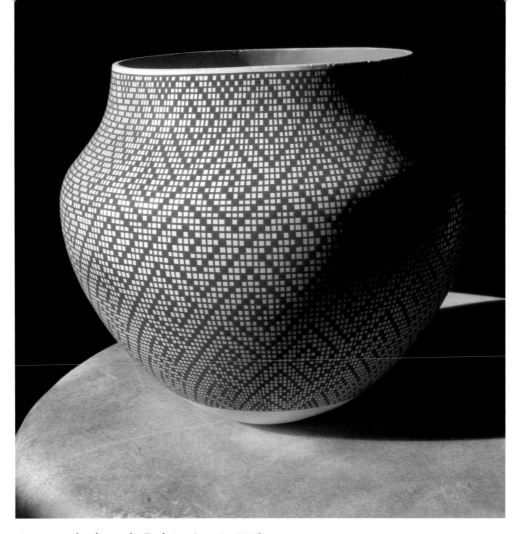

Acoma eye-dazzler pot by Frederica Antonio, 2006.

Grinding both the clay and the sherds makes for hard work. At other pueblos, most potters say that sanding is the hardest part of their job. At Acoma, they say that preparing the clay is. Lilly Salvador persuades her husband, Wayne, to do the grinding for her. Stella Shutiva and her daughter Jackie Histia used to hire a friend to grind clay with a corn grinder hitched to a washing machine motor. Anasazi sherds bought from Navajos from "up around Crownpoint" are even more difficult to grind (because they were tempered with sand) and probably require even more work than grinding Zia basalt.

From fully prepared and mixed clay, Acoma potters make large water jars known for their thin,

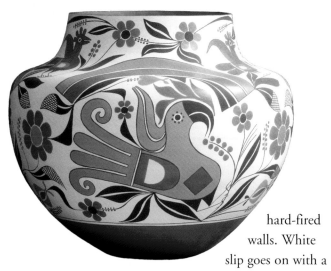

hard-fired walls. White slip goes on with a rag (Stella Shutiva said that old T-shirts and flannel work best). After stone-polishing the surface, the artists paint complex polychrome abstractions, swirling red bands, flowers, and parrots. The Acoma parrot design might seem exotic, but traders brought parrots from tropical Mexico in prehistoric times. Today Pueblo people keep them for their feathers, to be used on ceremonial costumes.

To an Acoma steeped in tradition, parrots may symbolize the zenith and its clouds; the nadir, ancestors, and death; or the south and the sun. Likewise, the color red is connected with the south, the sun, summer, and fertility. An Acoma potter may paint a red parrot on a water jar simply because "that's the way it's done." Even if she does not consciously think about meanings and metaphors, all these symbols underlie the "old way."

Many potters who specialize in smaller shapes or even owls and nativities also make classic large water jars. They mix the clay according to the task at hand. Rebecca Lucario adds no sherds for miniatures and more sherds for large pots.

The paints also take time to prepare, mixing the powdered black mineral base with boiled-down bee weed. Finding the paint rocks is even more of a challenge than finding clay. Juana Leno and her family went up to the mountains in search of the dense, black, iron-rich hematite they used for paint pigment: "You just

have to look for them, pick one up and try it out, rub it on a rock—'No, this one's too sandy'—then look some more." Carolyn Concho and her sisters are known for their colors, gathering clays from Zuni to Santa Clara.

Dolores Lewis Garcia stresses the value of all this work when she talks to her children about making traditional pottery: "Why be lazy to go get the clay? Why be lazy to go get the paints? All we have to do is go up there and get it, bring it home. Why spend more money on it when everything is there that my Mother Nature provided? That's what art is all about. You have to work hard to get where you are today."

Dozens of Acomas still make pottery. Many "waste" their painting talent on greenware. Others, like Frederica Antonio and Shana Garcia Rustin, make delicate pots with spectacular designs from traditional clays and paints. Delores Aragon says, "The future really depends on us. There aren't very many of us. It's complicated to be Acoma and try to survive in the western world. We're struggling to bring so much back and instill that in the kids—language, pottery, morals." For the Acomas, it's all connected on a continuum with their past.

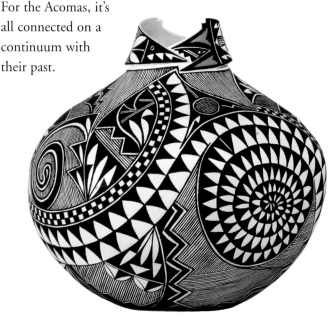

Above: Acoma high-shouldered parrot jar by Barbara and Joseph Cerno, 2006. Below: Acoma pot by Shana Garcia Rustin, 2006.

Rediscovering the Ancestors

The Acomas are noted for their revival of prehistoric pottery styles. Those Puebloan ancestors browsing in galleries would find corrugated ware much like their own cooking pots, Mimbres bowls like the ones used in eleventh-century burials by Mogollon people in southern New Mexico, and many abstract black-on-white designs from Mesa Verde, Chaco Canyon, and the country around Reserve and Tularosa, south of Acoma.

Juana Leno's favorite designs were the swirling spirals called Tularosa by archaeologists—now a family design, particularly when painted on three-chambered canteens like the one her mother first made in the late 1800s: "She used that pot for her wedding. She used to store cornmeal in there, then water. Dr. Kenneth Chapman from Santa Fe came around looking for potsherds, and my mother sold that pot to him to send me to school, to buy shoes and clothing for me. She sold it for fifty dollars."

Stella Shutiva credited her mother, Jessie Garcia, with reviving corrugated pottery: "I just adored her corrugated. When I started up again making pottery, I wondered if I could ever do it. If I just watch Mom, it's hard to learn my own way. So I had to do it myself. It took almost four years."

Stella's daughter, Jackie Histia, carries on corrugated pottery in the trademark "Shutiva style." She makes storytellers that sit on a corrugated plaque like her Grandmother Shutiva's braided rug, where Jackie sat to hear stories as a child. She gives her storyteller a traditional dress but "brings it up to this generation" by clothing her pottery children in numbered football jerseys. Jackie's turtle storytellers are corrugated on top, "like the turtle's shell."

Prehistoric potters created corrugated surfaces by pinching each coil as they made their pots. For today's corrugated pots, each coil is left unsmoothed on the

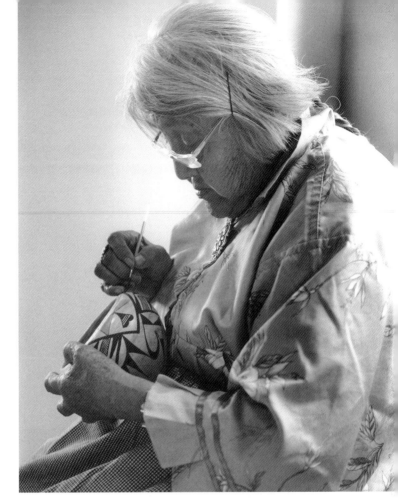

The late Lucy Lewis, Acoma pottery matriarch, 1985.

outside; all are textured with a pointed tool when the pot is completed. The coils must be made precisely, without mistakes. Lilly Salvador rolls the coils of her corrugated miniatures so fine that they are "almost like spaghetti." Someone once accused Stella Shutiva of using a cake decorator to texture her corrugated pottery. After that, when she brought in new pots, she would tell the trader, with a smile, "This is all I could bring. My cake decorator broke."

The Shutivas still keep water in traditional jars during summer because the pottery takes out the bitter alkaline taste of the desert. The wet pot smells like the earth after a rain. Jackie "can drink and drink" from the pottery jars: "You never want to stop."

Jackie's sister, Sandra, made small pots to keep her

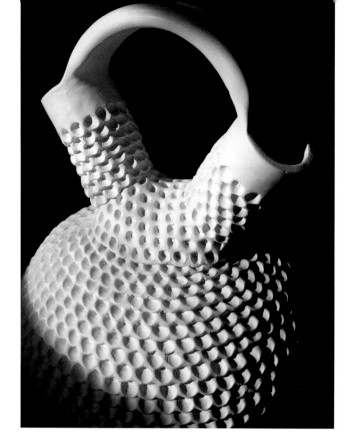

Today, Wilfred carves thirteen designs on his large, white, unpainted pots—cliff dwellings, kiva steps, bear tracks, eagles. He draws each new design and then creates a plastic stencil, using handmade tools and cutters for the flowing sculptural shapes: "People get jealous about their grandmother's designs. I'm going to avoid that. To this day, my work is all white and all mine."

Dazzling fine-line designs have become another Acoma trademark. Mary Ann Hampton says that she has to paint them in stages; otherwise, she starts "getting cross-eyed." Many potters make the fine-line pots, but the late Acoma pottery matriarchs Marie Z. Chino and Lucy Lewis and their families made these famous. Tight, narrow lines cover the pots in interlocking frets and hachures based on bits of potsherds and Anasazi pots in museum collections, reinterpreted and personalized by modern Acoma women. Even in Lucy's late eighties, when her eyes began to weaken and she wore glasses

family going after her husband, Wilfred, was laid off when the uranium mines closed. Wilfred moved on to a series of careers, including fifteen years in law enforcement. He had always done easel paintings on the side, but his mother-in-law, Stella, knew where he was headed long before he did: "She grabbed me and looked at my hands and said, 'You're wasting your time doing acrylics. Your hands are made for pottery.'"

Finally, one day Wilfred said to Sandra, "I bet you I can make me a pot today." She said, "Don't waste clay. I need it!" Wilfred started building: "It kept going and going. Finally, I started bringing it in at about fifteen inches. That first pot ended up in Jerry and Lois Jacka's book *Beyond Tradition!*" Wilfred sold that pot, carved with kiva steps and textured bear paws, for $500. Four years later, a man came up to him at Indian Market and asked him to sign the photo in the book; he had purchased the pot for $1,500. Years later, Wilfred heard that the pot sold at auction for $25,000!

Above left: Corrugated Acoma wedding vase by Jackie Shutiva Histia, 2006. Below: The late Stella Shutiva (right), with a corrugated Acoma jar, and her daughter, Jackie Histia, holding one of her own pots, 1986.

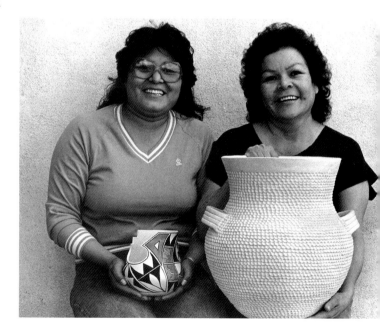

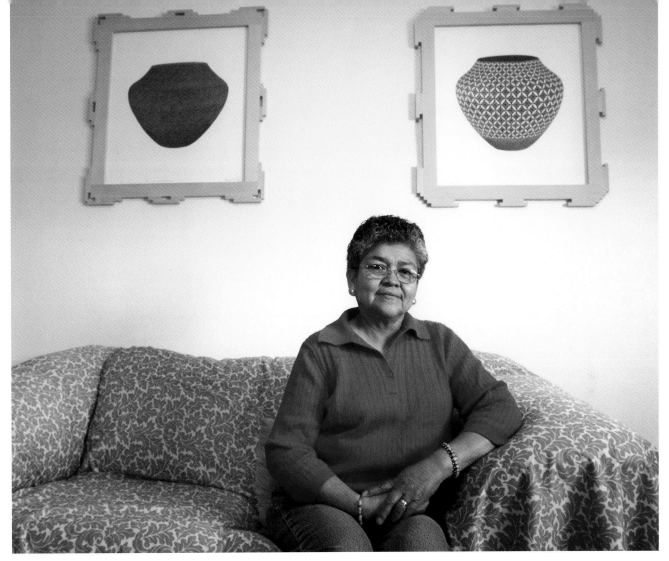

Above: Rebecca Lucario, in her home at the foot of Acoma Mesa where she was raised by her grandmother, with framed serigraphs of her pots . Left: Her fine-line Acoma plate, 2006.

while painting, her daughters Emma and Dolores said of her work, "We can't do that fine line. She's the one."

Marie Chino's daughters carried on her designs. Grace Chino said, "I don't copy from books. I just do like my mother. I took over the vase with the stepped design. When I paint it, I start it off with a little piece of straight paper to make it straight so it comes out even. I use my yucca brushes. I can't work with those commercial brushes."

Mimbres animals have become an Acoma "tradition" since anthropologist Kenneth Chapman encouraged modern potters to revive this striking pottery style. The Lewis family has been using these designs for decades, and many other Acoma potters paint them as well. The "other Lewises"—the five daughters of Edward and Katherine Lewis (Rebecca Lucario, Marilyn Ray, Diane Lewis Garcia, Carolyn Concho, and Judy Lewis)—make particularly fine pieces.

This extended clan is an energy center for Acoma pottery. When enlarged to include aunts (Marie Juanico and Ethel Shields) and cousins (Delores Aragon, Charmae Natseway), the swirl of artistic energy accelerates—always tied to the source, grandmother Dolores S. Sanchez. The family home lies at the base of Acoma Mesa, where Dolores raised her granddaughter Rebecca Lucario, who lives in the house today.

Dolores Sanchez initiated her granddaughter with practice pots made from plaster used for houses. When Rebecca was twelve, her grandmother switched her to clay. Rebecca remembers firings out back when she was a young woman: "The elders and women got together to cook. They shared and exchanged designs. Lucy [Lewis] and Marie [Chino] came. I'd see their pieces at the Gallup Intertribal Ceremonial. They were the inspiration."

Talk to any of the Lewis sisters and they praise the others. Rebecca describes Marilyn, the premier storytellermaker in the family, as her "backbone."

Carolyn says, "We share everything. My sisters are my friends, my psychologists, my doctors. Sometimes I'm blank. There are times when I'm exhausted. I'll pray to my grandmother or to Rebecca to help me do this pot. Rebecca thinks it's funny."

As Indian Market approaches, though, the sisters stay away from one another. Carolyn says, "We ask each other what we are going to make, so we don't compete. We put so many months into preparing for Indian Market. Around June and July, the children know they can't bother Mom. If a day goes by without me sitting here painting, it makes me feel bad about myself." All that work pays off, with such an array of pots that Indian Market visitors ask the sisters, "Do you have a staff?"

Carolyn is known for 3-D appliqué animals: "I start with my animal and design from there. Pottery is my job. You don't retire! I'm so thankful for my eyes and my hands. Pottery allows me to be there for my kids and my grandkids."

Cousin Charmae Natseway makes lidded boxes and pyramidal vases. Delores Aragon makes water jars with pre-twentieth-century designs. Delores looks for meaning in museum collections: "When I see an old pot, I wonder what this lady

Above: Acoma miniature with Mimbres animals by Lilly Salvador, 1986. Left: Acoma owl by O. Garcia, 1986.

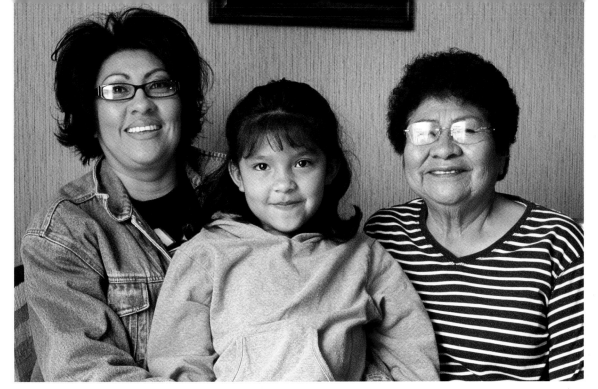

Three generations of Acoma Pueblo potters: Marie Juanico (right), her daughter, Delores Aragon (left), and granddaughter Grace Aragon, 2006.

was thinking. 'In this pot, I pray for rain, the sun, fertilization for the crops and animals, fertility of the women in the pueblo'—*so much.*"

Rebecca doesn't like to duplicate other people's designs: "I want the pots to represent me." She often double-fires, slowly starting her larger pieces in the kiln, then finishing them outdoors: "It just works better for the paints to outdoor-fire." All the Lewis sisters have kilns, and Rebecca does the family's outdoor firings. "We keep our grandmother's memory alive by doing the pots," says Rebecca. "It makes me appreciate life, takes me back in time. I think about my grandmother, my childhood." That connection to the past permeates Acoma pottery traditions.

Archaeologists have excavated thousands of Mimbres bowls from burials along the Mimbres River in southwestern New Mexico. Bowls with holes punched through the bottom were placed over the heads of the dead, leaving a "path" for the spirit to pass through to the next world. Mimbres people painted this remarkable

pottery from AD 950 to 1150. This may seem ancient to us, but only six lifetimes separate contemporary from historic Pueblo potters—not so long for an oral history to be passed along.

As Acoma is the bridge between the Rio Grande and Western Pueblo cultures, it is also the bridge between prehistory and the present. Lilly Salvador puts it this way: "We all came from one place. As people traveled, they spread. So our ancestors, some of them went down to the Mimbres Valley. We all just carried our designs. They were passed down to us.

"We have a friend down there in the Mimbres Valley with a ruin on his land. We spent a whole day there. It made me feel like we were at home and they were there too. I felt that we were all just talking to each other. When I got home, I went and sat down and started painting, and my animals just came out. We pounded the pottery sherds we picked up down there, and I mixed it in with my clay, and it just made me feel so good."

The Contemporary Traditionalists of Laguna

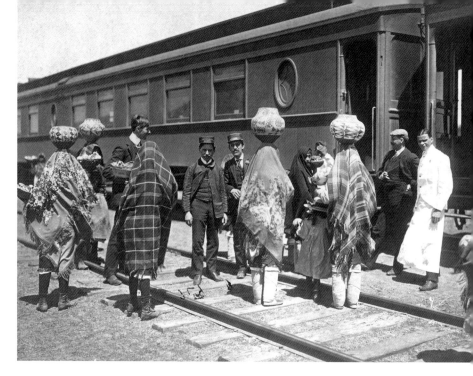

Historic Laguna pottery did not become recognizably different from Acoma pottery until about 1830. During the next century, the Lagunas perfected a variation of white-slipped polychrome with bold and simple designs, often banding pots with broad stripes and hearts of red. Laguna potter Max Early notes that "Euro-America says, 'If the pots are heavy, they are Laguna. If they are light, they are Acoma.'" Max doesn't agree: "It's a matter of expertise."

Pottery almost died at Laguna in the mid-twentieth century. In the 1970s Evelyn Cheromiah started making the old designs, designs that she says differ from Acoma in being "less busy, more spacious, balanced." Evelyn was joined in 1980 by Gladys Paquin.

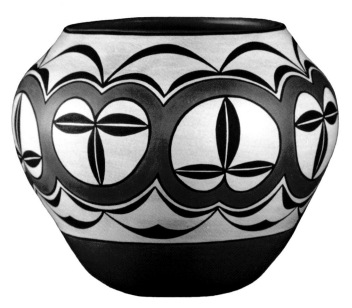

Two younger Laguna potters, Yvonne Lucas and her brother, Calvin Analla, learned from Yvonne's husband, the fine Hopi-Tewa potter Steve Lucas. Yvonne and Calvin paint their pots (formed from Hopi clay) with a bold confidence surely learned from circling in the powerful orbit of Steve's family, the Nampeyos.

Gladys Paquin embodies the complicated history of people and styles in today's pueblos. Born at Laguna, half Zuni, she was raised at Santa Ana. She lived in California for twenty-seven years before returning to Laguna and making pottery: "The Lord Jesus put a desire in me to make pottery. He got me from nothing and made me a potter. Pottery is a lot like your relationship with God. God molds you and makes you and puts you in the fire." Her son, Andrew Padilla, carries on the family independence with unpainted, high-polish, sculpted whiteware that reflects his twin heritages of Laguna and Santa Clara in shape and design.

At first, Gladys made pots inspired by her life:

Above: Selling Laguna pottery to passengers on trains passing the pueblo, Santa Fe Railway, circa 1902 (Detroit Photographic Company). Left: Laguna water jar by Gladys Paquin, 1985.

"The story on one pot was the Song of David. Another one I've kept, it has a butterfly—I was a worm, and the Lord came and changed me." Then pottery dealers and museum specialists in Santa Fe convinced Gladys that she needed a "bridge from the old pottery" to hers. She began making "copies" of old Laguna designs: "First, I used the word copy. Now, I think of carrying on their traditions, their inspiration. They were individuals just like me. One drew hearts, one drew something else. I can't believe it when they say that's traditional. I think it's just their inspiration."

Gladys learned the traditional ways on her own. She started with sherds as temper but switched to volcanic ash: "The hardest part was learning to control the fire, to know the fire. I pray to the Lord to have a hand on that pot." Gladys has taken her pots to the kiln to burn off black smoke clouds from ground firing, but the kiln-fired pottery turns orange instead of red: "It looks dead. The kiln dries it out. When it's done outside, it looks alive. That's why I stay away from the kiln.

"A real potter comes from the heart. I ask people to collect clay and grind sherds before they come talk to me about how to mold. If they can't go through the whole process, they don't have it on their heart to do it. I'm not stingy with information, but unless they care, they won't really work."

Gladys dreams of having time to experiment with other clays she has found: "I've become a slave to my bills, and the old designs helped me through. But I would like to make the things that I'm led to make, to have something of myself.... I don't live outrageous. I just live peaceable. I've never been so happy in my life."

Potters working largely on their own have much to say because they take nothing for granted. Max Early, for example, has a lot of time to ponder what pottery-making means to him. As a teenager growing up at the Laguna village of Paguate, he lived with his grandparents. His grandmother, Clara Acoya Encino, would ask

Laguna pot by Yvonne Lucas, 2006.

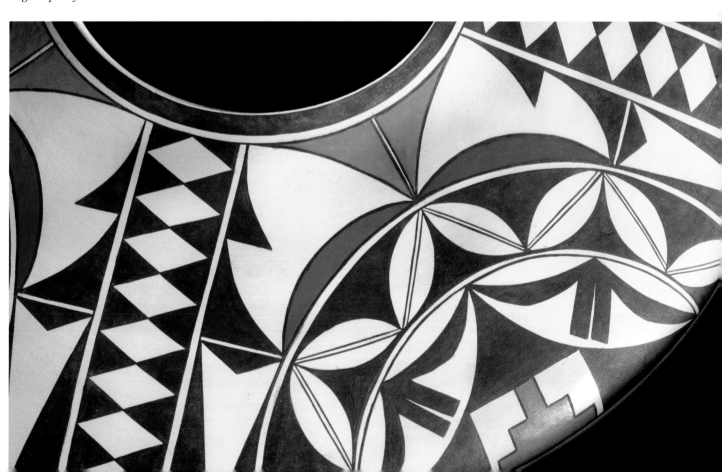

him to help paint small pieces, but she wouldn't let him work with the clay: "That was a woman's craft." Later, when he was married for a time to a Cochiti potter, Max began working with her clay ("My first Laguna pot was made with Cochiti clay") and then looked to several older Laguna ladies for advice, a "collage" of teachers: "It's all about small goals—till you create your ultimate vision."

Now, Max makes classic Laguna water jars with distinct flat shoulders, writing poetry while his pots are drying. He hopes to restore crumbling eighteenth-century homes in Paguate as small art galleries to display his work. In the meantime, he uses one of those old buildings as a grinding house for his clay, running the raw clay through a hand-cranked mill, dreaming of plans for the ancient structure. He fires small pots in a kiln and larger pots outdoors: "People tell me my pots look old, they have an antique patina. And I keep the concave bottom so ladies could balance them on their heads. I'm a traditionalist living in a contemporary

Max Early fires his Laguna pots at his home in Paguate in 2006. Inset: A cooling finished pot.

world." Max has shot dozens of rolls of film while researching old Laguna pots in museums: "I have designs to last ten lifetimes. It's nice for my hands to be the instrument to reawaken the old designs."

Thomas Natseway believes in those old designs as well, but he does them in miniature. He became interested in pottery when he married Acoma potter Charmae Shields. At first he made larger pieces, but he hated competing with his wife and his mother-in-law. Charmae suggested miniatures, and he has taken her suggestion to its ultimate expression. Now, his miniature replicas of classic water jars average little more than a

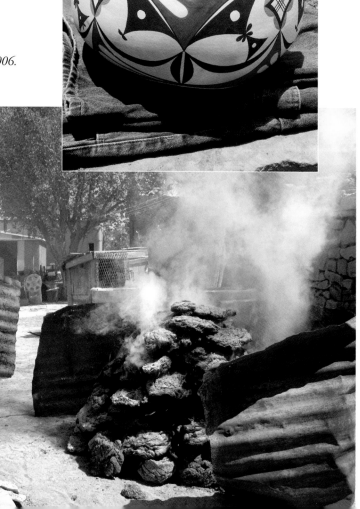

Thomas Natseway's miniature Laguna "triple pot" (see also page 8), 2006.

half-inch high; a one-inch pot "is gigantic" for him.

For these tiny pots, Thomas makes his own tools and must use the purest of materials: "My clay is like flour, my ground sherds like dust." His small bowl of Acoma clay "will last a lifetime." He has discovered that if he takes more than two hours on a piece, it starts to crack. He has to finish the slip before it dries completely. A guitar player himself, he times these stages with music: "I have to be almost done when the ninety-minute rock-and-roll tape is done playing."

Thomas does outside firings in a small firebox: "Contemporary? Traditional? It doesn't make that much difference to me." He revels in new forms. Recently, he created a set of dancing bears in a cave, six-piece train sets, and three-lidded pots. His new double-bird effigy pot is "a brain-teaser" ("I had to teach myself how to do it"). As for painting, he says, "The more designs it has, the more I like it. I like it complicated." This Laguna man, using Acoma clay and painting historic Mimbres, Hohokam, and Hopi designs, makes elegant little pots that are hard to categorize. In the end, he grins, "It's a Thomas."

The Power of Individualists: Isleta

At Isleta, Stella Teller has some of the same feelings about inspiration and tradition. Isleta's pottery was plain red until Laguna people settled there in 1880, introducing a black-and-red painted whiteware. Isleta potters made small bowls in this style, mostly to sell at the railroad station in Albuquerque. Stella remembers her mother using an old set of mattress springs for a firing grate, covering the single-bed-size springs with little pots.

When Stella made the transition from commercial to traditional pots, decades ago, she developed her own style. Now, she mixes her paints with the same white slip she uses to cover her pots. The lighter tones have a softness that contrasts with the turquoise Stella inlays in some pieces. Because she and her family are the most active traditional potters at Isleta, the Teller style goes far in defining Isleta Pueblo pottery.

She also makes figurines of nativity scenes, "corn doll" figures, Mother Corn with a bowlful of ears of corn. Stella finds figurines harder to fire than jars. She uses more volcanic ash temper for them and makes her molding mixture "clayier" for bowls "that will be stretched up."

Stella's daughters also make pottery. Robin, the oldest, was "the last to come to clay, but you can't get her to answer the phone now." Lynette, the youngest, mixes clay for the whole family, taking a commission on all sales. Stella says, "It's a strenuous job, and she is the strongest one." The girls call Stella the Star in both English and "Indian."

Robin Teller Velardez runs through the family artistic directory: "Mom's pieces are elegant looking, right to the point, like her. She always closes the eyes of

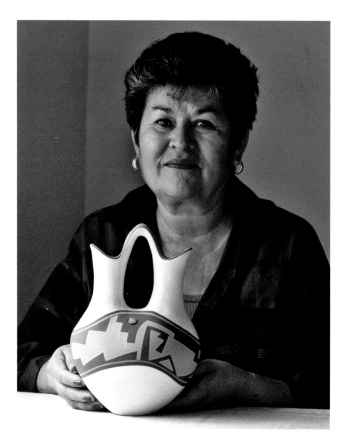

the pueblo unfolds outside her dining room window: funerals, dances, weddings, comings and goings: "I do want my storytellers to be telling a story. Some just sit and hold children. They are beautiful, but…" Robin's "stories" elicit heartfelt responses: "I've had people cry when they see my pieces. That is better than ribbons. My work communicates an *experience*."

Robin mixes red, black, and white to get fifteen shades. Painting is tricky because some pastels don't really show till after firing: "If I put on the peach color, I have to put it all on, or when it fires, you have blank spaces. We've gotten the firing technique down to such a simple method, I see no reason for using a kiln. I don't know what would happen to the colors."

Robin's storyteller figure often wears a shawl, and she treats the back of the shawl "like a canvas," painting the stories she sees out there on the plaza: "In my early

Above: Stella Teller, Isleta Pueblo, with her wedding vase, 1986.
Right: Robin Teller Velardez, with her Isleta storyteller, 2006.

her storytellers. It gives them a serene look. Chris has a tendency to stick with what she knows and does best, instead of being adventurous. Mona has a great heart, and her storytellers have lots of kids and animals. We all have children, except for Lynnette. Her storytellers have kids that are very disciplined and sit quietly.

"I'm out there in a million different directions, and my storytellers show that. I love beauty and try to incorporate that in my work. My style is more elaborate. My mother thinks I should simplify my painting and make more pieces, but all of my pieces are done the way that I want them to be."

Robin moved into her late grandmother's house next to the old mission church on the Isleta plaza in 2003. It's the perfect spot for a storyteller. The life of

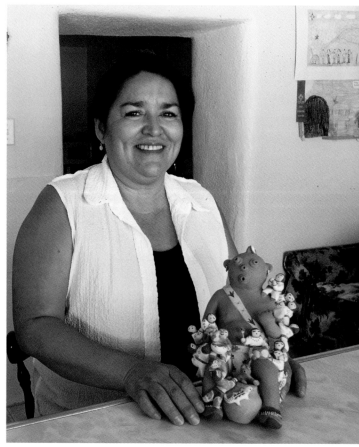

pieces, the shawl enclosed the kids. Now, I'm more secure and the shawl is open."

Robin sees her figures as a bridge to other cultures: "Native Americans have always talked through pictures. Pueblos, we speak through our daily way of life, in gestures more than words. With what Helen Cordero created, it gave Pueblo people the opportunity to share our lives, our oral tradition."

"I am proud of my pueblo," Robin's mother declares, "but I think of my pottery as Stella Teller pottery more than Isleta pottery, since it's my own style and the design ideas come from museum pieces, not from Isleta. Really, all the pueblos use the same motifs. They are individualized by the potters."

Other Isleta potters have followed Stella Teller's lead, creating personal styles. Kimo de Cora makes black-on-white bowls painted with Mimbres animals. Caroline Carpio makes pots and sculptures that try to "preserve and innovate the story." This is her way of praying ("since I'm more articulate with my hands"). In her studio, surrounded by Isleta fields, she responded to a "heartbreaking" drought along the Rio Grande with a clay sculpture of a Pueblo woman: "I called her 'The Keeper of Hope.' The piece has the shape of a raindrop. Her tableta is a cloud. She is holding corn over her heart. When I worked on her, I was praying to the rain clouds. I said, 'If you come this way, I'll take her outside so you can meet her.' It poured, and I kept my promise."

Caroline's pots, with inlaid bands of turquoise, gently scalloped edges, graceful appliqués of corn, or carved kiva steps, earn her "bread and butter money" and take about three-fourths of her time. The rest of the time, she works on sculpture: "If a piece really moves me, I want more than one person to have it, so I'll do a bronze, reinvesting my pottery money."

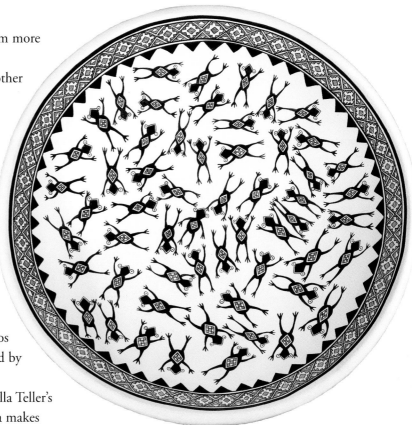

Isleta bowl with Mimbres frogs by Kimo de Cora, 2006.

Caroline majored in photography at IAIA but somewhere along the way "switched majors without knowing" and became a potter. She began by sculpting commercial clay but moved to natural clays, enthralled with "pushing the limit of the clay to sculptural form— it's a spirit that comes alive." Her reflective approach to pottery meshed well with her teachers' during an artist's residency in Japan. She brought home ideas for "wavy designs."

But the materials and the spirit are Isleta. Stella Teller expresses the potter's ethic: "From my great-grandmother on down were potters. My polishing stones came down from them. I'm always in the mood to make pottery. I'll never retire. I'll just keep making pottery and traveling until I'm an old woman."

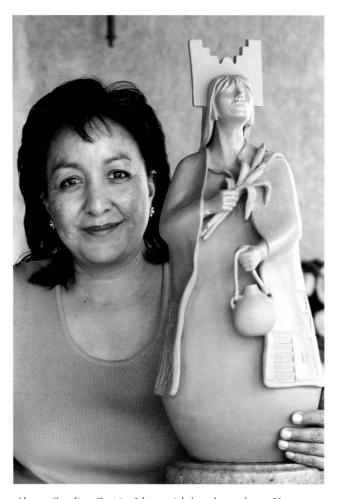

Above: Caroline Carpio, Isleta, with her clay sculpture Keeper of Hope, 2006. Right: Zuni cornmeal bowl by Eileen Yatsattie, 2006.

output not long ago. (Zuni potter Randy Nahohai attributes this to "too much Tupperware.") But two families—the Bicas and the Nahohais—kept making a few pieces, and pottery teachers in the school system introduced young Zunis to the art. In the 1930s the teachers were Zuni women. In more recent years, two non-Zuni teachers became the "pottery elders" of the pueblo: in the sixties and seventies, Daisy Hooee Nampeyo, a Hopi-Tewa married to a Zuni man; and after 1974, Jenny Laate, an Acoma married into Zuni. Both died in the 1990s, and Jenny's students took over the high school program—first Noreen Simplicio and then, since 1991, Gabriel Paloma.

Both Daisy and Jenny taught the children Zuni designs, using pictures of old pots in books; today's students and teachers may find their designs on the Internet. Though the students sometimes use commercial clay, the teachers try to keep them supplied with local clay.

Jenny Laate made two collecting trips per year, each trip yielding about two hundred pounds of clay before mixing with sandstone temper. The janitor at the school told her where to find the clay—and made sure that she prayed. Jenny sometimes ground-fired her own pottery at the family sheep ranch. Nearly all Zuni potters use electric kilns these days, many taking their

Rain Birds & Heart Lines

For the Pueblo people, the ceremonial cycle that ties together the fabric of their world also keeps pottery alive. Even if utilitarian pieces are no longer made at a pueblo and no one has yet begun making commercial art pottery, the kiva leaders still need ceremonial vessels. A few stew bowls must be made for carrying food to the gods. Rain priests need canteens to carry water from the sacred springs.

At Zuni, pottery reached this miniscule level of

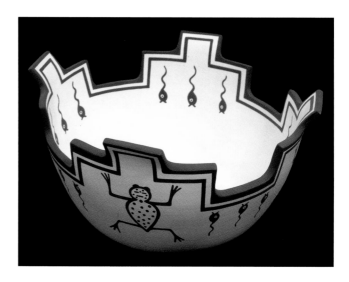

pots to the kiln at the school—in part because manure is scarce.

Beginning students must make three pieces in six weeks. Intermediate students move on to bowls, owls, and miniatures. (Traditionally, Zuni potters learned to pot by starting with owls.) Most of the students give a few small pots to their families, and that's that. In all these years, only a dozen or so have gone on to become potters. Jenny's best-known pupil is Anderson Peynetsa.

Peynetsa and his wife, Avelia, have been full-time potters for many years. Anderson moves quickly and confidently as he works with the clay, playing with speed, approaching big pieces like an athlete. He shapes and paints; Avelia sands and polishes. Anderson's sisters, Agnes and Priscilla, also make pottery. Priscilla continues to pot even after losing a hand in an accident. Says Anderson, "Her painting is even more amazing now than before." In fact, all three siblings are known for their graceful painting.

Gabriel Paloma realized that he wanted to become a potter during his senior year in Jenny's class. A few years later, he took over the classroom, seven periods a day, fifteen kids per class. He has done this year after year: "I'm committed to that school. It's my second home." He used to take his students to gather clay at Pia Mesa, to teach them the "do's and don'ts when picking clay." Now, daunted by paperwork and permits, he gathers clay for the class with his family. Gabe teaches in both English and Zuni: "I have to go back and forth to let the message get through. My job, my duty, is to pass on these skills."

Gabe is immensely proud of his students, though he admits that he finds the boys more patient than the girls. He sets aside nighttime, weekends, and summers for his own work: "That's when I really hit the clay." Often he includes mixed-media touches, such as adding feathers to the serpent-shaped strap handle of a corn-meal bowl or inlaying jet on the wings of a dragonfly strap handle.

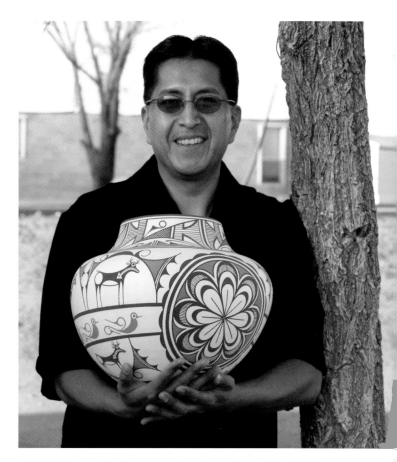

Gabriel Paloma, Zuni potter and pottery teacher at Zuni High School, 2006.

The animals that turn up on so many Zuni pots give them life. "At Indian Market," says Noreen Simplicio, "kids are sometimes afraid to touch my lizards because they are afraid they are real." After consistently winning blue ribbons in the two annual high school art shows, Noreen apprenticed with Acoma-Zia potter Angelina Medina. She learned to sculpt village scenes around the tops of her pots, and her tiny figures—fired separately and glued on to the ladders and rooftops of her carved pueblos—have become her signature design and another reason her work brings a smile to viewers. "They can't believe that these are my tools!" laughs Noreen, waggling her fingers.

Noreen Simplicio, Zuni potter, sculpted the rim of this traditionally coiled pot as a cliff dwelling, 2006.

Another classic Zuni design is the deer standing "in its house," with a heart line piercing its body. The white space around the heart line is the entrance trail of the deer's life breath. Daisy Hooee explained why "the Zuni deer is on that pot, when it looks funny there. It's because there's no water anywhere around where the Zunis landed" when they arrived in this world. A deer led them to water, and "everybody was happy that they found the water with that deer. So that's the reason they put the deer right there on the water pot."

Gabriel Paloma teaches his students that the deer and the rain bird need to face a certain way: "Jenny Laate brought the Acoma direction with her and taught us. I was painting my deer the wrong way. You want your life to go forward. That's why they should face to the right." Anderson Peynetsa paints many designs but remains fond of the "deer walking" around the pot, "kind of like a tribute to Jenny."

Water animals—tadpoles, dragonflies, and frogs—decorate ceremonial vessels: cornmeal bowls with stepped sides, terraced like clouds. Hatching means rain; feathers imply prayersticks and prayers. Black-and-white checkerboards represent the Milky Way. For Daisy Hooee, the designs were stories reflecting a world full of stories. She would look at the stars and see "a lot of stories up there."

Josephine Nahohai switched from jewelrymaking to potterymaking so that she wouldn't have to buy silver and turquoise: "All you have to do is just to get the clay and make the pottery." She talked with Daisy, and she talked with her aunt: "That's how I learn it." Eventually, the whole Nahohai family, including sons Milford and Randy, joined the potterymaking enterprise. Before Josephine's death in 2006, the family made "Generations" pots, with contributions from Josephine, Milford, Randy, and grandson Jaycee.

In the 1980s the Nahohais led a revitalization of Zuni pottery. Milford Nahohai helped found a tribally owned gallery, Pueblo of Zuni Arts and Crafts, creating a wider market for potters. Milford believes in the work, convinced that Zuni pottery is "distinguished by designing. There is a balance in the execution of the lines, an integration of abstract elements." The family visited museum collections, from the Smithsonian in Washington, DC to the Southwest Museum in Los Angeles. In 1986 Josephine received a Katrin H. Lamon artist's fellowship from the School of American Research to help teach traditional potterymaking to other Zunis. Potters like Eileen Yatsattie, who has done considerable teaching and demonstrating on her own, began their life's work in Josephine's classes. Rowena Him (married to Randy in the 1980s) continues to make mostly owls, bears, and duck canteens.

The Nahohais brought several potters with them to study old pottery in the School's research collection in Santa Fe. Three of the women were Zuni Olla Maidens, members of a social dance group who sing traditional Zuni songs while dancing with Zuni water jars balanced on their heads. Once, when the Zuni women were taking a break from working in the School's collections, each chose her favorite pot off the shelves and paraded happily around the vault with the piece in its traditional, rightful place—on her head. The curator of the collection walked in on this scene, to his delight (and concern!).

These students of the old designs started with copying, but they have never just copied. After time with the collections, Josephine began using designs that had more meaning to her than the deer design. Says Josephine's son Randy, "Every time, I mix around

Zuni pottery by the Peynetsas: small deer walking by Anderson; frogs and dragonflies by Priscilla, 2006.

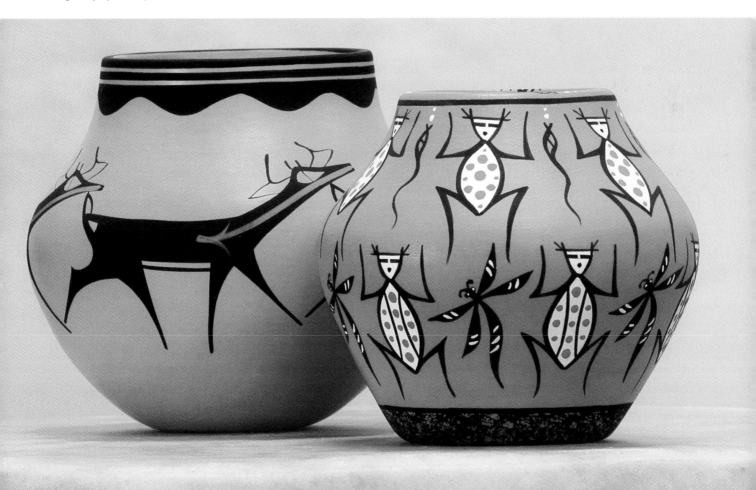

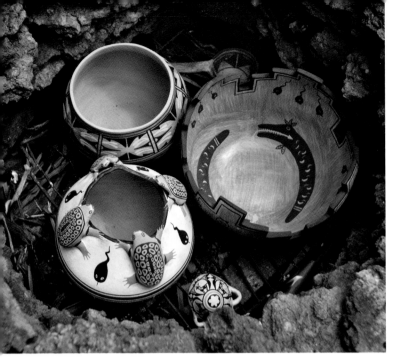

Zuni owls, for instance, can be made several ways. Jenny Laate made the body as a closed sphere, keeping the air inside so that it wouldn't collapse. Finally, at the very end of the process, she pierced the nose, opening up the owl before firing. Rowena Him makes a hole in her owls earlier, blowing gently into the body if she needs to fix a dent and attaching the wings and beak with small pieces of clay. Josephine Nahohai made her owls from thicker slabs of clay and pinched out the wings, beak, and ears from the body. Josephine said that the owl "is the protector of the night, always on the lookout for your family and making sure that your family is safe." Owls also announce death, and at both Acoma and Zuni, potters make

Above: Firing Zuni pottery by the Nahohai family, 1986. Below right: The Nahohai family in 1985: Milford holding pot; Randy holding baby Jaycee; their mother, Josephine; and Randy's (then) wife, Rowena Him.

the designs so that they are all original, my own interpretations of what the old designs meant. These traditional Zuni designs can be used by anyone. They are 'Zuni public domain.'"

Randy's favorite designs are the rain birds, an abstracted swirling spiral (sometimes identified as a rattlesnake) that has been used on Zuni pots for more than a century. He also loves the "unsurpassed abstract art" on pottery from the abandoned Zuni village of Matsa'kaya, designs he studied in museum collections. These bold motifs surely appeal to him because he came to pottery from painting. Randy has been drawing enthusiastically on whatever material comes to hand since he was three and still describes himself as a "two-dimensional artist working in a three-dimensional form." Brother Milford favors cornmeal bowls and sculptural relief: "I like to see the designs coming out at you." He often helped his mother paint. As these potters go along, they discover and rediscover what Zuni potters have been learning and relearning for centuries.

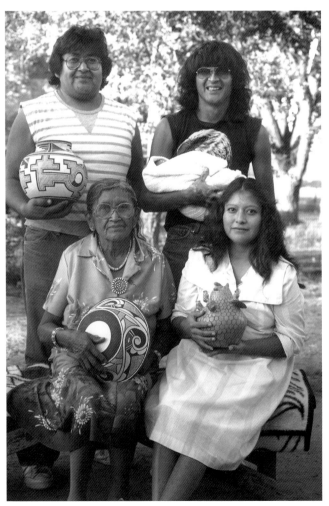

owls at times and, at other times make virtually none.

Randy Nahohai knows that "you have to mix your paint really right. If you don't mix it right—you add too much stone—it will just rub off. If you add too much of that wild spinach, it just cracks off or flakes off." He laments the work of potters who don't learn "the beliefs behind the painting."

One such belief is the "line break"—deliberately leaving incomplete one or more of the lines encircling a pot. Pueblo potters have used the line break, off and on, for at least a thousand years, and its original meaning has evolved with time. Randy believes, "That line is a representation of your own life. If you meet it together, you end your own life." Daisy Hooee said that the line

break has to do with "long life, children, healthy people." Lucy Lewis told Rick Dillingham that she used the spirit break on her Acoma pots only when they were made to be used in the kiva or to be given by kachinas to children during ceremonies. Some women leave the line open if they still can bear children, closing it if they cannot. Others say that two lines must be left broken, one through which the spirit of the pot can enter the vessel and one through which it can escape, allowing the pot to breathe.

Traditions change. Meanings evolve. Together, the Nahohais, the Zuni High School teaching team, and the students are rediscovering, refining, and rejuvenating Zuni pottery.

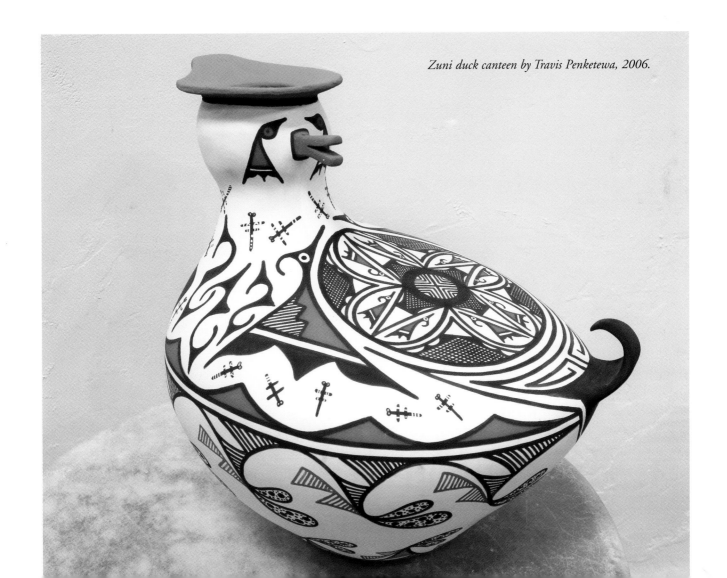

Zuni duck canteen by Travis Penketewa, 2006.

The Legacy of Sikyatki
Hopi

THE LONG-ABANDONED HOPI PUEBLO of Sikyatki left a legacy: a tradition of fine pottery that continues to nourish Hopi artistry. Today's Hopi potters choose to use the old designs not by rote but as an endless source of inspiration.

Arizona's Hopi villages are the only modern pueblos outside New Mexico, a disjunct expressed in many ways. Hopis speak a distinct language related to that of Great Basin Indian people. Their ceremonies focus more on bringing rain than do New Mexico Pueblo ceremonies. One Tewa describes Hopi religious practice as esoteric and magical "weather control"—and Hopi farmers need the magic. Unless rain comes to this driest of Pueblo homelands, the Hopi people have no food. Hopis lived in isolation longer than any other Pueblo group, removed from their Pueblo kin and from the influences of Spanish and Anglo colonists. As a result, Hopi traditions have remained strong; potters work in the quiet intervals between ceremonies.

After the Pueblo Revolt in 1680 and the Spanish reconquest in 1692, some Tewa people abandoned their pueblos near Santa Fe and moved to Hopi. Tradition has it that the Hopis invited them, for the Tewas had a reputation as fierce warriors and the less aggressive Hopis wanted their help in dealing with Ute raiders. The Tewas settled in a single village on First Mesa, called Hano (or simply, Tewa Village), and have lived as a minority within Hopi society ever since. Almost three hundred years later, the Hopi-Tewas still remain separate from their Hopi neighbors and their distant Tewa kin, but they long ago embraced Hopi pottery traditions.

Hopi-Tewas still act as "guards." The Naha family

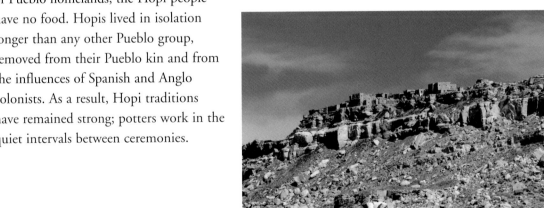

Facing page: Sikyatki-style Hopi bowl by Jacob Koopee, 2006. Right: Walpi Village, First Mesa, 1985.

was directed to move east of First Mesa three generations ago. The elders told them, "You need to leave your footprints out here. When people are vying for land, they'll say, 'There's people living out here. We can see their footprints.'" Rainy Naha looks up at First Mesa, standing tall five miles to the west: "We're not villagers. We watch from here."

In the old days, every Hopi village made pottery. Gradually, the mesas specialized in crafts: Third Mesa, wicker baskets; Second Mesa, coiled baskets; and First Mesa, pottery. A few potters at Third Mesa continue to make unpainted pottery. But in all three First Mesa villages—Walpi, Sichomovi, and Hano—as well as the modern village of Polacca at the base of the mesa, many families include potters.

Seven Generations of Nampeyo's Stories

Distinctive orange pottery has come from the Hopi mesas for six centuries. The trademark Hopi clay, gray before firing, can turn any shade from cream, buff, or yellow to apricot, peach, or light red, depending on its iron content and the firing (in a nonoxidizing fire, it even bakes to white). Higher firing temperatures, obtainable with local coal as fuel, yield the lightest colors. The surface of a single pot, polished unslipped or slipped with the same clay that it's made from, may grade through several of these colors. Golden Hopi pottery just might have given rise to the legends of golden vessels that drew Coronado and his Spanish soldiers northward in 1540.

Quality of workmanship and creativity of design in prehistoric Hopi pottery climaxed between 1375 and 1625 in the style named for the village of Sikyatki at the eastern base of First Mesa. The Sikyatki artisans intro-

duced several painting methods, including spattering and stippling, using black paints (mixed from vegetal and mineral pigment) and red clay paints.

In the late 1800s these pots came to light again as archaeologists excavated the ruins of Sikyatki. At the time, Hopi potters were making little of this traditional orange pottery. White-slipped pottery, with designs heavily influenced by Zuni (where many Hopis had waited out drought and a smallpox epidemic in the 1860s), had mostly replaced it.

One Tewa woman from Hano, named Nampeyo, became intrigued with the old designs. She had seen pottery and potsherds exposed after storms in the eroding soil of Sikyatki's ruins. With the arrival of the archaeologists, a multitude of new pots emerged. Maria Martinez of San Ildefonso and Nampeyo are still the best known of all Pueblo potters, but Nampeyo came first—the original "celebrity potter."

Like Maria's talent, Nampeyo's blossomed at a serendipitous time. Thomas Keam had opened a trading post for the Hopis in 1875, providing a market for pottery and a stock of coveted goods for trade. In the 1880s

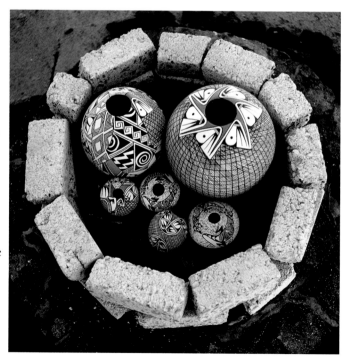

Firing Sylvia Naha's Hopi pots at her home in Polacca, 1986.

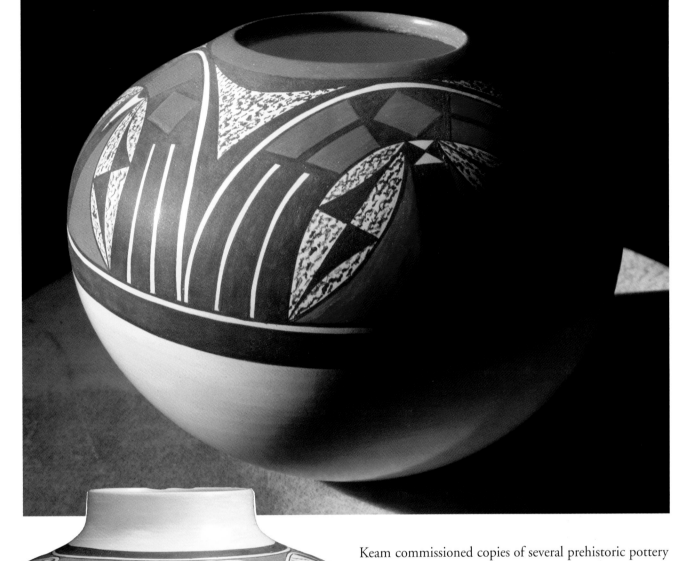

Keam commissioned copies of several prehistoric pottery styles, from plain and corrugated to Sikyatki, paying extra for fine work. Several potters, probably including Nampeyo, made copies for Keam. Nampeyo began using Sikyatki shapes and designs on her white-slipped pottery between 1885 and 1890.

In the 1890s archaeologists under Jesse Walter Fewkes excavated Sikyatki and other ruins, revealing dozens of exquisite vessels—as Nampeyo and her neighbors watched. By 1900 Nampeyo, at the age of forty, had created a personal style inspired by the work of the Sikyatki potters—experimenting, rediscovering the Sikyatki clay sources, abandoning white slip, and polishing the yellow clay body itself.

Above: Hopi jar by Steve Lucas, 2006. Below: Sikyatki design by Tonita Nampeyo, 2006.

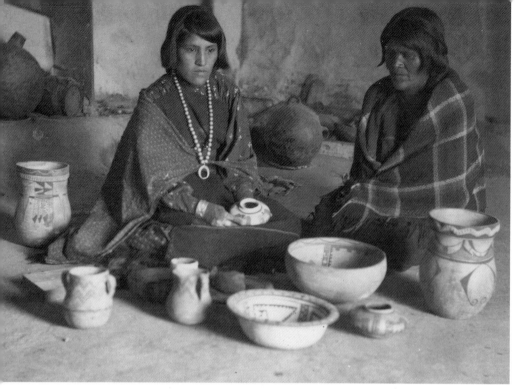

Nampeyo and her daughter, Annie Healing, late 1890s (photo by Sumner W. Matteson), courtesy Milwaukee Public Museum.

Although these old designs inspired Nampeyo, she distilled them through her own creativity. Her potteries were far more than copies; they were virtuoso improvisations on the Sikyatki themes. The other women of First Mesa followed her lead. With the encouragement of anthropologists collecting their work and the growing tourist market, these women brought about a renaissance in Hopi pottery.

Daisy Hooee learned potterymaking from Nampeyo, her grandmother, in those early years of the twentieth century and interpreted for her when visitors came, until Nampeyo's death in 1942. Daisy said, "In those days, we don't have no pencils. We used charcoal. Whenever we bring a paper sack from the store, we spread it out. And that's where she copies the designs if she goes to the ruins." They stacked the pottery designs drawn on paper sacks "with a flat rock on top." When Nampeyo made her big pots, "she would take one out, and she'd copy that on her pottery." In Barbara Kramer's analysis of Nampeyo's artistic career, she

suggests that Nampeyo did most of her improvising before Daisy's childhood and, indeed, was already losing her eyesight when Daisy was about twelve. Those drawings may have been Nampeyo's necessary records of her interpretations of the old potteries—and they have been copied and passed down through the family.

Through the ever-expanding generations, Nampeyo's stories live on. Daisy Hooee said, "All the grandchildren, now they're putting it on their pottery. We don't copy other tribes. It has to be a Hopi design. And when they buy from me, I tell the stories that Nampeyo tells me."

Nampeyo had twenty-two grandchildren, including Daisy, and forty-three great-grandchildren, including Dextra Quotskuyva. Says Dextra, "I feel good about doing the traditional designs of Nampeyo. I feel I'm closer to her because I'm using that design. Although she's gone, I feel that she's there." Dextra's niece, Jean Sahme, is always praying and thanking her ancestor, Nampeyo, for the gift of this livelihood: "I feel bad that she's not here to see it. I thank the Creator and all the ones who passed it on."

The Nampeyo family designs combine scrolls of fine-line decoration with stylized birds and bird wings, beaks, and feathers. The best of these have such a feeling of motion that they seem ready to swirl away under their own power and fly right off the table. These new versions of the old Sikyatki designs also include butterflies, birds, kachina faces, and a myriad of stylized animals. Another way to understand the family designs came from a man looking around at the Heard Museum

Indian Fair. He returned to Jean Sahme and told her, "There's *life* in your pottery." That compliment, said Jean, made her whole weekend.

The Sikyatki shapes are also distinctive: wide-shouldered flattened jars, often with outflaring lips; low bowls with spectacular decoration inside; and seed jars with small openings in their centers and flattened tops that seem to defy the laws of structural strength dictated by the clay. Other shapes that seem distinctly Hopi came from elsewhere. The wedding vase came from the Rio Grande, perhaps with the Tewa. Hopi-Tewa potter Rainy Naha thinks of wedding vases as medicinal jars: "You don't see them out in the open. Medicine goes in one side and pours out the other.
They are kept safe in kivas and places of healing."

Tiles were commissioned by Thomas Keam, who provided molds to ensure their uniformity. In 1922 Santa Fe writer Frank Applegate spent some time on the mesas helping potters. He encouraged them to make the tall, straight-sided vase that became a characteristic Hopi vessel. The largest ones, three feet high, were used as umbrella stands.

Designs from Dreams

Dextra Quotskuyva says, "Most of my designs are from the dreams that I had, from looking at the earth, everything in the universe." She still uses the Nampeyo family designs that she made with her mother, but when Dextra began making pottery on her own, she wanted to include other designs, other "feelings," other dreams.

"With one I designed, I wanted you to not really look at it but *feel* it. I had represented the sun and the moon from both sides. And then I looked at the sky and, to me, the sky is smooth. Then, looking at the ground—the sand, the rough places, the feeling of walking without shoes.... So I molded that pot, trying to make that pot look more like the world. Then I had the trail, just one trail, traveling and entering, going up. And not just the trail, but the spirit of everything, everybody, everything that's leaving this earth.

"You worry about your pots. It's just like your children that you are bringing into the world. There's a lot of pots with meaning that went out without

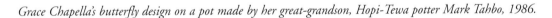

Grace Chapella's butterfly design on a pot made by her great-grandson, Hopi-Tewa potter Mark Tahbo, 1986.

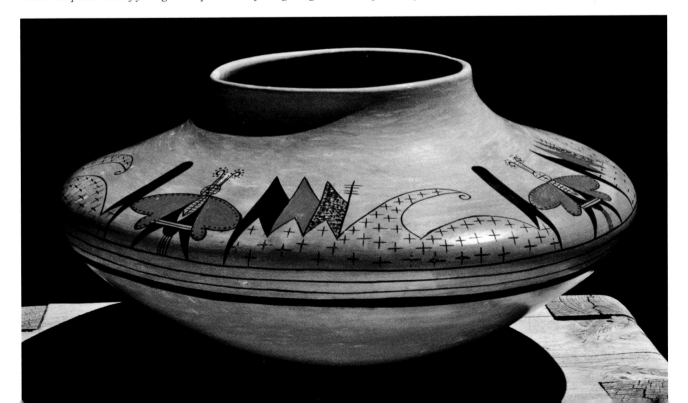

Sikyatki bird motifs swirling on a jar by Hopi-Tewa Dextra Quotskuyva, 1976.

explanation because some don't really ask. But if they're not interested in explanation, I know what it means. I have that feeling, and that's what it's talking about. If they just feel it, maybe they'll get closer to what I mean."

Approaching eighty, Dextra Quotskuyva had eye surgery that allowed her to continue painting. She encourages other Hopis and Hopi-Tewas to make pottery, "not just within our family." She says, "There's just no sense in forgetting what was there before. Art helps other people. You can't really hold it to yourself. It has to go out."

Jacob Koopee, Dextra's nephew, combines the Sikyatki designs with grace and flair. Striving to blend "traditional and abstract and contemporary," in 2005 he won Best of Show at Santa Fe Indian Market and at the Heard Museum Indian Fair. He was thirty-five years old. Jake had almost given up a few years earlier, when his father died and he had to quit college to take over as head of the family. Not until he had left behind his anger at his father for this unsolicited push into adulthood could Jake complete the huge piece painted with clan symbols that won at the Heard.

The community was with Jake. During the Bean Dance, kachinas charging in and out of his house took care not to bump the

pot. When the moment arrived to remove the piece from its successful firing, Jake was filled with gratitude: "I was thanking my Dad, my grandmother, all the potters who had passed. I was alone. I was jumping around." He was thrilled when the pot received its necklace of ribbons: "Happy on behalf of not just myself but all Hopi potters."

Jake's mother, his grandmother, and his Aunt Dextra had been telling him all along that "pottery really talks to you." He says, "All this time, I was making pots and waiting for that time when the clay talks to me. I never got the true meaning until the Heard pot. I had bottled everything up, and here it was right in front of me, within my heart. From then on, I talk, talk, talk while it's baking. I pray and pray and pray. I think about stuff I never thought about. It's therapy. It's your own psychologist.

"Talk to the clay. It listens to you. It *listens*."

Every family passes on designs through the generations, then adds its "own thoughts and feelings." As Dollie (White Swann) Navasie says, "It's traditional, but with that White Swann *something* put in." When Susanna Denet went to the Museum of Northern Arizona in Flagstaff, she was thrilled that she could pick out her mother's pots from two rooms full of Hopi pottery: "No one did the mouths like her. It made me cry to see those pots. We stood in silence for a while—it seemed so long—and then I pulled myself together and moved on. I carry her designs."

Grace Chapella was Nampeyo's next-door neighbor in Tewa Village. From among the Sikyatki bowls, Grace chose a butterfly pattern. Adding embellishments, she made it her own. Grace lived to be more than one hundred and taught her great-grandson Mark Tahbo, who carries on her designs. Just as Grace had done many years before him, Mark worked as a cook at Polacca Day

School. One payday, he came home to a check for a pot his family had sold for him. The pottery check was more than his salary check, so he quit his cooking job and began potting full-time.

While traveling the path from promising to prominent, Mark has taken his turn as a mentor. His nephew, Larson Goldtooth, and cousin, Dorothy Ami, credit Mark as their guide and teacher. Larson started by helping Mark fire: "I was fascinated watching him building the pots. Finally, Mark said, 'Why don't you just reach in the bowl and grab some clay?' It had energy in it. I could feel it as soon as I felt the clay."

Goldtooth started with bowls, big ones ("I have real big hands"). Mark had a video from the Wheelwright Museum that included an interview with Helen Cordero. Fascinated by her figures, Larson watched the

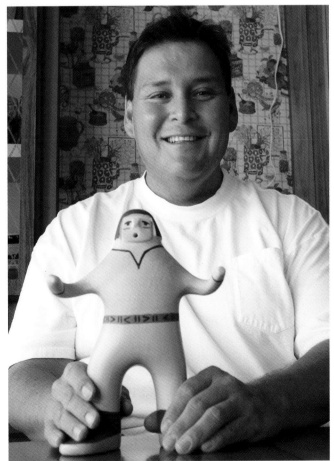

A Hopi figure made by the "big hands" of Larson Goldtooth, 2006.

film again and again. Finally, he tried making figures in Hopi clay, first with arms plastered against the body and with flat legs that broke easily. Eventually, he created the whimsical standing figures he is known for today.

"It's exciting," says Larson. "You start with a ball of clay and make *people!* I thought, 'This is what you are going to do—to make a statement with Hopi clay, to bring acknowledgment to Hopi that there's different art forms you can do if someone is willing to challenge themselves.'" Goldtooth is working with pure, untempered Hopi clay, testing its limits through the outstretched arms of his singing men dressed for ceremonies.

Mark Tahbo encouraged his cousin Dorothy Ami as well. A former preschool teacher, she is an educator at heart and does many demonstrations, always making a point of mentioning Nampeyo and Grace Chapella. "Pots need the same creativity and patience as school kids," says Dorothy, "but you don't have to take them to the bathroom and they don't talk back to you!" In 2005 she multiplied her daily inspiration by moving to a quiet corner of Polacca, immediately below the ruins of Sikyatki: "I needed to be here for the energy and spirit it carries, to explore and find new colors. When it rains, my whole area turns to clay." This can be messy, but Dorothy is thrilled to be surrounded by clay—it's almost like living inside a pot.

The huge, historic Hopi pots at the Heard Museum brought Dorothy to tears, as does a walk over the rubble of Sikyatki behind her home: "These people who made them are gone, but they left those millions of pieces of pots for us to find. When I see pictures of hands working with clay, I get real emotional because

Hopi figurine by Emerson Ami, 2006.

I know what that hand is creating. I never thought the clay would mean so much to me." The clay has won over her husband, Emerson, who makes pottery as a "stress releaser" in his off-hours (he's a Hopi policeman).

Rondina Huma, another Hopi-Tewa potter, has her own design: "It's related to the Nampeyos' with fine lines, but a lot different from theirs too. I used to make big designs, and I used to leave some areas not painted. I was just doing it one day, and I started from the top clear to the bottom. And I find that it looks better with more designs on there than just leaving so many blank spaces. I want one of my daughters or my sister's kids to take over my work if they can, my style, and make their living for themselves out of that."

After the intensity and excitement of Indian Market, Rondina and her buddy Karen Abeita often go to Jamaica to unwind. (It's not just for the beach. Hopis have a deep love for reggae, and Karen hosts the weekly reggae program on Hopi Public Radio.) Like those of Rondina, Karen Abeita's designs can be stunningly intricate, built from the Sikyatki sherd designs Karen sketches in the notebook always by her side. "It's a gold mine up there for me," Karen says of the ruins. "Those ladies at Sikyatki were the best Hopi potters *ever.*"

Yellow Clay, Red Pots, & White Slip

Tracy Kavena of Sichomovi said, "People ask me what the designs mean. I ask my grandma the same thing. She says to me, 'It's up to you to interpret. It's good to

make up your own designs based on the old traditional elements.'" Modern Hopi potters have revived so many prehistoric styles that they give pause to anthropologists trying to classify their pottery. One scholar noted that in the course of a year, a single Hopi family makes pottery that could be classified into twenty styles.

Hopi potters use a gray clay to make yellow pottery and a yellow clay to make red pottery. The more iron in the clay, the redder the fired pot. The darker the clay, the lighter it fires. Some potters use only a yellow slip to make red pottery, using the same slip for one color of polychrome paint.

Rondina Huma gathers her clay near the ruined village of Awatovi. The clay is so good, "it just shapes itself." She doesn't temper the Awatovi clay, "but other places, the clays are real rich."

You have to add a little sand to it." Adding sand also makes sanding the pottery easier. Other potters have fired plaques of white clay, ground them to flour, and used them as a very fine temper.

Susanna Denet liked to use extremely rich clay because she didn't use a slip. She polished only with rainwater ("You don't know what's in tap water"). Other potters like coarse, sandy clay and tell her that they can't work with her clay, that it's too rich and "will pop." Sikyatki designs appear on red or golden pottery. Red pottery, particularly, is decorated with a host of simpler geometric designs, made mostly in Sichomovi.

The late Garnet Pavatea popularized red bowls with a band of corrugation around the shoulder. Prehistoric potters used their fingernails to pattern corrugated vessels, and Garnet simulated this texture with the even imprints of a church key—a metal can opener. Other potters still make redware bean pots, stew bowls (complete with ladles), and mixing bowls to hold batter for the paper-thin Hopi piki bread, made of blue cornmeal. They use these too. Until her death in 2006, Susanna Denet had three ladles hanging next to her stove, one given to her by an aunt nearly seventy years ago.

Two intermarried families, the Navasies and Nahas, have specialized in whiteware. Their matriarchs were Frog Woman (Joy Navasie) and Feather Woman (Helen Naha). Firing the white clay requires an extra-hot fire. The Navasie family uses slates or slabs of asbestos instead of potsherds to protect the delicate white slip from

Hopi-Tewa Rondina Huma covers her pots with complex designs, 1986.

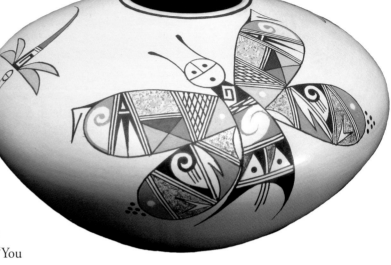

smudging. Designs on the whiteware are often Sikyatki inspired, but some, particularly the Naha pots, are derived from more ancient, black-on-white styles. "Whiteware is not contemporary," Rainy Naha reminds us.

The Nahas lived at a ranch below Awatovi, where daughter Sylvia first made play pottery with the adobe in the family cornfield. One day, in this very field, her father plowed up a pot with a swirling geometric design that was to become the family's "intellectual property" (in Rainy's words). "My mom told us that 'The Old Ones left these sherds for you,'" Rainy remembers. "'You are their children.'"

Sylvia Naha, who died in 1999, painted freehand, using yucca brushes for large pots, paintbrushes for small ones, and the butt of a wooden matchstick for

stippling. She applied layer after layer of white slip until it was "eggshell thick," polishing only the last layer. Rainy points out that the white slip "isn't clay. It's sandstone—*stone*—and doesn't burnish like clay." She says, "By the time other Hopi potters have finished burnishing six pots, we're still applying our slips and waiting for each coat to dry."

Helen Naha told her children, "Never leave anything out, in your design or your process. Sand and polish as far as your fingers will reach." Sylvia polished the insides of narrow jars with a nail or even her fingernail. She had a tiny polishing stone she used for miniatures, until her little boy accidentally swallowed it. She found other polishing stones in gravel.

For years, Rainy lived away from Hopi, working as an archaeologist in Utah. Moving home to be near her mother, Rainy started potting and "just settled in." She says, "I enjoy the solitude. I run below Awatovi and through those fields every morning. But I never feel alone when I'm working on my pots." She and her siblings started with Helen's "foundation" designs and then developed their own styles: "Sylvia moved toward

Left: Nona Naha, Hopi-Tewa potter, holding her pot painted with a red-tailed hawk design, 2006. Above: Hopi whiteware by Rainy Naha, 2006.

Mimbres. Burel moved to spiders. I've started to use up to eight different colors on my birds." Their niece, Nona Naha, has become known for the lightness of her pots.

Living back at Hopi after years as an art teacher and school administrator, Burel Naha became fascinated by a spider drawing on fluorescent green paper that his daughter brought home from a computer graphics class. "I couldn't get it out of my head," he says. "It was more like an inspiration, a dream." A member of the Spider Clan, he began putting spiders on his pottery (Now, "everybody calls me 'Spider Man'").

Nona Naha married into the family, and she "treasures" what they have given her. Rainy was her primary mentor, "from the bottom up to firing." Grandma Helen taught her to measure designs with her little finger to ensure symmetry. Sylvia taught her to paint fine lines and lizards. Nona's husband, Terry, came up with pinwheel and red-tailed hawk designs. Nona says that there may be creativity in a family but that, in the end, it all comes down to "just you, as a person."

Rondina Huma believes that white pottery is the hardest of all: "I tried it once, but it's not my style." To use the white slip, she says, "you have to be fast enough to polish that because it dries so fast. Then, when you paint, the paint soaks in so fast." Rainy Naha agrees that "it's tedious. You have to sand your entire pot back down if you make a mistake."

Sylvia Naha used razor blades (her little cousin called these her erasers) to scrape off any mistakes made with the five or six clays she painted with. She needed to take care not to slice down into the slip, or the mark would show. One advantage of white pottery, however, is that the white slip reveals air bubbles, so the potter is rarely surprised by a "pop" in firing.

Hopi whiteware pot by Burel Naha, with three designs honoring three Naha siblings: Burel's spider design; Sylvia's Mimbres design; and Rainy's feather design, 2006.

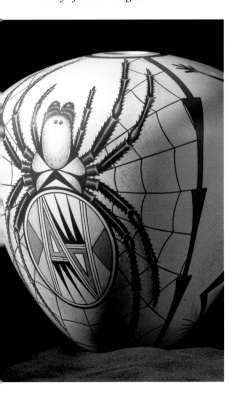
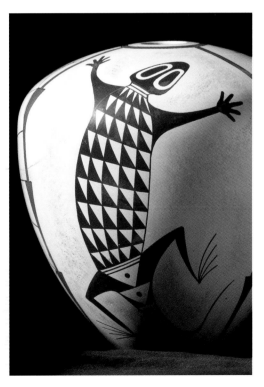
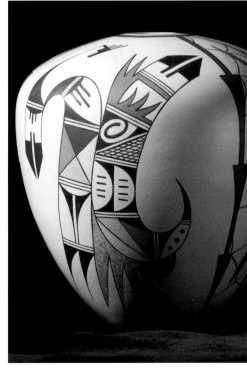

Mother Corn

Third Mesa potter Polingaysi Qoyawayma (Elizabeth White) generated a unique style single-handedly. In the early 1960s Polingaysi began making unpainted, cream-colored pottery, with the figure of an ear of corn pushed out from the inside and sculpted on the soft-hued side of her bowls. A pioneer Hopi teacher before turning to pottery, Polingaysi wrote of the power of "Mother Corn," who "nourished the Hopi people" and with "her pollen pathway like a rainbow in the sky directed the Hopi to life."

Her nephew Al Qoyawayma has carried on her style, adding sculpted butterflies, kachinas, blanketed Hopi men, and remarkably detailed cliff dwellings. Al comes to pottery trained as an engineer. He lives in Prescott and has become a technical expert on Hopi and Anasazi pottery: "I'm reflecting, leaning on ancient cultures." Reaching for the limits of structural strength in his flattened Sikyatki shapes, Al went back to the original ancient pieces and measured them. He found that the Sikyatki potters were unable to make the shapes that he had been unable to make. They, too, were engineers.

Al Qoyawayma goes to Hopi to gather his materials. He has a sense of history: "As I climb over the mesas and through the washes looking for clay, I realize that there have been many before me who have taken the same steps and have made the same search—and have seen the same beauty. I know that some of this clay may even contain the dust of my ancestors—so, how respectful I must be. And I think, 'Perhaps

Detail, carved Hopi pot by Wallace Youvella, 2006.

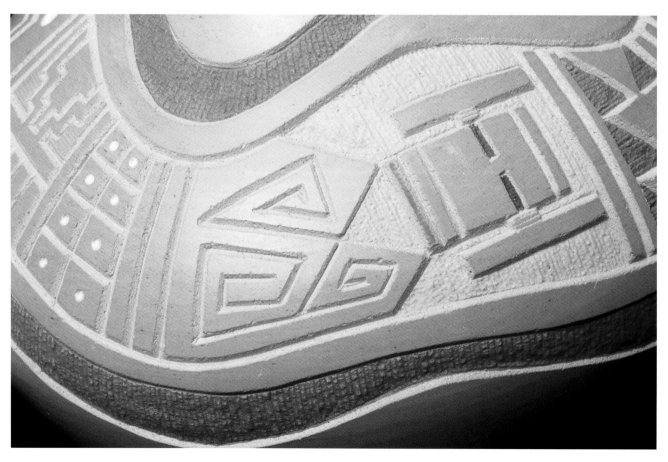

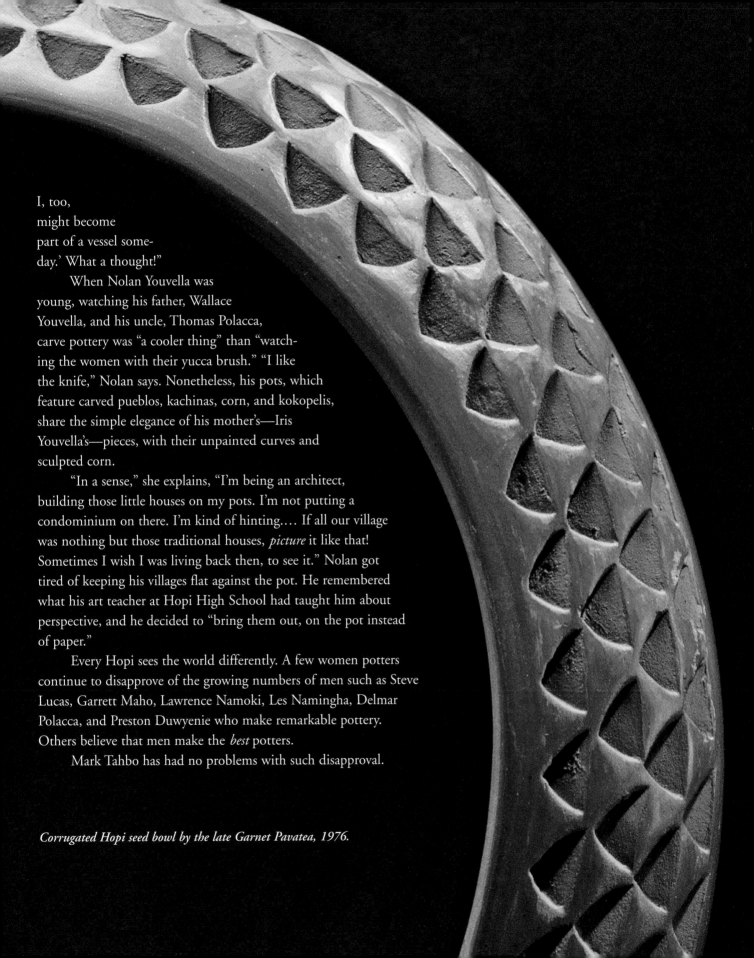

I, too,
might become
part of a vessel some-
day.' What a thought!"

When Nolan Youvella was
young, watching his father, Wallace
Youvella, and his uncle, Thomas Polacca,
carve pottery was "a cooler thing" than "watch-
ing the women with their yucca brush." "I like
the knife," Nolan says. Nonetheless, his pots, which
feature carved pueblos, kachinas, corn, and kokopelis,
share the simple elegance of his mother's—Iris
Youvella's—pieces, with their unpainted curves and
sculpted corn.

"In a sense," she explains, "I'm being an architect,
building those little houses on my pots. I'm not putting a
condominium on there. I'm kind of hinting…. If all our village
was nothing but those traditional houses, *picture* it like that!
Sometimes I wish I was living back then, to see it." Nolan got
tired of keeping his villages flat against the pot. He remembered
what his art teacher at Hopi High School had taught him about
perspective, and he decided to "bring them out, on the pot instead
of paper."

Every Hopi sees the world differently. A few women potters
continue to disapprove of the growing numbers of men such as Steve
Lucas, Garrett Maho, Lawrence Namoki, Les Namingha, Delmar
Polacca, and Preston Duwyenie who make remarkable pottery.
Others believe that men make the *best* potters.

Mark Tahbo has had no problems with such disapproval.

Corrugated Hopi seed bowl by the late Garnet Pavatea, 1976.

Hopi potters disagree about the ethics of using kachina designs on pottery. It is done now, and it was done in Sikyatki times. Thomas Keam encouraged these pieces. But several potters believe that it is not right because, in firing, the kachina is burned, and one should not do such a thing. Garret Maho believes that when he chooses a kachina to paint on a pot, that design will be the kachina leader: "He will take over the pot. Then you know where everything will go, and everything will come together."

Every potter has her own rules, her own designs, her own way. Rondina Huma says, "I guess if you know how to do your pottery a certain way, that's the only way you do it. And if you try it somebody else's way, it doesn't come out." Independence grows from tradition. Daisy Hooee said proudly, "It's all by freehand. Everything. That's the way my grandmother Nampeyo taught

Above: Karen Abeita (Tewa-Isleta) painting Hopi pottery at her home in Polacca, 2006. Right: Nolan Youvella, Hopi-Tewa potter, 2006.

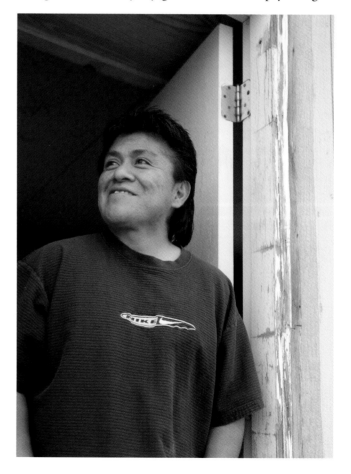

When he gets together with women who pot, he "talks pottery." When he had a bad year for firing, with a dark mark that repeatedly turned up and wouldn't burn off, he was almost ready to quit potting. Finally, he went across the road to Priscilla Namingha Nampeyo for advice. Together, they concluded that the old, rusted, galvanized bucket Mark used for soaking was contaminating his clay. Priscilla told him to buy a plastic bucket. He did, and the problem was solved. Loren Ami, too, relies on advice from his female elders. He specializes in canteens that he finishes by closing his eyes as he joins together the coils at the widest part—as his teacher, Dextra, advised.

me. Shiny stones, she gave these polishing stones to me. This is the rock for paint mixing that was hers too."

Tracy Kavena said, "We're all individuals, and no two potters are going to make the same pottery. A part of their personality goes into the pot.

"My father has a big water jug that my grandmother carried from Oraibi to Hotevilla when they left. It sits in the bookcase by my father's bed. Sometimes I just look at it and think, 'Someday I'll do something like that.' It's part of family history. All the knowledge needs to be handed down because someday we'll be the old people."

Dextra Quotskuyva remembers Nampeyo telling her and the other kids, "When you grow up and get older, do your potteries like me. You're going to survive on it." Dextra says, "At that time, I didn't know what she meant, 'You're going to live with it.' I used to think, 'Why is she telling us this?' She was a wise old lady."

Hopi pot with silver inlay by Preston Duwyenie, 2006.

One with the Clay
Economics, Art, & Tradition

HELEN CORDERO'S GRANDFATHER inspired her storyteller figures: "He was a wise man with good words, and he had lots of grandchildrens and lots of stories, and we're all in there, in the clay." Elizabeth White prayed to be "One with the clay. One with the Creator. One with every living thing, including the grains of sand."

We *are* all in there with the clay. And the clay is connected to the rest of a potter's world, to "everything in the universe," as Dextra Quotskuyva says. "Most of the time, I'm in there talking to the pots," says Dextra. "Indians always have too much to do. Harvesting time, planting, dances, we're very involved in cooking and all that stuff. We are baking from maybe Wednesday on for some occasion. We have Indian doings. As much as you want to fill orders, you can't explain because they don't know what we do besides making potteries. It takes time to make pottery."

Dora Tse-Pe says, "When someone orders a pot, they think you should have it by a certain day. You can say, 'I'll try,' but with our way of life, we have things coming up that happen just like overnight. There's no warning ahead of time. One evening they can come and say, 'Okay, we want you at the kiva.' So you drop all your work and go to the kiva. So then your pot isn't going to be ready on the day that the person wants it. And that's really hard to make people understand."

"It's living in two worlds," Dora said in 1986. "I worry. Because if it's that way now, I worry about what it's going to be when my children are grown and they have children and grandchildren. I hope they can cope with it." Twenty years later, Dora's daughters are grown.

A century of marketing. Facing page: View toward Saint Francis Cathedral, 1986 Santa Fe Indian Market. Right: Maria André and Maria Sophina selling their Isleta pottery, circa 1902 (Detroit Photographic Company).

Candace Tse-Pe Martinez even has her first granddaughter to think about. Candace says, "I cope by staying home with my children, and part of how I can do that is my pottery. I've always tried to keep up my pottery. When I didn't, I didn't feel good. I have to have that in my life. I do it for myself, for my soul. I do it for the passion of it.

"My kids have an easier time living in two worlds. I see it in their artwork, their creative writing, their access to Native chat rooms on the Internet. Schools are more culturally aware. And pottery is part of that —being proud of being Native."

Pueblo pottery is part of life, and Pueblo life is more than pottery. Nothing can be taken for granted. Will Pacheco left Santo Domingo for the University of New Mexico, where his classes in ceramics nearly broke his bond with the clay: "I began questioning the integrity of the work. It feels empty to make pots for the market. It's an extension of yourself that you are selling. I'm not certain what the purpose is. It's paralyzing.

"For me, the question, 'What is the pottery for?' is connected to 'What is my life about?' Potterymaking has been the artistic expression of who I am. It's a whole lifestyle that you have to commit yourself to." Pacheco finds solace in knowing that the "Pueblos are in a flux," trying to figure out their place in the world, "especially through the arts."

"In the olden days, Santo Domingos were taught to be respectful and not ask questions. Modern education teaches kids to ask questions. And Pueblo philosophy doesn't have an answer for a lot of things that are occurring. Pueblo stories say we are climbing into a different world. Philosophically, we are moving into a different mindset and understanding. The struggle is, keeping our traditional lifestyle relevant to those changes."

Words, stories, designs, pottery—all are part of being a Pueblo Indian. Delores Aragon treasures the Acoma traditions that her pottery carries, "the shared stories, the shared songs." Delores believes that "when you cook, don't be mad, otherwise you are just feeding your kids anger." In the same way, all your moods and emotions, your childhood and adult passages, your joys and sorrows—everything that makes you who you are, along with the entire history of your people, goes into each vessel.

It's a circle, a connection between the artist and her world. When we react to these pieces of pottery, when we hold them in our hands, when we purchase them and take them home, we take a dynamic and ever-changing world with us.

The potters have realized that their ancestors constantly adapted to change. They moved to new territories, found new sources for clay and slips, and adjusted their temper and fuel to these new materials. They invented new designs for ceremonial vessels. The notion of "tradition" is, in some ways, an artifact of the twentieth-century art market, a set of "mythological principles" (in scholar Bruce Bernstein's words) frozen in place by museum curators and collectors. Today's potters are looking for personal artistic freedom yet find reassurance in looking back over the hundreds of years in which potters had to set up shop anew after migrating from one ancestral home to another.

Lilly Salvador says, "It's not complicated to me because that's what was left here for us. I don't know how to describe it. You have to be an Indian to really understand it." Of traditional pottery Mary Trujillo says, "It has to be that way. Our life is that way."

A Sacred Business

For Lois Gutierrez-de la Cruz, the hardest part of being a potter is "the business." She finds pricing difficult: "Before Indian Market, my husband Derek and I put all our pottery out. And that's the hardest thing, trying to figure out how much we're going to charge for some-

thing—to be fair about it to the customer and to our-selves, as far as the time and the work we put into it.

"I can't hold on to every pot. Bills have to be paid. I enjoy it while I'm doing it. And I think that's the important thing, to enjoy what you're doing. If you don't, I think it shows in your work."

Derek adds, "When we first started out, Lois's mom, Petra, said, 'It's okay to make a living. It's okay to be good at it. But don't get crazy about it. Don't get greedy. Have respect for what you do.'" After Lois won Best of Show at Indian Market, the frenzy of the collec-tors so offended Derek and her that they decided to withdraw from competition. They continue to make pottery full-time but are taking Petra's advice—they don't want to go crazy.

Josephine Nahohai used the money she made from

pottery for her family: "I buy things for the home. That makes the house stronger." Angie Yazzie says, "The pot-tery is the owner of the house."

Bernice Suazo-Naranjo says, "Sometimes I wish that I didn't need the money, so that I could keep some of the pieces. But that's where some of the rewards come in. When someone else likes the piece, you feel really good. I like to sell to collectors because you know that they are buying it for their own self and they will hoard the pot. It's a different feeling than selling to galleries or wholesalers." Robin Teller Velardez feels that "selling to a gallery is like going to the dentist!" She has a hard time pricing her storytellers: "How can you say how much your grandchildren are worth?" Robin's pieces "touch people, connect with something in their childhoods. Even though we all come from different backgrounds,

Roxanne Swentzell's large bronze Window to the Past *sits outside her Tower Gallery at the Poeh Center, Pojoaque, 2006. Swentzell chose to open her gallery here, near the homes of friends and family, to give them a better chance to see her work.*

as a human soul, we experience the same things."

Potters don't hoard the past; pottery is meant to go out on its journey. Rebecca Lucario says goodbye when she sells a piece: "I part with a goodbye prayer. My grandmother would always hold a pot to her chest with her hands. She would pray for the people taking it." The late Acoma potter Juana Leno said, "If I don't give it away, what's the point of making it?" Experienced potters speak with glee of seeing their crude and crooked early pots in collections, almost as if someone else had made them. These potters live in the present.

The potters also speak of becoming lost in what they are doing, staying up until two or three in the morning working. Mary Cain says, "Sometimes I would sit there, busy, busy, busy, and I even forget to come in here to the kitchen and do the cooking for supper. On those days, my family excuses me. Then they take me to McDonald's."

Gladys Paquin occasionally yearns for a "regular" job: "My mind tells me eight-to-five would be a lot easier. My heart tells me different." Rainy Naha says, "It's a calling. We could be working at grown-up jobs. It's not an easy life. The ladies who work for the government eight-to-five, they are like an alien culture to me. They say, 'You have it so easy.' It makes me cringe!"

Dora Tse-Pe's pottery for sale at Santa Fe Indian Market, 2002.

Artisans & Artists

Few other Pueblo arts inspire such dedication. Pottery provides a living that comes right out of the culture: silverwork, sculpture, and easel painting have weaker connections to Pueblo tradition. Though some archaeologists persist in calling the revival of prehistoric pottery styles "decadence," others have pointed out that such a revival quietly reflects the worth of the past, the importance of community values. Perhaps this is why there is such sadness among the older potters when they talk about the use of molded pottery, commercial paints and clays, and kiln firing.

Why should a twenty-first-century Pueblo potter *not* use all the tools available to her in order to create art? Can a single new technique like electric kilns destroy the continuity of a living culture that has survived for 1,700 years? Surely, making pottery with *any* deference to traditional materials counteracts loss rather than accelerates it. Caroline Carpio explains, "Why do I do what I do? To save our culture through our art."

Innovators like Diego Romero find themselves caught between markets: "I'm this kid from Berkeley who is half-Indian. If I do the traditional craft, it's not accepted. If I do my own thing, it's breaking the rules, changing the market.

"There are some who are scared of it—it's not Indian art. There are some who are critical of it—it's political. Others say, 'We needed that.' All that reassures me. If it's that powerful, it's art."

A delicate balance exists between buyer and potter. Fire clouds and pitting make pottery undesirable to many consumers, so the Indian women reluctantly resort to kiln firing to solve these problems. When collectors then refuse to buy pottery because it has been kiln-fired, potters are caught in the middle of irreconcilable demands.

Pueblo potters can recognize commercial shortcuts because these make the pieces look "too perfect." Though many potters strive for perfection, they always compare pottery to people, and because people are not perfect, pottery can be the same way and still be valid.

Acoma potter Mary Ann Seymour at Santa Fe Indian Market, 2005.

Prize-winning Zia pot by Elizabeth Medina, Santa Fe Indian Market, 1986.

by doing so. It's tempting to avoid all the work of preparing clay, molding, and sanding and to get right to the business of demonstrating their painting skills. Clarence Cruz asks the critical question: "Do you think your grandmother said it was too much work?"

Pottery scholar Rick Dillingham pointed out a positive aspect of glazed ceramics. Because traditionally made pottery has become too valuable to keep, Pueblo families use greenware painted with familiar old designs —flowerpots or candy holders sitting on windowsills, serving pieces on the dinner table, chalices on the altar at the local Catholic church.

Competition has isolated potters from one another. In 2003, when five potters created a single figure at the School of American Research—a project captured in the 2003 film *Clay Beings*—the collaboration thrilled them. As a small statement in favor of collaboration over competition, the five signed the piece on the inside of the figure where no one can see their names. It's the opposite of commodification, a bow to the spiritual and cultural traditions.

Delores Aragon hates to see all the ribbons go to contemporary artists: "My mom [Marie Juanico] enters every year—nothing. Aunt Ethel [Shields] enters every year—nothing." Delores fantasizes about conspiring with her cousins Rebecca Lucario and Charmae Natseway: "This year, let's not enter, so the elders can be recognized. They are the people who created the market. I'm so proud of our family."

So many potters acknowledge mentors and teachers. Hubert Candelario, at San Felipe: "My melon bowls were inspired by Nancy Youngblood. I'm overwhelmed when I see Lonnie Vigil's pots—they are so gracious." Larson Goldtooth: "Virgil Ortiz's stuff is amazing, mind-boggling." Dorothy Ami: "Mark Tahbo saw an interest in me and encouraged me and told me he would help me. To this day, he still does."

One historian of Pueblo pottery distinguishes between artisans and artists. The latter are the conscious

Clarence Cruz notes that galleries may label a pot as traditional because the *person* who made it is traditional: "People need to be truthful. If the appraiser catches you, all hell breaks loose and that artist is blackballed."

At the cutting edge, the most creative artists pull the market along with them. The collectors then push the rest of the potters to follow. This push-pull is the driving evolutionary force in the art pottery world.

Potters still pray to Clay Woman before making their pots, but they must depend on their work for a living. Some skilled Pueblo potters paint molded "ceramics" in the belief that they can earn better wages

innovators, and the innovations have been happening for centuries. So has the business. Pueblo pottery played a part in the nation's oldest culture-based economy—pots were traded for Mexican macaw feathers a thousand years ago. Just before Americans introduced factory-made vessels to the Southwest in the 1800s, Pueblo potters were making pieces to supply forty thousand New Mexico settlers, as well as for their own use. They traded pottery for goods in those days. Now, they sell their work on the Internet and ship the pieces anywhere in the world. Robin Teller Velardez acknowledges that, in addition to being an artist, a potter must be "an accountant, a publicist, a marketer."

The 1970s created the Indian art market. Anthropologist Bruce Bernstein believes that the sixties counterculture's romantic notions of American Indians contributed to the Indian jewelry boom and consequent blossoming of Indian art galleries in the Southwest. The 1962 founding of the Institute of American Indian Arts encouraged individualism. In 1974 the Maxwell Museum exhibit Seven Families in Pueblo Pottery opened in Albuquerque. This event, along with the publication of Rick Dillingham's best-selling catalog, marked the beginning of collectors searching out individual potters, pueblo by pueblo. Suddenly, Indian material culture had become art. Pueblo women found themselves speaking for the first time for their

communities with the new status granted them by the dominant culture.

Santa Fe began staging the first version of Indian Market in 1922. Today about eighty thousand people come to Santa Fe for the annual event. They spend nearly $20 million in two days and more than $100 million statewide in the course of their weeklong August visit. An estimated $2.5 million goes directly to the Indian people exhibiting at the market, and many millions more are spent in the dozens of Santa Fe galleries, on pieces by artists who were first discovered in a market booth.

The potters speak time and again of trying to save their best pieces for Indian Market, for the Hopi and Zuni shows at the Museum of Northern Arizona, for the Heard Museum Indian Market in Phoenix, or for the Eight Northern Pueblos Show. Noreen Simplicio, at Zuni, especially treasures museum purchases of her work: it means that your pot "is the best of the best."

Jemez potter Fannie Loretto admiring clay sculpture by her daughter, Kathleen Wall; Santa Fe Indian Market, 2005.

Setting up on the plaza before dawn, Santa Fe Indian Market, 2005.

Robin Teller Velardez has realized, "Three hundred years from now, my pieces will be in museums. This is how I'm going to live forever!"

Hopi potter Larson Goldtooth captures the scene at First Mesa the day before Santa Fe Indian Market—three hundred miles away: "We're still here firing at 9 or 10 in the morning, when we should be on the road. By the time we get to Santa Fe, we're totally burned out. You're just sitting there in your booth, staring." He rallies, of course, when people come by, delighted with his Hopi figures: "I had to learn to talk. Now, I can rattle on and on about making the art."

These days, buyers come to potters' homes year-round. This helps young potters without vehicles. It also helps collectors understand the work—seeing the rooms where potters create, looking at the views they ponder

while imagining designs. On workbenches in front of those windows, cell phones rest next to paint rocks and yucca brushes, and buyers call frequently, pushing and prodding, some gentler than others. Saving a pot for a big show takes willpower when a potter knows that it will sell immediately for a good price. As much as potters love their work, the product supports them. Clarence Cruz says, "I'll have to make bigger pots when my son goes to college!"

Those prices keep going up. "Sometimes the prices shock *me*!" says Jean Sahme of her fine Hopi pots. "I'm sure they are worth it. I remind myself of all the hours I put into it." Dollie Navasie remembers how her heart raced when she was asked how much one of her award winners cost ("I couldn't breathe"). She answered with her highest price ever—$10,000.

Angie Yazzie felt guilty charging so much for each of her large, fine Taos pots, until she remembered what her grandmother, Isabel C. Archuleta, told her: "Mother Earth provides us with everything we need. We build houses with Mother Earth. We have food from Mother Earth. The money we make we use to feed our families. We help people in the community. Mother Earth is providing us with these things."

Hopi potter Gloria Mahle sees a generation-to-generation tradition in collectors, just as with potters: "A lot of the collectors have already been exposed to pottery, maybe by their parents or grandparents." Others worry that the younger generation is so entranced by technology, with no connection to the earth or to older, slower ways of creating art, that these future buyers won't be interested in traditional pottery. Also, people hold on to their money in chaotic times. After September 11, 2001, people retreated—they weren't buying art.

Potters clearly pay attention to what their customers want. They quietly keep tabs on the marketplace, mostly through their own experience of what sells and what does not. Wayne Salvador knows that his wife, Lilly, will do well at the Heard Museum if she brings pots with Mimbres designs. The Heard has hosted a Mimbres exhibit, so people there "recognize that type of art." Stella Teller says that nativity scenes sell best at Santa Fe Indian Market, corn dolls in Arizona, and that Europeans always buy the most expensive pots, Texans the biggest. The Nahohai family's bear figurines sell fast in California. "Older ladies" buy Virgil Ortiz's "most outrageous pieces." Younger collectors buy "safer pieces."

As the potter's world widens, unpredictable new problems arise. The line break seems to be dying out because buyers think that it makes the design look unfinished. Stella Teller sometimes has to refire her pots after shows, to burn off the greasy, sticky fingerprints left by people eating fry bread and honey. Glendora Fragua cringes as people wearing chunky rings handle her painstakingly polished pots: "You can hear the SCCRRTTCH" as the jewelry rubs across the surface. Karen Abeita worries about her hands. Besides making Hopi pottery, her other passion is softball: "I don't care where the ball hits me, just not my hands!"

Many potters keep to themselves. A woman living in a cinderblock house a quarter mile from an old adobe pueblo talks about friends who live "down at the pueblo" as if they lived miles and miles away. Most potters say that they pay no attention to anyone else's work. Many live up to this claim. Some say a jealous word or two, accusing others of using commercial clays or paints, painting molded

Jacob Koopee (left), Hopi potter, bringing his Best of Show piece to Indian Market (2005) at 6:00 a.m. It sold immediately.

greenware, or even sanding off the name from the bottom of a pot and signing their own. Rainy Naha believes that there is "a tremendous amount of spirituality and unity" in the circle of potters at Hopi: "Most of the backbiting is political and religious, not in the art world. Even those who are experts still call around for help." Jean Sahme wishes that everyone could just show their work and not do juried shows: "There are so many very talented people out there."

For the sake of "progress," we often strike devil's bargains to gain something new. Individuality creates artistic freedom, but a nourishing sense of community is lost. Success and wealth and "career" can stifle both cultural connection and creativity.

Nancy Youngblood treasures the rare compliments from other potters in her family: "When it does come, it means something. They know the time, how technically difficult it was. They know you took a chance. When my aunt LuAnn Tafoya comments, 'That's beautiful,' it's like Best of Division, Best of Show." Nancy's highest praise came years ago when her grandmother, Margaret Tafoya, looked at one of Nancy's early miniature Santa Clara melon bowls and said, "I think I could make that piece, but I don't think I could polish it."

Some tribal leaders and potters get upset with Indians who give demonstrations at museum shows or teach pottery workshops to non-Indians, fearing that

Nathan Begaye claims both his lineages: Hopi and Navajo. Does he make "Pueblo" pottery? 2006.

they are giving away "secrets." Every potter who takes such a step must ask herself why she does so. Susanna Denet used to see her people "cut down to nothing in price." Her response: "I wanted to do something to help my people. I demonstrate to educate the outsiders so that they will know what goes into the potteries." Her family supported this decision. Candace Tse-Pe Martinez often demonstrates potterymaking. For years, she worked as a hotel concierge in Santa Fe; in that role, she helped people understand "the whole culture." Candace feels like "an educator of the Southwest" and believes that "the buyers are intrigued by the whole process, not just the piece itself." It's a long way from the thirties and forties, when the great Zia potter Trinidad Medina toured the United States, demonstrating at world's fairs. Seated behind a railing, she remembered feeling just like "a cow in a corral."

Children and grandchildren continue to take up potterymaking. It's a choice today, rather than an unquestioned element of Pueblo identity. And with the increase in prices, more people can make a living as full-time potters. As a result, the twenty-first-century Pueblo pottery marketplace is lively. Acoma and Santa Clara each claim more than three hundred potters. Rainy Naha guesses that at Hopi only fifteen to twenty people "really work" at pottery at First Mesa, but their "dedication" to their work as the real "culture preservationists" nourishes her hope.

When Max Early's teenage son made pottery, he

chose to make a little replica of a Game Boy controller out of clay. Max, a born teacher, said to him, "You know how you are with your video games, how you play and play? That's how I am with my pots." His skeptical son went away with new understanding, new interest. Max believes that it takes "a certain mind frame" to learn potterymaking: "You have to be almost like an artist already." Some of the finest potters leave that judgment to the outside world. Robert Tenorio says that he always "would prefer to be called a potter rather than an artist."

Dora Tse-Pe is afraid that potterymaking is "going to go" one day: "I tell my girls, 'I feel good that I'm helping keeping it going. And I want you to do the same thing.'" In 1986 she was proud to say, "They are following my advice." In 2006 her daughters still make pottery. Dora's mantra echoes through all Pueblo families: "I hope they always will."

The micaceous glitter of San Felipe pots by Hubert Candelario, 2006. With its winding black line, the "evolution" plate "is about myself evolving in my life."

Acknowledgments

I COULD NOT HAVE PUBLISHED the original edition of this book in 1987 without the trust and patience extended by the School of American Research (SAR), particularly Jane Kepp and Jonathan Haas. Michael Hering, director of the Indian Arts Research Center at SAR, helped in many ways. Richard M. Howard and the late Rick Dillingham were generous with their time, knowledge, editorial criticism, and collections. Al Anthony, Robert Breunig, Laurie Davis, Andrea Fisher, and the late Alfonso Ortiz suggested potters to me. Andrea Fisher generously allowed me to photograph pottery in the Case Trading Post at the Wheelwright Museum, Santa Fe. Barbara Babcock shared her storyteller research and gave me permission to quote from her work. I also thank Ann Marshall at The Heard Museum, Phoenix, and Ann Hedlund and Art Wolf at the Millicent Rogers Museum, Taos. Jane Kepp and Tom Ireland kept me on the right track editorially, and Linda Montoya made the black-and-white prints of my photographs.

Two people deserve special thanks. In 1984 my friend Robert Breunig transformed my career when he asked me to work on the slide program "Our Voices, Our Land" for the Heard Museum. The idea for this book first came from conversations with Maria Goler Baca when she was managing Ortega's Gallery on the Santa Fe plaza.

Many thanks to James Brooks and Catherine Cocks of the School for Advanced Research for their enthusiasm when I suggested a twentieth-anniversary edition of my book. Catherine Cocks, especially, earns my gratitude for her exceptional collegiality as co-director of SAR Press. Copy editor Kate Whelan helped in the search for clear thinking and syntax. Cynthia Dyer created our elegant new design and handled production with crisp professionalism. And thanks to Lynn Baca for marketing the book with such energy.

Jonathan Batkin, Jerry Brody, Eric Blinman, and Andrea Fisher took time to read the manuscript and point me toward current research and to correct errors I would have missed.

Once again Andrea Fisher gave me free rein to photograph—this time in her gallery-full of fine work in Santa Fe, Andrea Fisher Fine Pottery. Robert Nichols, Bob Andrews, and Vickie Simmons shared their knowledge of contemporary artists and allowed me to photograph pottery in their galleries (respectively, Robert Nichols Gallery in Santa Fe and Andrews Pueblo Pottery and Agape Southwest Pueblo Pottery in Albuquerque). The staff at McGee's Trading Post at Keams Canyon helped me locate Hopi potters and let me photograph pottery. Cameron Trading Post, Mesa's Edge, and Santa Clara Trading Company also helped me to choose fine work to photograph. My thanks to SWAIA (the Southwestern Association for Indian Arts) for keeping me in touch with trends in Pueblo pottery by inviting me to judge at Santa Fe Indian Market every few years.

I have tried to provide a fair sampling of well-known,

established artists, beginning artists, diverse styles, and major families. The text retains the most eloquent stories and quotes from the original edition, including those of the elders we have lost. To orient the reader in time, I have added birth and death dates to index entries and have quoted deceased potters in the past tense. Because I could not document every active potter in each pueblo, I want to extend my apologies to the many fine potters whom I have, regretfully, neglected.

Notes on Sources

THROUGHOUT THE TEXT, quotations from potters come primarily from interviews I conducted with Pueblo artists in 1984–1986 and 2006. The originals of taped interviews recorded in 1985–1986 are archived at the School for Advanced Research (SAR), Santa Fe, New Mexico. I acknowledge the Heard Museum, Phoenix, Arizona, for permission to quote from my 1984 interviews with Bessie Namoki, Blue Corn, Rose Naranjo, and Jody Folwell.

Published sources from which I quote potters include Barbara Babcock's work on Helen Cordero (see chapter 4 note, below); Duane Anderson's work with micaceous potters (see chapter 2 note, below); Ruth Bunzel's *The Pueblo Potter* (Dover reprint, 1929); Rick Dillingham's "Nine Southwestern Indian Potters," *Studio Potter*, vol. 5, no. 1 (Summer 1976); Alice Marriott's *Maria: The Potter of San Ildefonso* (University of Oklahoma Press, 1948); "Southwestern Pottery Today," *Arizona Highways* (May 1974); an interview with Nathan Youngblood by Jaap VanderPlas, *Artlines* (August 1985); and Laura Fragua-Cota and Virgie Bigbee speaking in Nora Naranjo-Morse's film, *Clay Beings* (SAR Press, 2003).

Some Larson Goldtooth quotes come from *Larson Goldtooth Figures: Humorous, Outdoor, Fired, Polished, Innovative* by Barbara Jones, Bob Jones, and Larson Goldtooth (BBJ Investments, 2005), and some of Dextra's words come from *Painted Perfection: The Pottery of Dextra Quotskuyva*, edited by Jonathan Batkin (Wheelwright Museum of the American Indian, 2001).

Clay People: Pueblo Indian Figurative Traditions, edited by Jonathan Batkin (Wheelwright Museum of the American Indian, 1999), is a landmark source, with essays on historic figurines and on the work of Nora Naranjo-Morse, Roxanne Swentzell, and Virgil Ortiz.

In the following notes, author-date citations refer to works previously cited.

INTRODUCTION– *The People*

The primary source on southwestern Indians, both prehistoric and contemporary, is the *Handbook of North American Indians*, vol. 9, *Southwest*, edited by Alfonso Ortiz (Smithsonian Institution, 1979). For a less scholarly introduction, with a wealth of quotes from contemporary people, see my book *The People: Indians of the American Southwest* (SAR Press, 1993). The prehistoric Pueblo story told here comes mostly from *Archaeology of the Southwest* by Linda S. Cordell (Academic Press, 1997) and the less technical *Anasazi World* by Dewitt Jones and Linda S. Cordell (Graphic Arts Center, 1985). David E. Stuart's remarkable *Anasazi America* (University of New Mexico Press, 2000) tells the story of the transition from Ancestral Pueblo times to today's enduring communities of Pueblo people.

For more on today's Pueblo Indians, see Edward P. Dozier's *The Pueblo Indians of North America* (Holt, Rinehart and Winston, 1970) and Joe S. Sando's *Pueblo Nations: Eight Centuries of Pueblo History* (Clear Light, 1992). Alfonso Ortiz explores Pueblo worldview in *The*

Tewa World (University of Chicago Press, 1969) and in *New Perspectives on the Pueblos* (University of New Mexico Press, 1972). Tessie Naranjo's "Social Change and Pottery-Making at Santa Clara Pueblo" (Ph.D. dissertation, University of New Mexico, 1992) provides an insider's analysis.

CHAPTER ONE—
Talking with the Clay: Technique

In addition to Bunzel's (1929) classic, for more information on the techniques of Pueblo potters, see Alfred E. Dittert Jr. and Fred Plog's *Generations in Clay: Pueblo Pottery of the American Southwest* (Northland Press, 1980); Betty LeFree's *Santa Clara Pottery Today* (University of New Mexico Press, 1975); Marjorie F. Lambert's *Pueblo Indian Pottery: Materials, Tools, and Techniques* (Museum of New Mexico Press, 1966); and Carl E. Guthe's *Pueblo Pottery Making* (Yale University Press, 1925). *From This Earth: The Ancient Art of Pueblo Pottery* by Stewart Peckham (Museum of New Mexico Press, 1990) places contemporary Pueblo pottery squarely within the "uninterrupted tradition" that begins with prehistoric pottery. Jonathan Batkin brings that tradition into the twentieth century with *Pottery of the Pueblos of New Mexico, 1700–1940* (Taylor Museum, Colorado Springs Fine Art Center, 1987).

The story about the Albuquerque psychiatrist comes from Susan Peterson's *Lucy M. Lewis: American Indian Potter* (Kodansha, 1984).

For a broad survey of styles, with emphasis on collecting inexpensive pots, see the engaging, almost gossipy, *Southwestern Pottery: Anasazi to Zuni* by Allan Hayes and John Blom (Northland Publishing, 1996). Bruce Hucko squeezes a lot of warmth and information and many pottery examples into his *Southwestern Indian Pottery* (KC Publications, 1999).

To keep track of interrelated families at Hopi, Acoma, Zia, Cochiti, Santo Domingo, Santa Clara, and San Ildefonso—with quotes, portraits, and photos of representative work—consult Rick Dillingham's exhaustive *Fourteen Families in Pueblo Pottery* (University of New

Mexico Press, 1994), which is an update of his classic 1974 *Seven Families*. Schiffer Books (Atglen, Pennsylvania) publishes artist directories (with price guides) and monographs on individual potters. Gregory Schaaf compiles exhaustive genealogies and biographies of potters (published by the Center for Indigenous Arts and Cultures).

Rina Swentzell's *Children of Clay: A Family of Pueblo Potters* (Lerner Publications, 1992), a children's book illustrated with photographs, takes the reader through the potterymaking process with Rose Naranjo's amazing family at Santa Clara.

CHAPTER TWO—*Mountain Villages: Taos, Picuris, & the Micaceous Revolution*

Published sources concerning Taos- and Picuris-style pottery were meager until Duane Anderson's landmark *All That Glitters: The Emergence of Native American Micaceous Art Pottery in Northern New Mexico* (SAR Press, 1999). I quote Juanita DuBray, Jeralyn Lujan Lucero, Sharon Dryflower Reyna, and Lonnie Vigil from Anderson's text.

CHAPTER THREE—
The Red & the Black: Tewa Pueblos

The story of Maria comes from Marriott (1948); Richard L. Spivey's *The Legacy of Maria Poveka Martinez* (Museum of New Mexico Press, 2003); and Susan Peterson's *The Living Tradition of Maria Martinez* (Kodansha, 1977). Jonathan Batkin and J. J. Brody helped me avoid some of the inaccuracies that have been repeated for decades as part of the myth of Maria. See also Kenneth M. Chapman's *The Pottery of San Ildefonso Pueblo* (University of New Mexico Press, 1970); Nancy Fox's "Rose Gonzales," *American Indian Art Magazine* (Autumn 1977), pp. 52–57; and the Maxwell Museum of Anthropology's *Seven Families in Pueblo Pottery* (University of New Mexico Press, 1974).

The most complete source on Santa Clara is LeFree (1975). See also Francis H. Harlow's *Modern Pueblo*

Pottery 1880–1960 (Northland Publishing, 1977); Rick Dillingham, Richard W. Lang, and Rain Parrish's *The Red and the Black: Santa Clara Pottery by Margaret Tafoya* (Wheelwright Museum, 1983), from which the title of this chapter comes; and Mary Ellen and Laurence Blair's *Margaret Tafoya: A Tewa Potter's Heritage and Legacy* (Schiffer Publishing, 1986).

Tammy Garcia: Form without Boundaries (Tapestry Press, 2003), with contributions from Bruce Bernstein, John Grimes, and Benjamin Rose, showcases Garcia's elegant work and includes her own words, from which I quote. Nora Naranjo-Morse's *Mud Woman: Poems from the Clay* (University of Arizona Press, 1992) pairs Nora's clay sculptures with her poems and begins with an eloquent essay.

Quotes from Roxanne Swentzell come from Gussie Fauntleroy's "Clay People," *Native Peoples* (Summer 1999); Patricia Fogelman Lange's *Pueblo Pottery Figurines: The Expression of Cultural Perceptions in Clay* (University of New Mexico Press, 2002); and Gussie Fauntleroy's *Roxanne Swentzell: Extraordinary People* (New Mexico Magazine, 2002). Duane Anderson's *When Rain Gods Reigned: From Curios to Art at Tesuque Pueblo* (Museum of New Mexico Press, 2002) tells the story of these often denigrated figurines.

CHAPTER FOUR:
Telling Stories: Middle Rio Grande Pueblos

I am grateful to Barbara Babcock for permission to quote from her many fine publications. Most of the quotes from her interviews with Helen Cordero appear in *The Pueblo Storyteller* by Barbara Babcock and Guy and Doris Monthan (University of Arizona Press, 1986). This book gives a thorough history and survey of figurative potters and pottery. It also has a wonderful bibliography citing other works by Barbara Babcock; see especially "Clay Voices: Invoking, Mocking, Celebrating," in *Celebrations*, edited by Victor Turner (Smithsonian Institution, 1982).

The story of Clay Old Woman comes from Ruth Benedict's *Tales of the Cochiti Indians (Bulletin of the*

Bureau of American Ethnology, vol. 98, 1931). Some Virgil Ortiz quotations come from an interview with Louis Leray in *Bliss* (Winter 2005). See also *Clay People* (Batkin 1999). Some Diego Romero quotations come from his online interview with Larry Abbott (http://www.britesites.com/native_artist_interviews/dromero.htm).

For Santo Domingo, see Kenneth M. Chapman's *The Pottery of Santo Domingo Pueblo* (University of New Mexico Press, 1953); for Santa Ana, see Francis H. Harlow, Duane Anderson, and Dwight P. Lanmon's *The Pottery of Santa Ana Pueblo* (Museum of New Mexico Press, 2005). For Zia, see Francis H. Harlow and Dwight P. Lanmon's *The Pottery of Zia Pueblo* (SAR Press, 2003) and Michael J. Hering's "The Historic Matte-Paint Pottery of Zia Pueblo, New Mexico, 1680s–1980s" (unpublished M.A. thesis, University of New Mexico, 1985).

N. Scott Momaday's book *The Names* (Harper and Row, 1976) has lyrical descriptions of Jemez Pueblo people, landscape, and ceremonies. For a brief description, with photographs of Evelyn Vigil's work on Pecos glaze ware, see Sheila Tryk's "Solving the Pecos Pottery Mystery," *New Mexico Magazine*, vol. 57, no. 7 (1979), pp. 20–23. Her grandson's story of re-creating Jemez Black-on-white appears in "Jemez potter rediscovering lost techniques," by Marissa Stone, *Santa Fe New Mexican* (August 19, 2005); I quote Joshua Madalena from this story.

For general overviews of all these pueblos, see Harlow (1977); Dittert and Plog (1980); and Hayes and Blom (1996).

CHAPTER FIVE— Clay Made from History: Acoma, Laguna, & Zuni

General background on these pueblos appears in Larry Frank and Francis H. Harlow's *Historic Pottery of the Pueblo Indians 1600–1880* (New York Graphic Society, 1974); Harlow (1977); Dittert and Plog (1980); and *Fourteen Families*. For the connection to ancestral Mimbres styles, see J. J. Brody's *Mimbres Painted Pottery* (SAR Press, 2005). For Acoma, begin with Peterson (1984). For a charming and comprehensive history,

with many quotes from contemporary potters, see Dillingham's *Acoma & Laguna Pottery* (SAR Press, 1992).

The primary academic source for Zuni is *Gifts of Mother Earth: Ceramics in the Zuni Tradition* by Margaret Ann Hardin (Heard Museum, 1983). I quote from interviews with Josephine Nahohai in *Dialogues with Zuni Potters* by Milford Nahohai and Elisa Phelps (Zuni A:shiwi Publishing, 1995), a wonderfully intimate collection of stories and photographs.

For further details on the line break, see Kenneth M. Chapman and Bruce T. Ellis's "The Line-Break, Problem Child of Pueblo Pottery," *El Palacio*, vol. 58, no. 9 (1951), pp. 251–289. Josephine Nahohai's owl story comes from Babcock, Monthan, and Monthan (1986).

CHAPTER SIX—
The Legacy of Sikyatki: Hopi

For Hopi, in addition to the general sources—Harlow (1977); Dittert and Plog (1980); and *Fourteen Families*—the best introductory work comes from the Museum of Northern Arizona Press in Flagstaff. See "Hopi and Hopi-Tewa Pottery," *Plateau*, vol. 49, no. 3 (Winter 1977); *An Introduction to Hopi Pottery* by Francis H. Harlow and Katherine Bartlett (1978); and *Contemporary Hopi Pottery* by Laura Graves Allen (1984). Two fine biographies of Nampeyo have appeared: *Nampeyo and Her Pottery* by Barbara Kramer (University of Arizona Press, 1996) and *The Legacy of a Master Potter: Nampeyo and Her Descendants* by Mary Ellen and Laurence Blair (Treasure Chest Books, 1999).

I quote from *Al Qoyawayma: Hopi Potter* (Santa Fe East, 1984) and from the Wheelwright Museum's Dextra Quotskuyva catalog (Batkin 2001).

A 1977 children's book by Carol Fowler, *Daisy Hooee Nampeyo* (Dillon Press), tells the amazing life story of Nampeyo's granddaughter. Daisy left Hopi for eye surgery in California and went on to attend L'École des Beaux Arts in Paris and to study sculpture with her wealthy patron on a trip around the world before returning to marriage and family at Hopi and Zuni.

Other useful books include *Hano: A Tewa Indian Community in Arizona* by Edward Dozier (Holt, Rinehart and Winston, 1966), for general background; *Hopi Traditions in Pottery and Painting, Honoring Grace Chapella* by John E. Collins (Master's Gallery, 1977); and two books about the beginnings of the Sikyatki revival, by Edwin L. Wade and Lea S. McChesney: *America's Great Lost Expedition: The Thomas Keam Collection of Hopi Pottery from the Second Hemenway Expedition, 1890–1894* (Heard Museum, 1980) and *Historic Hopi Ceramics: The Thomas V. Keam Collection of the Peabody Museum of Archaeology and Ethnology, Harvard University* (Peabody Museum Press, 1981).

CHAPTER SEVEN—*One with the Clay: Economics, Art, & Tradition*

David Snow's articles helped with historic context: "The Rio Grande Glaze, Matte-Paint and Plainware Tradition" in *Southwestern Ceramics: A Comparative Review* (*Arizona Archaeologist*, vol. 15, 1982) and "Some Economic Considerations of Historic Rio Grande Pottery" in *The Changing Ways of Southwest Indians: A Historic Perspective,* edited by Albert H. Schroeder (Rio Grande Press, 1973). Betty Toulouse, in *Pueblo Pottery of the New Mexico Indians: Ever Constant, Ever Changing* (Museum of New Mexico Press, 1977), surveys the history of Pueblo pottery, with emphasis on the interaction of potters with museums and Anglo patrons. The story of Trinidad Medina feeling like a cow in a corral comes from Harlow and Lanmon (2003); the comments about greenware being put to daily use, from Dillingham (1992). See also Ralph T. Coe's *Lost and Found Traditions* (University of Washington Press, 1986) and Bruce Bernstein and J. J. Brody's *Voices in Clay: Pueblo Pottery from the Edna M. Kelly Collection* (Miami University Art Museum, 2001). Bruce Bernstein summarizes his ideas in "Contexts for the Growth and Development of the Indian Art World in the 1960s and 1970s," in *Native American Art in the Twentieth Century: Makers, Meanings, Histories*, edited by W. Jackson Rushing (Routledge, 1999).

WEBSITES

A number of dealers have good, dependable information posted on their websites. In listing them here, I am verifying the reliability of their information, but I'm not suggesting that these are the only places to shop for pottery. Other reputable galleries may not have such extensive websites.

Adobe Gallery, Santa Fe: http://www.adobegallery.com

Ancient Nations/McGees Indian Art, Keams Canyon:
http://www.ancientnations.com

Andrea Fisher Fine Pottery, Santa Fe:
http://www.andreafisherpottery.com

Andrews Pueblo Pottery, Albuquerque:
http://www.andrewspueblopottery.com

Artists' bios: http://www.hanksville.org

Canyon Country Originals, Tucson:
http://www.canyonart.com

The Enchanted Southwest, Albuquerque:
http://www.usanewmexico.com

King Galleries, Scottsdale: http://www.kinggalleries.com

Native American Collections, Denver:
http://www.nativepots.com

Pueblo Pottery Maine: http://www.pueblopotteryme.com

Towa artists: http://www.towa-artists.com

Short clips from two lovely documentary films about Lonnie Vigil and Roxanne Swentzell are archived at http://www.nmculturenet.org

COLLECTION, GALLERY, & ARCHIVAL CREDITS

Agape Southwest Pueblo Pottery, Albuquerque: pages 80, 85, 134.

Andrea Fisher Fine Pottery, Santa Fe: Cover, pages vi, 19, 30, 33, 60, 69, 72, 90 (bottom), 93 (bottom), 101, 135.

Andrews Pueblo Pottery, Albuquerque: Cover inset, pages 42 (inset), 47, 66, 90 (top), 99, 108, 111 (bottom).

Blue Rain Gallery, Taos/Santa Fe: page 52.

Cameron Trading Post, Arizona: pages 78, 82, 86, 89, 92 (top), 97, 111 (top), 123.

Rick Dillingham Collection: pages 113, 117.

Heard Museum, Phoenix: pages 20 (NA-SW-Ac-A7-55), 121 (NA-SW-Ho-A12-12), 146 (NA-SW-AC-A2-12).

Richard M. Howard collection: pages ii, 45, 51, 114.

Library of Congress: pages 96 (top): (Detroit Photographic Company, 1902; Lot 9148, LC-US262-47842), 125 (Detroit Photographic Company, 1902; Lot 9148).

McGees Indian Arts, Keams Canyon, Arizona: pages 15, 83, 116, 118 (top), 120.

Mesa's Edge Gallery, Taos: page 38.

Milwaukee Public Museum: page 112 ("Nampeyo and her daughter," photo by Sumner W. Matteson. Photo #44743).

Robert Nichols Gallery, Santa Fe: pages 71 (top), 74 (top), 136.

Poeh Art Center, Pojoaque: pages 42 (background), 127.

Pueblo of Zuni Arts and Crafts, Zuni: pages 23, 102 (bottom), 105, 107.

Katherine H. Rust Children's Collection, Mudd-Carr Gallery, Santa Fe: page 48.

Santa Clara Trading Company, Santa Clara Pueblo: pages 53, 138.

School for Advanced Research: page 96 (bottom); SAR Collection.

Jack Silverman serigraphs, Silverman Museum, Santa Fe: 93 (framed art on wall).

Richard L. Spivey: page 44 (from *The Legacy of Maria Poveka Martinez*, Museum of New Mexico Press, 2003, used with permission).

Roxanne Swentzell Tower Gallery, Poeh Art Center, Pojoaque: pages iii, 58, 127.

Wheelwright Museum of the American Indian, Santa Fe: page 62. Photo by Addison Doty, used with permission. Figures from Wheelwright Museum (Zita Herrera, 1970; 40/239) and School for Advanced Research (Historic figure collected by Jesse L. Nusbaum in 1907 or 1908; 2735).

Wheelwright Museum of the American Indian, Case Trading Post, Santa Fe: pages 31, 67.

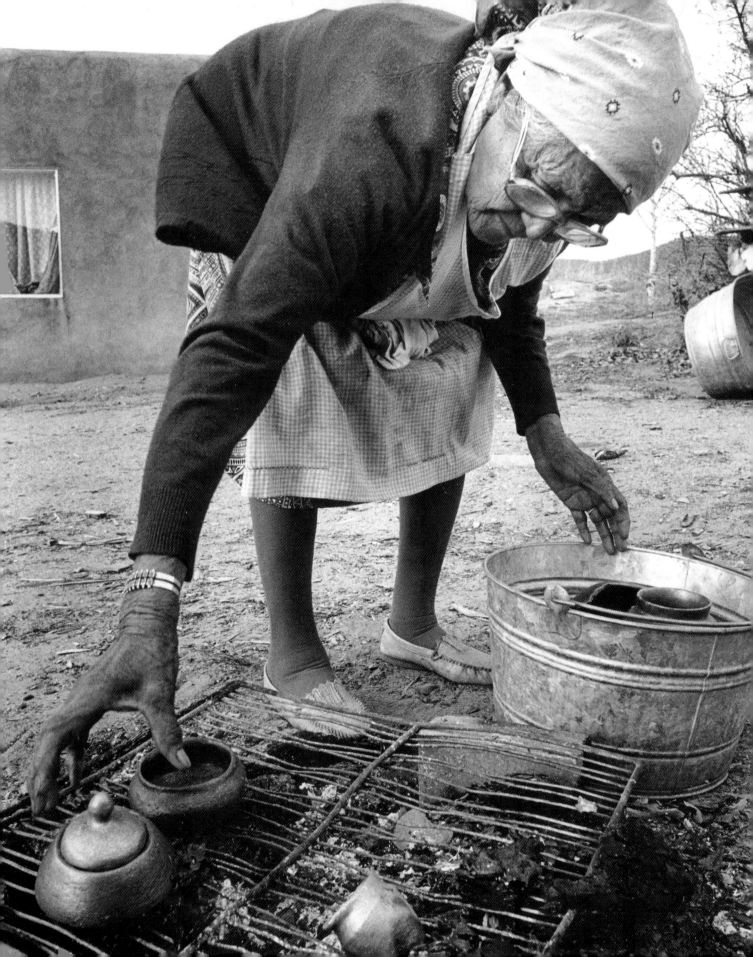

Index

Note: known dates for potters in **boldface**; photographs in *italics*.

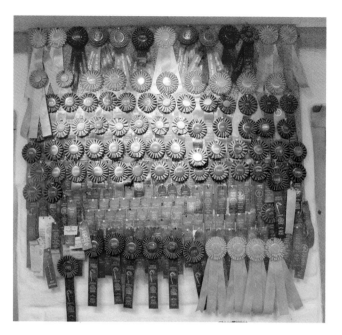

Nichols, Robert, ix

Author photograph by Joanne Slotnik.

WRITER AND PHOTOGRAPHER Stephen Trimble took home his first Pueblo pot (*this* one, an Acoma jar by Juana Leno) after a 1970 field trip to New Mexico from Colorado College. In the 1980s, Steve lived three miles from San Ildefonso Pueblo, and his ten years of fieldwork in Indian Country led to the first edition of *Talking with the Clay* in 1987, as well as *Our Voices, Our Land* and *The People: Indians of the American Southwest.* His twenty books also include *The Sagebrush Ocean: A Natural History of the Great Basin, The Geography of Childhood: Why Children Need Wild Places* (with Gary Nabhan), and *Lasting Light: 125 Years of Grand Canyon Photography.*

Steve has received significant awards for his photography, his non-fiction, and his fiction—including the Sierra Club's Ansel Adams Award for photography and conservation. To learn more about his work, go to www.stephentrimble.net.